ELIZABETH FULLERTON

# ARTRAGE!

The Story of the
## BritArt Revolution

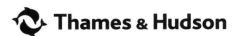 Thames & Hudson

## For Matthew, Oliver and Theo

First published in the
United Kingdom in 2016
by Thames & Hudson Ltd,
181A High Holborn,
London WC1V 7QX

*Artrage! The Story of the BritArt Revolution*
© 2016 Thames & Hudson Ltd, London

Text © 2016 Elizabeth Fullerton

Dead fly on jacket: Nataliia K/Shutterstock.com
Other fly on jacket: irin-k/Shutterstock.com

Jacket design by Gray318
Book design by Lisa Ifsits

British Library Cataloguing-in-Publication Data
A catalogue record for this book is available from
the British Library

ISBN 978-0-500-23944-5

Printed and bound in China by
Shanghai Offset Printing Products Limited

To find out about all our publications, please visit
**www.thamesandhudson.com**. There you can subscribe
to our e-newsletter, browse or download our current
catalogue, and buy any titles that are in print.

# CONTENTS

# INTRODUCTION

On the evening of 1 July 2014, a cheer rang out across the packed room as the Christie's auctioneer brought down the gavel. Tracey Emin's rumpled bed, strewn with blood-stained underwear, used condoms, cigarette butts and empty vodka bottles, had sold for £2.5 million, more than triple the lowest pre-sale estimates. The gavel's thud sealed the market's judgment on one of the most controversial icons of Young British Art, which with its in-your-face grimness and disregard for traditional artistic skill epitomized all that riled conservatives about the art of the 1990s. In itself the price tag wasn't astounding given that Damien Hirst's work regularly sells for more. But Tracey's *My Bed* dramatically polarized debate in Britain about whether it even deserved to be called art.

When it was displayed for the 1999 Turner Prize shortlist, two Chinese pranksters had a pillow fight on the bed and a housewife tried to clean it with disinfectant.[1] Journalists filled column inches galore arguing whether it was a shameless self-promoting gimmick or a searingly honest self-portrait. For Tracey, *My Bed* (1998) marked an epiphany in her life, a dawning of clarity after a week spent passing in and out of consciousness in an alcoholic haze following a devastating breakup with a boyfriend. After barely managing to crawl to the kitchen sink for a grubby glass of water and staggering back to her bedroom, she describes how 'I just suddenly thought, "This is horrific." And then it all turned around for me. It stopped being horrific and started to become beautiful. Because I hadn't died, had I?' The market's validation of the work – with barely a murmur of disapproval from the press – and its subsequent loan to the Tate for ten years show just how far British artists have come since the late 1980s when the Goldsmiths generation burst onto the nation's parochial art scene and changed the landscape irreversibly. This book tells the story of that journey.

The London art world in the late 1980s prior to 'Freeze' was essentially a 'very discreet gentlemen's club', according to the gallerist Sadie Coles. The commercial scene revolved mainly around one thoroughfare: Cork Street in Mayfair, site of a string of upmarket galleries largely dealing in modern art. 'There was no market for sales. There was no press. There were no collectors. There was no audience. It was empty. I mean it was an empty vessel. It was a desert,' recalls former Serpentine Gallery director Julia Peyton-Jones.

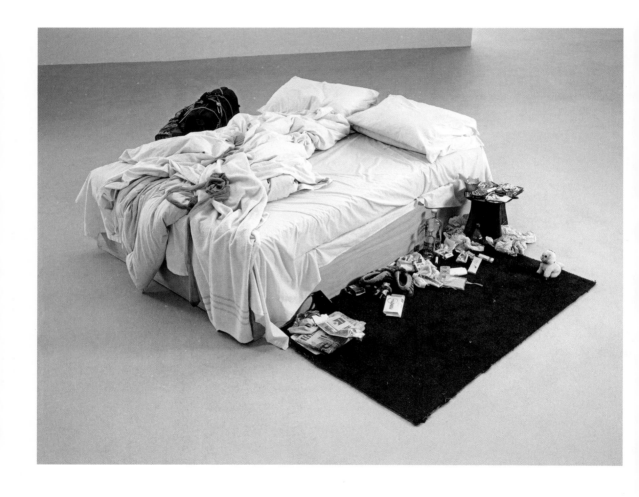

Tracey Emin, *My Bed*,
1998. Mixed media,
79 × 211 × 234 cm
(31 × 83 × 92 in.)

The art world functioned under a strictly prescribed code. Apart from rare stars such as Julian Opie, who had been signed up by the Lisson Gallery after graduating from Goldsmiths, art students faced years of penury, supporting themselves through odd jobs before they could hope for a show at a private gallery. 'Everyone was waiting in line, when do I get a show, do I have to wait till Howard Hodgkin dies?' remembers the critic Adrian Searle. Only once artists were established would a public institution take an interest in them, but without a gallery how to become established? It was catch-22. 'The idea of being a professional artist who was paid was somehow vulgar and wasn't really even seen as possible in England,' says the Goldsmiths-trained artist Richard Patterson. 'If you were going to be a successful artist, you just somehow had to miraculously be moneyed or something.' The artist Jake Chapman concurs: 'The concept of the young artist, the artist that was not some wizened old git scrubbing around in their kitchen sink, was not a thing that existed.'

It was an amazing moment.
It was the **biggest birth in British art** in a way.

**NORMAN ROSENTHAL**

That all changed in the summer of 1988 when a group of exceptionally talented, cocky and determined art students from Goldsmiths College, led by Damien Hirst, took matters into their own hands and staged the now legendary exhibition 'Freeze' in a derelict warehouse in Docklands. It marked the vanguard of a revolution that was to smash down the elitist barriers around art, transform the national psyche and put British contemporary art on the international map. 'It was an amazing moment. It was the biggest birth in British art in a way,' says Norman Rosenthal, former exhibitions secretary of the Royal Academy, who co-curated the contentious 'Sensation' exhibition there with the collector and adman Charles Saatchi in 1997.

That core group of sixteen 'Freeze' exhibitors, including now well-known names such as Gary Hume, Sarah Lucas and Fiona Rae, quickly expanded to embrace artists from other London colleges, such as Jake and Dinos Chapman, Tracey Emin, Gavin Turk and Rachel Whiteread, as well as Scottish artists like Douglas Gordon, who were spearheading an alternative scene in Glasgow. Refusing to wait for establishment blessing, artists organized shows in their front rooms, squats, disused factories, vacant shops. 'I don't think anybody had any hopes for being involved in the grown-ups' gallery system. That

seemed to be sewn up,' says Dinos Chapman. 'Nor did they want to join the system. It was too much fun outside it.' But if a curator did visit one of their studios, the artist would insist on taking them to see several others in the spirit of solidarity of the time.

Apart from Modernists such as Barbara Hepworth, Henry Moore and later Anthony Caro, only a handful of contemporary British artists had previously made it into the mainstream. The public was just about aware of Pop artists like Peter Blake, Richard Hamilton and David Hockney, who had made their name in the 1960s, and School of London standouts such as Frank Auerbach, Francis Bacon and Lucian Freud. The more art-informed would have been familiar with Central Saint Martins graduates Gilbert & George and Richard Long, as well as the 1980s generation of sculptors on the Lisson Gallery roster such as Tony Cragg, Richard Deacon and Anish Kapoor. Women artists barely registered on the radar, except for possibly Bridget Riley with her Optical Art and Paula Rego's Magical Realist painting.

> The one thing we all have in common is **we didn't sit around talking about <u>El Greco</u>**.
>
> LIAM GILLICK

The BritArt generation mostly looked beyond their British forebears for inspiration, to America and Europe. They found it in Minimalists like Donald Judd, in Andy Warhol's brand creation and in the slick, market-driven art of Jeff Koons. Big bucks Neo-Expressionist painters such as Julian Schnabel in America and Georg Baselitz in Germany, German Conceptualists like the iconoclast Martin Kippenberger and Arte Povera artists such as Janis Kounellis also exerted an influence.

But this was not a generation inhibited by the weight of art history. Many considered art before 1945 as artefact. 'The one thing we all have in common is we didn't sit around talking about El Greco,' says Goldsmiths artist Liam Gillick. 'Later on in the '90s I'd meet younger artists and they'd all be going on about "Did you see the Fra Angelico show?" and I'd say, "No, I didn't. But I saw *Sabrina the Teenage Witch* this morning." It's…as if we started…without any history.'

The YBAs plundered recent art, advertising and media ruthlessly but they transformed what they found to their own ends. Using sliced-up animals in formaldehyde, mutant child mannequins with penis-noses and anus-mouths, heads sculpted from human blood and casts of whole houses, the artists grabbed the British public, punched them

in the face and shook them out of their torpor. 'They did something
that nobody else had managed to do, which was to puncture public
consciousness,' says Peyton-Jones. 'It really started with artists
realizing "no one's interested in contemporary art, we've got to make
something that speaks to the wider public". Making work that...was
accessible and...talked...in a language that anyone could understand.
And the media immediately followed that,' agrees Matthew Slotover,
who co-founded the magazine *frieze* in 1991 and the eponymous art
fair twelve years later. No medium was taboo: kebabs, unmade beds,
elephant dung, waxworks, chocolate. Grand scale frequently aimed at
maximum impact. Their art spanned *Time Out* ads, the reconstruction
of a human skeleton, tits and bum tabloid spreads, press conferences,
forensic pathology images, interactive drawing machines, ink pads
and sharks. The way was open. The playing field was level for men
and women, at least for a time. Young dealers came
knocking at the door, followed – at a distance –
by museums.

> They did something
> that nobody else
> had managed to do,
> which was to puncture
> public consciousness.
>
> JULIA PEYTON-JONES

Not that there were many dealers in
London then. In the late 1980s, only a smattering
of commercial spaces displayed contemporary
art in the capital. In the west, the most prominent
galleries were the Lisson, Anthony d'Offay in Mayfair,
the newly opened young German dealer Karsten
Schubert, and Charles Saatchi's immense Boundary
Road space in the outreaches of north-west London that exhibited
his world-class collection of contemporary German and American
art. In the then inhospitable industrial east, the artist Robin Klassnik
pioneered an experimental space called Matt's Gallery, and American-
born Maureen Paley held avant-garde shows in her home-cum-gallery
in Bethnal Green.

Institutions such as the Institute of Contemporary Arts, the
Royal Academy, the Hayward Gallery and the Whitechapel Gallery
mounted some impressive shows of contemporary artists, but the
reception by the media and public was generally hostile or indifferent.
This may be partly explained by a sense in Britain of the twentieth
century as a cultural failure, reflected in the sparse representation
of the period in the Tate's national collection. 'The picture that people
had of the twentieth century...looked really kind of an embarrassment

in comparison with the nineteenth century or the eighteenth century or the Renaissance. Those things were represented in Britain fabulously,' says former Goldsmiths tutor Michael Craig-Martin.

The public outrage over the Tate's purchase in the 1970s of the American Minimalist artist Carl Andre's *VII* – or *The Bricks* as it came to be known – most clearly illustrates the British suspicion of contemporary art as a con. Several of the works by the BritArtists would spark comparable controversy, but in the course of the 1990s the media came on board, aware that shocks made good copy. 'What their art spoke of was a willingness to see shock as a medium in a way that was not necessarily so of the artists who we would consider shockers before them like Carl Andre's bricks, or Donald Judd's square boxes…,' says the television commentator and artist Matthew Collings. 'Those artists weren't necessarily laughing about shocking the audience whereas I think the YBAs were.'

On the political front, Prime Minister Margaret Thatcher was on her way out after three terms in office. Her government had crushed the miners' strike of 1984, irreversibly weakened the unions and shifted the economy away from manufacturing to financial services, triggering high unemployment, especially in the north. After several years of economic boom the economy plunged into recession in 1990, which would have a significant impact on the fortunes of British art. Feeling the pinch, Charles Saatchi sold off his American and German art collection in favour of the cheaper, ragtag bunch of artists emerging on his home turf. For the best part of a decade he would wield considerable power as virtually their sole patron, buying up often the most visually eye-catching and outsize art for display in his gallery. 'I think Saatchi is one of the biggest, if not the biggest, reason for the YBAs,' says Damien Hirst. 'I give all credit to Saatchi really.'

Jay Jopling, who started dealing art from his Brixton flat in the late 1980s, teamed up with Damien Hirst around 1991 in an irrepressible alliance that formed the backbone of Jopling's White Cube gallery, today a polished brand with franchises in several countries and a number of YBA stars still on its books.

By the end of the 1990s, young British artists had forged international careers, routinely exhibited their work in the most prestigious galleries and represented Britain in the Venice Biennale. Cabbies, those perennial barometers of man-in-the-street opinion,

would gossip about the outlandish art on the Turner Prize shortlists, in which BritArtists were prominent. Artists hung out with pop stars and fashion designers, dominating the features pages in newspapers and lifestyle magazines, as much for their bad behaviour as for their art. As Britain's culture grew more celebrity-driven, several artists became household names. A massive appetite for contemporary art had been awakened, as witnessed by the record 300,000 visitors to the Royal Academy's 'Sensation' exhibition and the instant popularity of Tate Modern on its opening in 2000.

This book explains how that happened. Looking at more than just the famous names, it focuses on a loose group of thirty British artists who came to prominence in the late 1980s and early 1990s and took part in many of the important shows of the decade. From the core of the group to the periphery, it examines the iconic works, seminal exhibitions, quirky performances and colourful characters that shaped BritArt. Paradoxically, despite the harsh political and social circumstances of Thatcher's government, these artists from mainly lower-middle-class backgrounds benefited from greater class and gender equality, thanks to generous state grants. After enjoying free college education, many were 'employed' under the 'enterprise allowance scheme', which was set up to massage unemployment figures, and paid £40 a week in return for attending a loosely defined business course.

The artists, of course, play the starring role but certain figures were instrumental in supporting and promoting them. Besides Jopling and Saatchi, Carl Freedman, for instance, curated some of the landmark shows of the decade, Karsten Schubert was one of the first dealers to spot the Goldsmiths artists' potential, and the idealistic impresario Joshua Compston staged anarchic village fetes and impromptu art events around Hoxton that helped to spark the area's regeneration.

Based on interviews with around fifty artists, gallerists, museum directors and critics, the book offers the first comprehensive objective overview of this defining period:[2] from the exhibition 'Freeze' to the blaze in a depot used by the storage company Momart that devoured major BritArt works. With the benefit of more than twenty-five years of perspective, it chronicles the artists' rise to prominence and subsequent fading from centre stage, examining along the way

milestones such as the warehouse exhibitions of 1990, the creation of Rachel Whiteread's sculpture *House* in 1993, the group show 'Brilliant!' in Minneapolis, the scandals around 'Sensation' in London and Brooklyn, and key Turner Prize moments.

First names will mainly be used to refer to the artists to convey a sense of the intimacy of this group who showed together, socialized together and in many cases slept together. As with any loose historic grouping, the periphery was fluid and the selection is necessarily subjective. Several important artists who became prominent in the period – Fiona Banner, Don Brown, Roderick Buchanan, Keith Coventry, Martin Creed, Tacita Dean, Jeremy Deller, Peter Doig, Cerith Wynn Evans, Ceal Floyer, Georgie Hopton, Jaki Irvine, Simon Linke, Steve McQueen, Mike Nelson, Paul Noble, Tim Noble & Sue Webster, Cornelia Parker, Simon Perriton, Grayson Perry, Jenny Saville, Yinka Shonibare, Ross Sinclair, Bob and Roberta Smith and Rebecca Warren – have not been counted as BritArtists because they did not feature in many shows with the group.[3]

> It felt like **London could become a contemporary city** instead of being a <u>post-war, miserable, unsophisticated backwater.</u>
>
> SADIE COLES

The term YBA has a derogatory connotation today as one-liner art, invariably linked to Saatchi, but this ignores the kaleidoscopic diversity of art that was produced. The period's richness lies in its inclusion of both the visceral and the cerebral: it encompasses Damien Hirst's pickled animals as well as Jane and Louise Wilson's psychological explorations of historic buildings through film. While no overarching aesthetic unites the group's art, certain strands stand out such as the focus on death and decay and the exploitation of the self as subject. Some of the group also straddled another movement, 'Relational Aesthetics', that was concerned with human relations and their social context.[4]

Many myths and misunderstandings have sprung up around the BritArt generation. They have been alternately portrayed as Thatcherite entrepreneurs, cynically inculcated with market savvy at Goldsmiths, and wild-living, counterculture rebels. The media would paint a picture of the period as a renaissance of 1960s 'Swinging London', calling it 'Cool Britannia'. Jumping on this bandwagon, Tony Blair's Labour government would exploit BritArt and Britpop in an effort to rebrand Britain as a nation of creative hip young things.[5]

This book aims to set the record straight on many of the questions people have about the YBAs, a label loathed by most of those it describes. Who exactly is a YBA? Is it a movement? Is it still going? And where are those artists now? Given that most have hit the age of fifty and the art world has become globalized, the terms YBA and BritArt feel outdated and simplistic. However, while recognizing their shortcomings, both have been used in this book for ease of recognition.

As with all cultural phenomena subject to intense media hype, the YBAs as a group went out of fashion. Upcoming artists reacted against them, as new generations do. Critics grew tired of the over-exposure and over-commercialization of their work, which in the more sober, multicultural age of the new millennium started to feel too big, too brash and too shiny.

Yet this compelling era merits scrutiny. As Sadie Coles says, 'Suddenly it felt like there was this home-grown movement, energy, art being made here, that was really relevant and in-the-moment. It felt like London could become a contemporary city instead of being a post-war, miserable, unsophisticated backwater.'

This book examines the rise, impact and legacy of the most significant group to emerge in Britain since the Pre-Raphaelites, according to David Thorp, former director of the Showroom, Chisenhale and South London Galleries. It tells the stories behind pivotal artworks and charts the fortunes of the artists, now mostly ensconced in the establishment. With a CBE from Her Majesty The Queen and a professorship of drawing at the Royal Academy of Arts, Tracey Emin, for example, has gained 'national treasure' status in Britain: quite a trajectory from the days of drinking herself into oblivion that produced *My Bed*.[6] A few of these BritArtists have fallen by the wayside, some have left the gallery system; yet a remarkable number continue to exercise sway over the public imagination and the London art scene. 'If you talk about Pop Art and Minimalism, Abstract Expressionism, which are very big loaded terms, and then you look at the timeframe, what's really shocking is it's five, six, seven years and then that moment is over,' says Karsten Schubert. 'What's extraordinary about this one is that it carried on for the longest time....It feels like nothing has taken its place. Now that's an odd phenomenon.'

**CHAPTER ONE**

**THE BIRTH OF THE YBAS: 1988**

By the time of the 'Freeze' launch on Sunday 7 August 1988, Mat Collishaw was a wreck. His hands lacerated and bleeding, he had been up for three days straight labouring on his installation for the show. Between bar shifts at a Hoxton nightclub, he had been cutting up sheets of galvanized steel and sawing fluorescent tubes to make fifteen light boxes. Mat and his friends were still mounting what would be arguably the most enduring image of the show when visitors arrived. Titled *Bullet Hole*, the gigantic photo installation featured a glistening, fleshy vagina-like wound radiating from parted hair, so unbearably magnified that it sent shudders down the spine yet simultaneously transfixed the viewer. Mat remembers his friend Angus Fairhurst, who was also in 'Freeze', coming up and saying, '"Your piece looks like shit." He was joking, of course, in a very dry way. But I was feeling a little vulnerable because of the lack of sleep and the fact that it was an opening. I just thought, "My God, it's shit."' No doubt the other

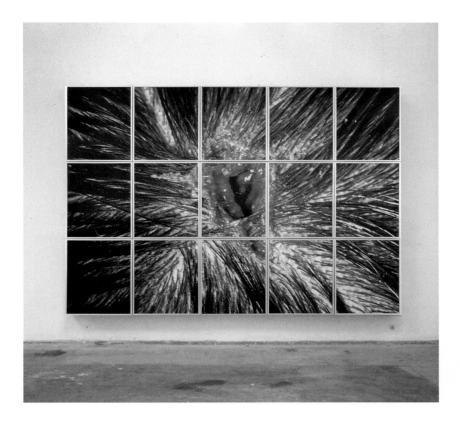

Mat Collishaw,
*Bullet Hole*, 1988.
Cibachrome mounted
on fifteen light boxes,
243.8 × 365.8 cm
(96 × 144 in.)

fifteen Goldsmiths students and alumni in the show shared Mat's apprehension after three weeks of hard labour overhauling the derelict Port of London Authority warehouse.[1]

The stakes were high: the tiny London art scene was virtually a closed shop and this was a rare chance to have work seen. 'Freeze' has gone down in art world lore, not so much for the art, nor for its setting in an abandoned warehouse, which was not a new concept; it was more the sheer chutzpah of those fledgling artists staging a gallery-standard exhibition, commissioning a remarkably professional catalogue and inviting the art world's top dogs to the no-man's-land of Surrey Docks to see it. No one could have foreseen the impact the show would have. It would blow apart the elitist hierarchy of the fusty art world and rewrite the rule book. In the process it would launch a new generation of British artists who thought big, reached out to mass audiences and weren't prepared to wait for approval from some higher authority. 'I have no words to tell you from my perspective how important that show was,' says former Serpentine Gallery director Julia Peyton-Jones. 'It was a revolution…. It really taught me something about vision. Ambition. Desire. And also attitude.'

But 'Freeze' was not born from a vacuum. It resulted from a perfect storm of teaching, chemistry between students and specific social, cultural and political circumstances. To understand how it came about and what made it so extraordinary, it is vital to go back to Goldsmiths College in the mid-1980s.

> It was a revolution….
> It really taught me something about vision. Ambition. Desire. And also attitude.
>
> JULIA PEYTON-JONES

## THE UTOPIAN BUBBLE OF GOLDSMITHS

On the green in front of the Millard Building, a Victorian former hospital that housed the Goldsmiths fine art and textile faculties in far south London, Damien Hirst and his friends would hang out and argue with the group intellectual, Liam Gillick, about art. 'Damien was caught up in a very complex caricatured idea about what it is to be an artist. He'd make strange gestures, raise his fist and say "Art!"' says Carl Freedman, a friend from Damien's hometown Leeds, who was

studying anthropology at University College London. The two shared a house for several years and Carl grew to know Damien's first-year mates Mat Collishaw, Angus Fairhurst and Abigail Lane, his friends in the year above, Angela Bulloch, Ian Davenport, Anya Gallaccio, Gary Hume and Michael Landy, as well as third-year students Sarah Lucas and Fiona Rae, all of whom would take part in 'Freeze'. Separated from the rest of Goldsmiths, the Millard Building was, according to Carl, 'a self-contained bubble of idealism and experimental culture' where students from all social strata could unleash their creative impulses.

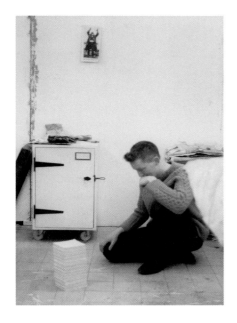

'You could write poetry, you could wander round for twelve hours with pigs' trotters hanging off you with a balaclava helmet on,' says Michael Landy, referring to a fabled performance by fellow student Shaun Caton. Michael earned the nickname 'Stacks' because he would stack objects obsessively, from bread trays to biscuits. 'I used to stack toilet rolls,' he recalls. 'Like pull off the individual leaves and stack them up into piles until they fell over. As art.'

This sense of freedom emanated from the unique teaching structure and ethos at Goldsmiths, set in place by its visionary principal and later dean of the school of art, Jon Thompson. When he arrived there in the late 1960s, disillusioned by the conservative teaching he had himself received at art school, the college was a hotbed of radicalism and he was pelted by Maoist students with little red books. However, he was interested in a real revolution in art education, not empty idealism. On becoming head of department, his first step was to abolish all hierarchies, announcing: 'We don't have students here, we only have artists.' Secondly, he dissolved the divisions between disciplines, convinced that would-be artists fresh out of school had no idea yet where their strengths lay.

Michael Landy stacks toilet roll leaves at Goldsmiths College of Art, 1986. Photograph by Abigail Lane

In contrast, art schools like Chelsea, the Slade and the Royal College of Art confined students to one discipline, such as sculpture, for their whole course and had a more traditional approach to art education. The artist Gavin Turk, who failed his degree at the Royal College for presenting an empty room but for a blue UK heritage

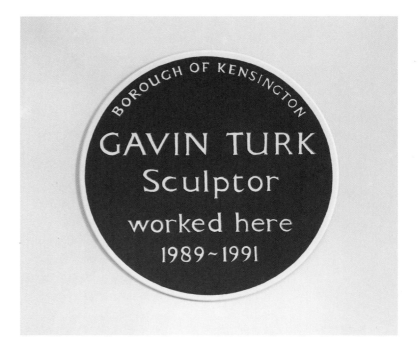

BOROUGH OF KENSINGTON

GAVIN TURK
Sculptor
worked here
1989~1991

Gavin Turk, *Cave*, 1991.
Ceramic plaque in room,
675 × 675 × 1,000 cm
(265 ¾ × 265 ¾ ×
393 ¾ in.)

plaque bearing his name, profession and dates, says: 'They wanted
to supply objects for aristocrats' gardens. It's called the Royal College
of Art, and…obviously the royals have quite old-fashioned taste.'
Jake Chapman, who also attended the Royal College, describes it as a
'finishing school'. Saint Martins in the 1980s enjoyed a similar vitality
to Goldsmiths, sparked by the students drawing inspiration from
each other, according to the critic Adrian Searle, who taught at both.

At Goldsmiths all the tutors were practising artists, engaged
with the art world of now. 'There was a sense that students might be
within touching distance of making it as artists, whereas at Chelsea
there was a course "Is there life after art school?" and the short answer
seemed to be no,' says Mark Wallinger, who did a BA at Chelsea and
taught at Goldsmiths after completing his MA there. Goldsmiths had
the fortunate accident of being a 'historical freak', caught between two
sources of funding: the University of London and the local authority.
Jon Thompson exploited this fortuitous independence to the full.
A Europe-leaning intellectual himself, he hired a broad spectrum
of teachers. He mixed Conceptualists such as Michael Craig-Martin

and Richard Wentworth with traditional painters like Basil Beattie, performance artists such as Lindsay Kemp and feminist artists like Helen Chadwick and Andrea Fisher.

People often label the YBAs as 'Thatcher's children', equating their rags-to-riches success with Margaret Thatcher's emphasis on individual resourcefulness at the expense of the collective. In fact, they were both a product of and a reaction to Thatcher's government, their entrepreneurial 'fuck-it' attitude owing as much to the legacy of the punk era as to the 1980s DIY ethos. Their teachers were anything but Thatcherite, espousing the 1960s ideals of the Welfare State. Ironically, given Thatcher's lack of interest in the arts and discouragement of welfare reliance, the grant system that continued under her government supported many artists from modest backgrounds through art school and beyond. People like Sarah Lucas, who grew up on a north London council estate, and Damien Hirst, who was brought up in Leeds by his working-class mother, had access to free higher education, which they wouldn't have under today's student loan system.[2]

Within this mini social utopia, students had their own studio spaces in an open-plan room and could request tutorials with any of the artists. 'I actually made it my business to have a tutorial with every single tutor that went there. I think I maybe missed out on one,' recalls Fiona Rae, who was perhaps more self-possessed than some of the others, having been brought up in Hong Kong and attended boarding school. Sarah Lucas, on the other hand, preferred to catch a tutor over a beer in the canteen. 'There wasn't any syllabus and it was a very self-conscious place because it was up to you what you did,' says Sarah. 'It could be quite a glare to be in. I don't think it suited everybody actually, but it was a brilliant time.'

Students bonded on many levels. Tuesday was disco night where everyone danced like mad and drank Newcastle Brown Ale or watched Ian Davenport's country band, the Good Ol' Hometown Boys, perform.

Twice a week students could display their work in designated exhibition spaces and have it critiqued in an open seminar. Competition for these opportunities was stiff; fifty students might turn up to watch tutors debate the merit of the exhibits, at times clashing fiercely. 'That was really fascinating....The teachers would feed off each

other and argue and the students would play off each other. There was
a lot of exchange,' says Liam Gillick, who was not in 'Freeze' but took
part in subsequent shows with the group. 'It was very contestatory,'
admits Thompson, 'but there was an immense
amount of trust.'

It was like carving out an arena
for people to sort of perform in,
and it was <u>very desired</u>.
**It was like a cult.**

ANGELA BULLOCH

This atmosphere of fervent enthusiasm
sprang from the passionate engagement of the
teachers. Irish-born Michael Craig-Martin, who
trained in America, had one of the most sought-
after tutorial groups. 'He created this sense of
urgency and importance about what that group
was doing. And everybody was so competitive, and
wanted to do well,' says Angela Bulloch. 'It was like carving out an
arena for people to sort of perform in, and it was very desired. It was
like a cult.' People would bring their latest creations to the tutorials
and 'everybody would look and examine whatever thing you'd done
in this very intense way, it was almost medical,' she recalls.

Of the sixteen-strong 'Freeze' group, those who studied under
Craig-Martin at different times include: Angela Bulloch, Mat Collishaw,
Ian Davenport, Gary Hume, Michael Landy, Abigail Lane, Sarah Lucas,
Richard Patterson, Simon Patterson and Fiona Rae. Damien Hirst did
not, but Craig-Martin would later become a mentor to him. 'I think
everybody who got something special out of the course went on a bit
of a journey,' says Ian. Angela found her own language using digital
technology and silicon chips to dim or turn lights on and off within
sculptures. Early on she made installations using Belisha beacons,
originally devised to help people cross roads safely, and supplanted
that system of flashing lights with her own. Craig-Martin 'was very
good at helping you understand what it was you'd actually done.
Taking it apart and starting from scratch really,' Fiona remembers.
'One student, for example, took a car bonnet and put it on the wall,
and so Michael talked about that and whether it was now a painting.'

Ian Davenport, Gary Hume and Fiona Rae managed to develop
their own signature styles in paint, defying the Postmodern consensus
that painting was dead. Ian moved into the sculpture department,
where the approach to materials was more investigative. Faced with
the perennial quandary of what to paint, he chose the dripping paint
pots cluttering his studio. 'And then over a period of weeks the paint

pots started to dissolve into ellipse shapes, almost as if the pots had disappeared. It became a repeated mark with all these drips made with wax and God knows what else,' he says. As he threw the paint around with a controlled randomness influenced by Jackson Pollock, the paint itself and the process became the subject of his painting. 'From that being a very small idea, I realized it could be a huge idea with massive implications,' he says.

Fiona Rae was also experimenting with paint, exploring different styles: 'I never just went with one way of putting on paint... I thought why limit myself – quite a polyglot I suppose.' Prior to

'Freeze' she began laying out marks in rows, like colourful hieroglyphs or calligraphy, possibly influenced by her childhood in Hong Kong. 'I was thinking about cartoon cels as well, and the way things change from one cel to another. But then because they were laid out in rhythmical ways, the whole canvas would have a presence. So you'd have one big painting made up out of nine small paintings.'

Gary Hume turned to hospital doors as a subject, inspired by a health insurance advert, which featured a sleek Modernist door and proclaimed the end of the ideal that the state could meet everyone's needs. 'It had this nice sense of the end of a loose socialism and a dreaming...of a better world being encapsulated with the end of Modernism,' says Gary. Painted in ordinary household gloss, the doors functioned formally as abstract Minimalist paintings, yet contained a human narrative as literal entrances to a public institution where birth and death occur. Like many BritArt works, the doors deliberately blurred the distinctions between the real object and artwork. 'If I painted it in oil paint, then I would have a painting of it,' Gary explains. 'But if I painted it in gloss paint, I would have something which is very similar to *it*, so the bit between...the representation and the actual thing is very close: is it a door, or is it not a door?'

Ian Davenport in his studio at Goldsmiths, London, 1988. Photograph by Bill Stewart

This sort of conceptual thinking and interest in Minimalist form was prevalent at Goldsmiths. Craig-Martin had made his name

ABOVE: Ian Davenport,
*Untitled*, 1988.
Oil on canvas,
213.4 × 213.4 cm
(84 × 84 in.)

OPPOSITE: Fiona Rae,
*Untitled*, 1988.
Oil on canvas,
213.4 × 198 cm
(84 × 78 in.)

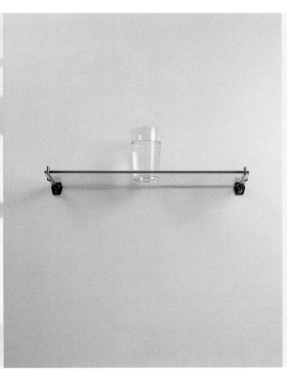

Q: To begin with, could you describe this work?
A: Yes, of course. What I've done is change a glass of water into a full-grown oak tree without altering the accidents of the glass of water.
Q: The accidents?
A: Yes. The colour, feel, weight, size …
Q: Do you mean that the glass of water is a symbol of an oak tree?
A: No. It's not a symbol. I've changed the physical substance of the glass of water into that of an oak tree.
Q: It looks like a glass of water …
A: Of course it does. I didn't change its appearance. But it's not a glass of water. It's an oak tree.
Q: Can you prove what you claim to have done?
A: Well, yes and no. I claim to have maintained the physical form of the glass of water and, as you can see, I have. However, as one normally looks for evidence of physical change in terms of altered form, no such proof exists.
Q: Haven't you simply called this glass of water an oak tree?
A: Absolutely not. It is not a glass of water any more. I have changed its actual substance. It would no longer be accurate to call it a glass of water. One could call it anything one wished but that would not alter the fact that it is an oak tree.
Q: Isn't this just a case of the emperor's new clothes?
A: No. With the emperor's new clothes people claimed to see something which wasn't there because they felt they should. I would be very surprised if anyone told me they saw an oak tree.
Q: Was it difficult to effect the change?
A: No effort at all. But it took me years of work before I realized I could do it.
Q: When precisely did the glass of water become an oak tree?
A: When I put water in the glass.
Q: Does this happen every time you fill a glass with water?
A: No, of course not. Only when I intend to change it into an oak tree.
Q: Then intention causes the change?
A: I would say it precipitates the change.
Q: You don't know how you do it?
A: It contradicts what I feel I know about cause and effect.
Q: It seems to me you're claiming to have worked a miracle. Isn't that the case?
A: I'm flattered that you think so.
Q: But aren't you the only person who can do something like this?
A: How could I know?
Q: Could you teach others to do it?
A: No. It's not something one can teach.
Q: Do you consider that changing the glass of water into an oak tree constitutes an artwork?
A: Yes.
Q: What precisely is the artwork? The glass of water?
A: There is no glass of water any more.
Q: The process of change?
A: There is no process involved in the change.
Q: The oak tree?
A: Yes. the oak tree.
Q: But the oak tree only exists in the mind.
A: No. The actual oak tree is physically present but in the form of the glass of water. As the glass of water was a particular glass of water, the oak tree is also particular. To conceive the category 'oak tree' or to picture a particular oak tree is not to understand and experience what appears to be a glass of water as an oak tree. Just as it is imperceivable, it is also inconceivable.
Q: Did the particular oak tree exist somewhere else before it took the form of the glass of water?
A: No. This particular oak tree did not exist previously. I should also point out that it does not and will not ever have any other form but that of a glass of water.
Q: How long will it continue to be an oak tree?
A: Until I change it.

OPPOSITE: Gary Hume, *Dream*, 1991. Oil on panel, 211 × 140 cm (83 × 55 in.). Gary's early Door Paintings such as those displayed at 'Freeze' were mint green monochromes and became more colourful after he left Goldsmiths.

ABOVE: Michael Craig-Martin, *An Oak Tree*, 1973. Glass, water, shelf and printed text, 15 × 46 × 14 cm (5 ⅞ × 18 ⅛ × 5 ½ in.)

with his 1973 work *An Oak Tree*, comprising a glass of water on a shelf accompanied by a philosophical discourse on how he had changed the object into an oak tree. The belief in the artist's power to transform an ordinary object into art derives ultimately from Marcel Duchamp's insistence that anything – even a urinal – can be art if the artist decrees it. Duchamp's idea of the 'readymade' had a profound influence on the students, as did the Arte Povera idea of creating art from found objects. Andy Warhol's unashamed embrace of consumer culture, use of shocking subject matter and innovative approach to authorship and reproduction were also significant.

I often said to students…
**'Stop being so creative,
it's too much.'**

MICHAEL CRAIG-MARTIN

Craig-Martin had a particular knack for identifying what made each student's work unique. Time and again he would notice someone struggling to create work they thought they should make. 'Then he would find out they would go home and make a galleon out of matchsticks or some bizarre hobby and he'd say, "Well that sounds weird, bring that in and make that the thing you do,"' recalls Richard Patterson. 'It's a secret because they think it's not worthy of attention,' Craig-Martin explains. 'It's too personal. It's…not avant-garde enough.…There's a thousand reasons why people dismiss things.' Often students would be paralysed by the need to come up with some interesting new idea. Craig-Martin released them from this anxiety. 'Everything is actually already more interesting than you can cope with,' he says. 'I often said to students…"Stop being so creative, it's too much."…You have to learn, how do you limit yourself, how do you focus?'

Every tutor had their own idiosyncratic approach. Richard Wentworth infuriated Anya Gallaccio by telling her to throw out of the window an overcomplicated sculpture she had been toiling over for months. 'It was devastating. I think I cried for a week,' she says. But she learnt a useful lesson: to focus on the essential idea in her work.

As crucial as the teaching was the tutors' insistence that students should interact with the forbidding art world. In this pre-internet time, knowledge about the latest international art developments was patchy, gleaned from exhibitions or art magazines. Tutors would pin up invitations to openings or accompany groups to shows. Richard Patterson remembers Craig-Martin driving him and

four students out to Charles Saatchi's gallery in a 2,787-square-metre (30,000-square-foot) converted paint factory in Boundary Road, north-west London. In its first two years, Saatchi's gallery showcased an array of American artists including Donald Judd, Sol LeWitt, Richard Serra and Andy Warhol. 'During the '80s, the Saatchi collection showed the greatest contemporary art in the whole world in the most perfect conditions. You couldn't have seen it better anywhere. It was sensational,' remembers Craig-Martin. 'This idea that our tutor could give us access to this private experience,' says Richard, 'you realized there was some other world so it was very energizing.' The pristine white space with exposed rafters quickly became a pilgrimage site for art students and cognoscenti.

The Minimalist shows had been impressive, but the Saatchi Gallery's exhibition 'New York Art Now' in September 1987 electrified Damien Hirst and his friends. There, they saw American wunderkind Jeff Koons's slick vitrines encasing gleaming Hoovers, which would directly inspire Damien's art, as well as Haim Steinbach's shelves of carefully arranged items and Robert Gober's eerie waxwork body parts. 'When I saw the Saatchi Gallery I was just like, boom, I want to show there,' says Damien. 'And that dictated the scale, the size, the impact. And that's what it needed to be to work on an international level. There was nowhere else in London doing that.'

At this time Damien and his circle were gripped by gruesome medical images of dissected bodies and murder victims. G. Austin Gresham's *A Colour Atlas of Forensic Pathology* (1975), purloined from Foyles bookshop by Carl Freedman's brother and passed to Marcus Harvey (a buddy from Leeds and Goldsmiths painter), was doing the rounds. Mat Collishaw was especially struck by the back cover image of an ice pick wound, which was ambiguous 'because you couldn't really see what it was' and 'your mind could escape'. It was only months after he selected that image to magnify to colossal proportions for his piece *Bullet Hole* that he realized the wound was actually not from a bullet. Yet if Michael Craig-Martin could transform a glass of water into an oak tree, Mat could turn an ice-pick wound into a bullet hole.

Critics have attacked the amoral tone of works like *Bullet Hole* that exult in their abjection.[3] However, the nihilism was not intended to be gratuitous; it reflected the prevailing social mood and the emotionally detached literature of J. G. Ballard and Bret Easton Ellis

that was popular among members of the group. 'That was part of a late twentieth-century condition, that violence is happening all around us; it's happening on TV and in imagery, but our response to it isn't quite as empathetic as it could be,' Mat explains. Damien had long been obsessed with death and the pathology images would feed into future works, but at this point his art was unformed.

Damien had taken the tutors' advice to heart about engaging with the art world. In his second year he landed a part-time job at Anthony d'Offay's gallery. Craig-Martin's first impression of Damien was not for his art but for him serving champagne at an opening at London's swankiest gallery. 'Well that's quite an amazing initiative isn't it?' Craig-Martin recalls. 'And what he was doing was looking at: How is it done? What goes on?…What do you do?' In his conception of 'Freeze', Damien would incorporate the consummate professionalism he learnt at d'Offay with the soaring space and industrial chic of Saatchi's gallery. He also 'borrowed' d'Offay's mailing list of art world bigwigs.

> I can honestly remember thinking…they could be the **next generation of successful British artists** because there's such strength here.
>
> MICHAEL CRAIG-MARTIN

By visiting these contemporary shows, particularly at Boundary Road, the art students saw cutting-edge art being made by people little older than themselves. They drank it all in and returned to college galvanized to make their own mark. Goldsmiths offered the perfect hothouse environment where an extraordinary number of students discovered their artistic voice. Craig-Martin says: 'I can honestly remember thinking…they could be the next generation of successful British artists because there's such strength here. But the thing that was so noticeable, and that 'Freeze' consolidated, was the sheer number of them.' Even before 'Freeze', their talent was getting noticed. The young dealer Karsten Schubert took Gary Hume and Michael Landy onto his roster from their June degree shows. Then veteran gallerist Leslie Waddington bought Ian Davenport's entire degree offering in a move unheard of among the venerable galleries of Cork Street. 'That was a ground-breaking moment for me,' Ian admits.

As an aside to this, after Ian graduated, Damien and Carl Freedman noticed one of Ian's paintings crumpled in a skip and fished it out. 'There was a feeling around London even then that he would be a superstar and it would be worth holding on to his early college

work,' says Carl. They re-backed it and hung it on the garden washing line. Naturally it rained. 'We had this Ian Davenport on the washing line for about a month getting mouldier and mankier. It ended up in the bin.'

A common myth about Goldsmiths is that students were prepped with careers advice, but that would have been pointless since no one collected British contemporary art. 'There wasn't a commercial career to go to,' says Craig-Martin. 'So the actual motivation for people was not to become rich and famous; it was, how can they survive as artists now? And for the next year?' What the college did was to equip students with a set of valuable practical tools with which to face a hostile art world. Jon Thompson insisted students gain some knowledge of art theory. 'I wanted to make these people self-reliant. I wanted to enable them to make an argument about what it is they were doing and why,' he says.[4] 'The whole thing about being an art practitioner is that you have to spot a gap. And fill it. You have to say, "That's my space", and...defend that space. And if you can't do that, you can't survive in the modern art world.'

In practice, the difficult philosophical ideas of Post-structuralists such as Jean Baudrillard and Roland Barthes about authorship and originality met resistance among the 'Freeze' group. 'They rather liked the idea that you could take...or reuse anything or make art that didn't look like art without having to take on all the theoretical apparatus,' says the critic Adrian Searle. Jake Chapman, a rare devotee of theory among the YBAs, identified the work of the Goldsmiths lot as underpinned by 'some sort of serious scrutiny of Situationist text'. It came as a disappointment later to realize most of them were in fact antagonistic to theory. 'Essentially they were the same kind of Royal College...life study oil painters but somehow manifest in hard-edged anodized aluminium and chopped-up sharks,' he says.

## GETTING 'FREEZE' OFF THE GROUND

Having had it drummed into them that they couldn't expect any breaks in the art world, the students decided to strike out on their own. Several months before 'Freeze', Angus Fairhurst organized an

exhibition of mates including Mat Collishaw, Damien Hirst and Abigail Lane, at the Institute of Education in Bloomsbury. 'It was the first nod to, well let's get out of the walls of this place and do something,' says Abigail. Damien talked about setting up an exhibition for months but few thought it would materialize: 'I just thought, somehow, getting together in a group was going to be much more beneficial…than individually me thinking about myself.' When he took the reins, he showed himself to be an exceptionally effective organizer. In addition to those mentioned, Damien selected students who were making exciting work, such as the photographer Lala Meredith-Vula, Steven Adamson, recent graduates Stephen Park and Richard Patterson, and Richard's brother Simon, who was creating conceptual portraits of famous people by silkscreening their names in black type onto a white canvas.

Liam Gillick might have been included but for the fact that his on-off girlfriend, Angela Bulloch, was seeing Damien. 'It's just as simple as that. I mean, they nearly had a big fight,' Angela says of Liam and Damien. Even if it hadn't been for the love triangle, a natural antipathy existed between Damien, the cheeky prankster and exhibitionist, and the intellectual Liam, with his constant theorizing. 'I wasn't that interested in this sex and death thing. I thought it was stupid frankly,' says Liam, who by then was already writing critical reviews for art magazines like *Art Monthly*.

The top-floor tower block council flat near Surrey Docks that Angela shared with Sarah Lucas became a nerve centre for planning the show. Damien would jump out of bed, half-naked and hung-over, wheeling and dealing on the phone, his innate gift of the gab enhanced by his experience working for a telephone market research firm. 'He was always teasing anybody he was trying to get money off…,' Sarah laughs. 'Not at all businesslike about it but at the same time he would wing it, it would work.' Somehow he convinced the property developer Olympia & York to cough up £10,000 for the catalogue and the London Docklands Development Corporation

Angela Bulloch sitting on Damien Hirst's lap during the preparations for 'Freeze' in the Port of London Authority (PLA) building, 1988. Photograph by Simon Patterson

to provide the disused Port of London Authority building and £4,000 for art materials.[5]

Emulating the sophistication of Anthony d'Offay's catalogues, Damien brought in the top designer, Tony Arefin, the photographer Edward Woodman and Goldsmiths tutor Ian Jeffrey to write the essay. Jeffrey attributed the show's title to its attempt to capture a freeze-frame of a moment. The truth is more prosaic. Abigail Lane remembers discussing the show with Mat Collishaw, Damien Hirst and Michael Landy while throwing together a lunch of lasagne with lettuce. 'It was a frisée lettuce...God knows who said what, but then it must have started a little conversation that led from frisée to "Freeze",' she says.

A natural risk-taker and attention-seeker, Damien would pull crazy stunts like climbing onto the outside of the balcony of Sarah Lucas and Angela Bulloch's thirteenth-floor flat. Or 'he'd be in the lift, way up, get himself into the corner and jump up and down really fast. He would do things like that and terrify everybody,' according to Angela. But despite the larking around, Damien proved to be highly motivated. He sent round a typewritten letter with a detailed work schedule to make the building ready for the show, urging everyone to pull their weight, saying IT IS GONNA BE GOOD!

> God knows who said what, but then it must have started a little conversation that led from frisée to 'Freeze'.
>
> ABIGAIL LANE

The well-known photograph taken on the day 'Freeze' opened belies the weeks of spats and toil that went before. Under Damien's rota system, they revamped the neglected space, sanding down the floor, tearing out radiators, redoing the electrics, boarding up windows and doors, and cleaning out pigeon droppings.

Health and safety barely figured on the radar and there were casualties besides Mat Collishaw's hands. Anya Gallaccio was rushed to hospital with third-degree burns after splashing molten lead into her boot while pouring her lead floor sculpture. Simon Patterson trod on a large rusty nail, twice.

The gruelling preparation also took an emotional toll on the far from cohesive group. Bitter arguments erupted over the hang as everyone coveted the most advantageous spots. 'It got really nasty,' says Anya. 'You sort of saw people's teeth then.' Fault lines were mainly determined by who was sleeping with whom, since half of the sixteen participants were couples. Fiona Rae's boyfriend, Stephen

FREEZE                                                    -2-

There is a lot of work to do in the next few weeks and I am
relying on everyone to do as much as possible to prepare the
space - starting on Tuesday, 12th July, as specified on the
attached schedule.  If any day listed is unsuitable, please
use the other attached list,of addresses and telephone numbers,
to arrange an alternative day.  If everyone works their allotted
time (i.e. 8 days each person), everything should get done in
time.  Those who do not work on the preparation will be expected
to do more invidulation.  And anyone with additional time to spare
will be welcome.

If you have any problems - or ideas - please telephone me.

  Thanks

DAMIEN HURST

        IT  IS  GONNA  BE  GOOD !

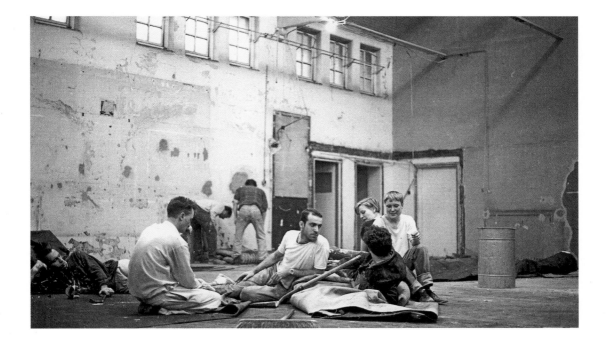

ABOVE: 'Freeze'
preparations, 1988.
L–R: Michael Landy, Steve
Adamson, Damien Hirst
(with back to us), Angela
Bulloch and Sarah Lucas,
at back Gary Hume and
Mat Collishaw dismantling
a radiator. Photograph
by Lala Meredith-Vula

OPPOSITE, ABOVE: The PLA
building where 'Freeze'
was held, Surrey Docks,
London, 1988. Photograph
by Lala Meredith-Vula

OPPOSITE, BELOW: Damien
Hirst's original schedule
for 'Freeze', 1988. (Oddly,
his surname is misspelt.)

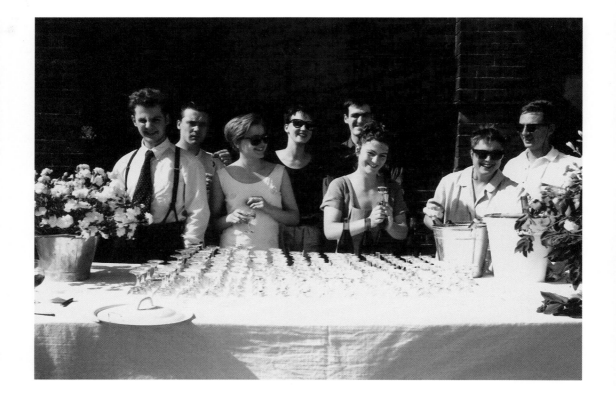

Park, insisted Sarah Lucas's crushed aluminium forms didn't make the grade for the show. 'I remember when one particularly grim squabble was going on during the hanging of "Freeze", we turned round and Damien was sitting on the floor with his back to the wall and he had a hammer and just banged his head with it until we stopped,' says Fiona. Damien's friend Dominic Denis was dumped from the exhibition at the last minute, despite being featured in the catalogue, 'which was really brutal, because he did a fuck of a lot of work in terms of the labour,' recalls Anya. The consensus was that his painting was too expressionistic and didn't fit with the 'cool, ironic detachment' of the rest, according to Fiona.

'Freeze' was the most amazing launching pad for me…. It was as if Damien gave us a moment of maximum visibility and opportunity.

FIONA RAE

Even Damien was not immune from attack, despite organizing the show. He had hung two works from the rafters consisting of cereal boxes painted in household gloss, one in grey-green, the other in bright colours, described by Richard Patterson as 'Mondrian via Blue Peter'. But the boxes kept falling down and the green work obscured one of Michael Landy's attractive wall sculptures of blue tarpaulin pinned with crocodile clips. 'It's funny because in a way Damien didn't fit into the show except as curator,' says Simon Patterson. In the end Simon's brother Richard climbed up a ladder during the installation and took down the offending work by popular demand. 'I didn't feel too great about taking his sculpture to pieces, but I still actually think the show looked better for it not being in there,' says Richard. Damien was annoyed but too exhausted to protest, according to Simon.

However, the triumph of pulling off the show eclipsed the rows, the injuries and the hard grind. Although rough around the edges, the work bore promise and a raw dynamism. Among the most memorable were Angela Bulloch's sexy flashing lightbulbs, Simon Patterson's name portraits, Mat Collishaw's *Bullet Hole*, the paintings by Ian Davenport, Gary Hume and Fiona Rae, and Anya Gallaccio's installation *Waterloo*, made from a ton of lead, which unpredictably formed a latticework grid upon mixing with the industrial floor glue.

Few of the artists remember much about the opening. Damien had made the mistake of buying all of the alcohol upfront for the two scheduled parts of the show; inevitably the lot was drunk at the

Before 'Freeze' private view, July 1988.
L–R: Ian Davenport, Damien Hirst, Angela Bulloch, Fiona Rae, Stephen Park, Anya Gallaccio, Sarah Lucas and Gary Hume.
Photograph by Abigail Lane

OPPOSITE: Damien Hirst,
*Boxes*, 1988, Household
gloss on cardboard
boxes, 173 × 262 cm
(68 ⅛ × 103 ⅛ in.)
variable

ABOVE: L–R: Angela
Bulloch, Fiona Rae and Ian
Davenport at the 'Freeze'
opening, July 1988.
In the background are
Michael Landy's tarpaulin
work and Sarah Lucas's
sculpture. Photograph
by Abigail Lane

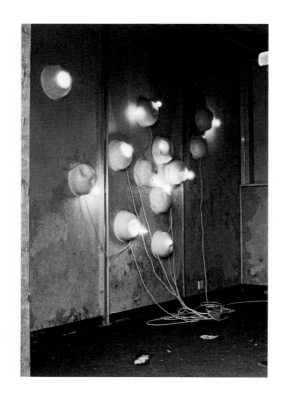

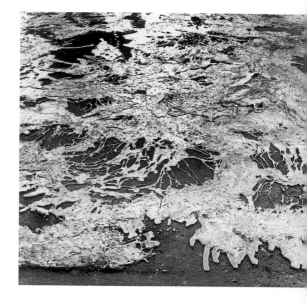

**ABOVE LEFT:** Angela Bulloch, *White Light Piece*, 1988. Entrance of 'Freeze' part I, PLA building, July 1988

**ABOVE RIGHT:** Anya Gallaccio, *Waterloo* (detail), 1988. One ton of lead, poured in a rectangle on the floor, and bronze cast of a child's cardigan, 303 × 544 cm (119 ¼ × 214 ³/₁₆ in.)

**OPPOSITE:** Installation view of 'Freeze' with Simon Patterson's photographic silkscreen on canvas *Sadat Carter Begin* and Abigail Lane's starched cotton sculptures *Essentials* in the foreground

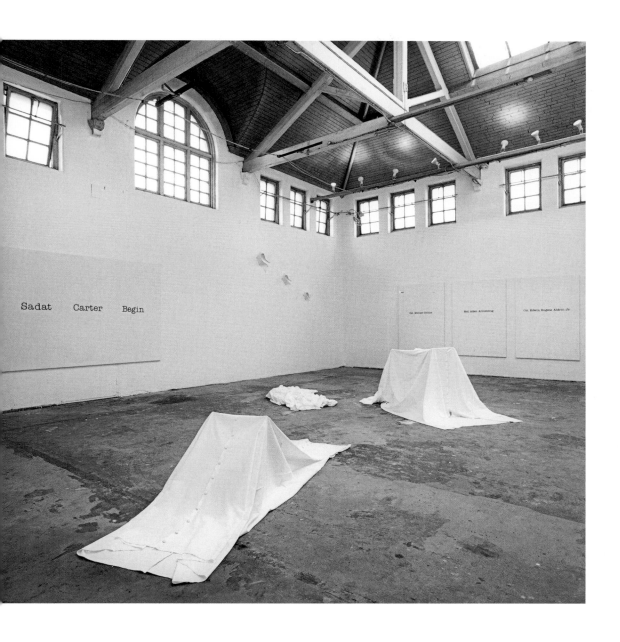

opening. 'There was a fight and vomiting and usual shenanigans,'
says Mat. Michael Landy manned the bar briefly until he collapsed,
drunk. At the second 'Freeze' opening, a tower block went up in
flames across the river. 'There was a fire in a block of flats that was
quite spectacular and it felt like a very, very specially laid-on massive-
scale destruction just for the evening, black smoke billowing,' says
the gallerist Karsten Schubert: a fitting harbinger for the launch of
a new art movement that would reflect urban reality in all its
glorious grimness.

For the nine weeks that the two-part show lasted,[6] the artists
took turns to invigilate for the trickle of visitors or left a key under
the doormat. Yet among the few who came were the tastemakers of
the future. Thanks to the well-connected Michael Craig-Martin, London
gallerists Karsten Schubert and Maureen Paley, Esther Schipper,
who would set up a respected gallery in Cologne, German gallerist
Tanja Grunert, Clarissa Dalrymple, a British curator living in New York,
and Barbara Gladstone, now a doyenne of the New York gallery scene,
all paid a visit. Charles Saatchi also passed through. '"Freeze" was
the most amazing launching pad for me....It was as if Damien gave
us a moment of maximum visibility and opportunity and then things
just started to happen,' says Fiona Rae.

## THE RISE AND RISE OF DAMIEN

Still having access to the warehouse after the show, Angela Bulloch,
Mat Collishaw, Angus Fairhurst, Damien Hirst, Sarah Lucas and Simon
Patterson staged a third part of 'Freeze'. While they used the space
as a studio, Damien hit upon the idea for his vibrant spot paintings
that look machine-made and use randomly chosen colours, with
no repetition permitted. These would become a cornerstone of his
practice and marked a break with the sculpture collages he had been
making in the tradition of the German artist Kurt Schwitters. 'With the
spot paintings I completely let go of the past and arrived somewhere
in the present, or it felt like that. And then it felt like I joined everybody
in the third part of "Freeze" as an artist.'

While the spot paintings appear blankly cheerful, for Damien
'there's something uncomfortable about them, because they never

PLA building used by
Damien Hirst and friends
post 'Freeze', with Mat
Collishaw's *Bullet Hole* on
the far wall, a spot painting
by Damien Hirst on the
right, his *Boxes* scattered
on the floor, and various
works by Angus Fairhurst.
Photograph by Abigail Lane

stop moving. They look decorative but they're not. You can't settle anywhere with it.' Damien quickly offloaded the laboriousness of making them, selling them to buyers as make-your-own kits with a certificate of authenticity. Soon, following the lead of Andy Warhol's Factory, he would employ teams of assistants to make them, declaring 'I couldn't be fucking arsed doing it' and that they did a better job than he could.[7] The spots have become an incredibly successful commercial brand, numbering some 1,350 paintings plus an array of merchandise such as spot clocks, mugs and deckchairs. The series was originally intended as infinite – arousing investor concerns about overproduction.[8] 'I wanted there to be endless variety, endless sizes, endless scale...I was very comfortably happy with an endless series, whereas for some reason, twenty years into it, I'm trying to end it,' Damien says.

Damien Hirst making one of his earliest spot paintings at the PLA building, winter 1988. Photograph by Angela Bulloch

It was during this third phase of 'Freeze' that Damien personally invited the newly installed Tate Gallery director Nicholas Serota

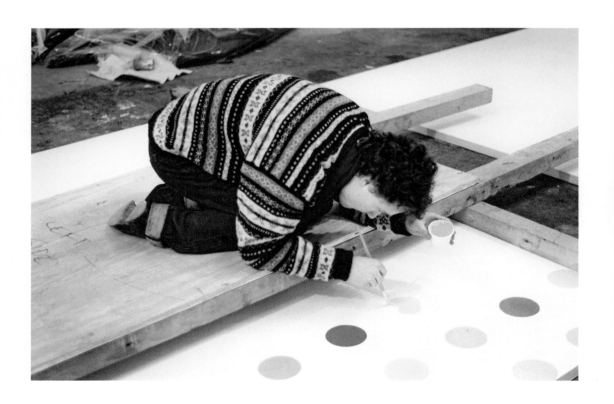

and ferried Norman Rosenthal, then exhibitions secretary of the Royal Academy, in a taxi to the show. Maureen Paley brought a couple of American collectors, who bought some works, including Mat Collishaw's *Bullet Hole*, but he called off the sale because the offered price was less than it cost to make. The piece ended up rotting in a rubbish skip. Paley mooted the possibility of representing the group, according to Damien. 'She'd got all our hopes up, and then she...said, "I think no to Sarah." So I was like, "Fuck that. I can't do that." And then it just all broke apart,' he says.

Sacha Craddock in the *Guardian* wrote one of the only reviews of the show, revealing a British dislike of brazenness; among all the eye-catching pieces, she picked out for praise Richard Patterson's looped drawings and Damien's boxes for their 'quiet control of their materials'.[9] 'There is no self-doubt paraded in this line-up,' she wrote. '...mistake and confusion are no longer virtues, humble grind has been replaced by "I can do that too".'[10] This lack of self-questioning would be an oft-repeated criticism of the YBA group as a whole.

But this was a generation in a hurry, unwilling to follow the traditional route. By November 1988, Ian Davenport, Gary Hume and Michael Landy were showing at Karsten Schubert. The following year 'Freeze' artists exhibited in Cologne, France, Italy and New York.

Back at Goldsmiths, the remaining 'Freeze' participants, now in their third year, faced a backlash from students and tutors. The corporate backing of 'Freeze', particularly from the London Docklands Development Corporation, created by Thatcher to regenerate Docklands, was seen as tantamount to bedding the enemy. The fact that some of the artists had sold their work to gallerists and collectors was equally frowned upon. Students produced a pamphlet called *Anti-Freeze*, and seminars were organized about the show's moral bankruptcy to which opponents wore fur coats and pretended to shiver. 'I think their problem was that the work seemed too slick and commercial and market-oriented,' says Mat Collishaw. 'For us it certainly didn't seem like a sin to sell an artwork. But I think for them, it was selling out.' In the wake of 'Freeze', Goldsmiths witnessed a sharp influx of ambitious students keen to jump on the coat-tails of

> With the **spot paintings** I completely let go of the past, and **arrived somewhere in the present**....And then it felt like I joined everybody in the third part of 'Freeze' as an artist.
>
> DAMIEN HIRST

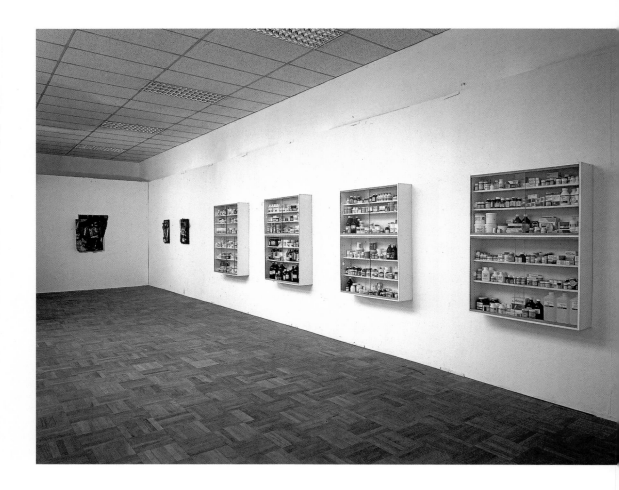

Installation view of Damien
Hirst's 1989 degree
show at Goldsmiths, for
which he presented four
medicine cabinets: *Bodies*,
*Liar*, *Seventeen* and *Pretty
Vacant* (all 1989). Their
titles were taken from Sex
Pistols song tracks.

Damien's group. 'A lot of them were expecting...a kind of careerist idea which hadn't existed in the school,' says Michael Craig-Martin.

I'd always take things from life and feel as an artist you have to change them....And then...with the <u>medicine cabinets</u> I just realized, don't do anything. **Just take it, and present it.**

DAMIEN HIRST

Mat and Damien felt they'd found their feet and returned to their art with gusto. They appropriated the Minimalists' clean aesthetic but incorporated the messiness of real life. Mat continued to mine ethically ambiguous images from criminal documents and scientific manuals, such as children with Down's syndrome framed within Donald Judd-like boxes. He was almost denied his final degree mark for presenting images of headless rape and murder victims half-hidden in the bushes, on the grounds they institutionalized misogyny. To Mat, they resembled French realist Gustav Courbet's photographic studies for his paintings of women lying in nature. This tension between beauty and repulsion would come to define the core of Mat's practice.

Meanwhile, Damien translated his interest in the hyper-sanitized industry of modern medicine into another staple of his practice: medicine cabinets lined with colourful pill packets and bottles: 'I saw Koons's [Saatchi Gallery] show of the Hoovers. And I just thought, "I wish I could do that."...I'd always take things from life and feel as an artist you have to change them....And then...with the medicine cabinets I just realized, don't do anything. Just take it, and present it. And that was like a big breakthrough.' A self-confessed romantic, he saw ordinary people like his mum believing in medicine but not in art. 'So I just wanted to...turn it on its head. And then I thought, well you can just hijack...the medicine.'

Damien gave the cabinets jarring titles like *Pretty Vacant* from tracks on the 1977 punk album 'Never Mind the Bollocks, Here's the Sex Pistols' and presented four of them for his degree show. Jake Chapman remembers being hugely impressed: 'It was absolutely astonishing, probably one of the most exciting experiences of looking at anyone's art. It was like being on the moon.' Karsten Schubert bought the four cabinets for £500 each. By the time he left Goldsmiths, Damien had already created two of his signature pieces and was thinking ahead. 'I've never seen anything like it, he was chomping at the bit,' says Sarah Lucas. Next step: art world domination.

# FORMATIVE MILESTONES AND ALLIANCES: 1990–1992

'Freeze' got the ball rolling for most, but not all, of the participants. Sarah Lucas languished in the shadow of her boyfriend Gary Hume and other men in the group, who were being feted with shows in Europe and America. Disillusioned, she gave up art and, paradoxically, found her voice. Fuelled by anger and feminist literature, she made a portrait of herself, *Eating a Banana* (1990). With no make-up, short hair and leather jacket, she glowers confrontationally at the viewer in an 'are you looking at me?' way. Yet the pose is ambiguous, the very act of eating the phallic fruit potentially implying 'come hither' at the same time. 'I thought, "Oh yeah, that's really good,"' she recalls. 'Because although it's got that connotation, it was such a different image than you'd ever seen in pornography just because of the way I looked, and that was its power I suppose.' Realizing that she'd hit upon something potent, Sarah experimented further with her androgynous look, producing self-portraits in jeans and workmen's boots or smoking, mostly looking straight at the camera as if challenging the viewer to fault her unfeminine appearance. Initially Gary would take these photos under her instructions but after a time she found them unacceptable, he remembers, 'because they had very

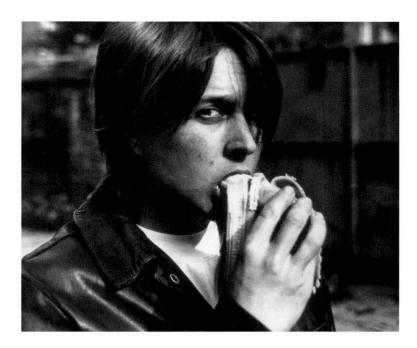

Sarah Lucas,
*Eating a Banana*,
1990. Black-and-
white photograph,
74.9 × 81.9 cm
(29 ½ × 32 ¼ in.)

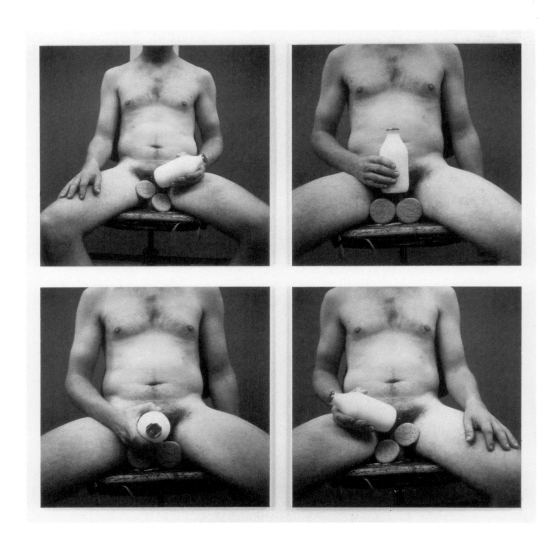

Sarah Lucas, *Get Off
your Horse and Drink
your Milk*, 1994.
Cibachrome on board,
4 parts, each 84 × 84 cm
(33 ⅛ × 33 ⅛ in.)

much a male gaze to them, as if I wanted to fuck her….She was like, "That's shit, that's shit, will you stop photographing me like that!"'
So Sarah decided to use Gary's body instead of her own. 'The moment that I substituted it for Gary all the life went in it,' she says. The result was a raft of comical shots of headless male nudes with milk bottles or slabs of meat strategically positioned over the genitalia.

it was such **a different image than you'd ever seen in pornography** just because of the way I looked <u>and that was its power I suppose</u>.

SARAH LUCAS

In this breakthrough period, the momentum begun by 'Freeze' gathered as artists exploited every resource to show their work and shared these opportunities with others from different schools. Artists requisitioned non-commercial spaces abandoned following the property crash of the late 1980s, from warehouses to squats to shut-up shops; gallerists and dealers positioned themselves for the most promising artists while public institutions circled tentatively. Pivotal personal and professional alliances were forged, most notably between Damien Hirst and Jay Jopling. A revitalized Turner Prize received television sponsorship and a younger focus, placing an unprecedented spotlight on the emerging scene. Contemporary art was now hot.

## SHOWS IN WAREHOUSES AND SQUATS
## – THE THRILL OF THE CHASE

While Damien Hirst had been organizing 'Freeze', his housemate Carl Freedman had fled, movie-style, to Central America with his girlfriend Billee Sellman, escaping a gangster sugar daddy she had picked up while working as a hostess in a Mayfair bar to fund her university studies. On their return, it seemed natural to build on the success of 'Freeze' and stage more shows in a similar space. Damien, Carl and Billee decided to form an art curating business, calling themselves initially the BCD and then, sounding more like a solicitors' firm, Sellman, Hirst and Freedman. Around this time, a new breed of intellectual freelance curator was emerging in Europe who was unconnected to a particular museum and more interested in the exhibition as an art form than in art objects.[1] However, Carl, Billee and Damien were concerned with the glamour of mounting

Damien Hirst,
Billee Sellman and
Carl Freedman, *c.* 1989.
Photograph by
Edward Woodman

exciting shows rather than any critical theory. 'We employed the photographer Edward Woodman to take a picture of us as the BCD,' recalls Carl. 'We thought we were these popstar curators.' The trio put some people's backs up in the process. 'They were arrogant and entrepreneurial, but in a way they were so competitive. It was just about making money. They were transparently "on the make",' says Angela Bulloch, who split up with Damien around then and subsequently went out with Liam Gillick.

> We thought we were **these** popstar curators.
>
> CARL FREEDMAN

Billee, Carl and Damien became partners in every sense. As seamlessly as the trio had formed a business, they slipped cosily into a *ménage à trois* in their cottage in North Greenwich. It was an efficient team with a business plan and assigned roles: Damien as curator, Billee client liaison and PR, Carl chief executive officer. Dressed up to the nines, Billee was sent to charm corporate executives into sponsoring them. Her efforts secured the rent-free loan for three months of a 2,600-square-metre (28,000-square-foot) warehouse in Bermondsey, south London, previously owned by the Peek Freans biscuit company. So, with sponsorship from the London Docklands Development Corporation, Rank Xerox, Saatchi & Saatchi and various galleries including Lisson and Anthony d'Offay, Building One was born, the site of three seminal shows in 1990: 'Modern Medicine', 'Gambler' and 'Market'.

'Modern Medicine' reflected Damien Hirst's fascination with the theme rather than any curatorial intent and included six Goldsmiths artists plus two others.[2] In the months spent revamping the interior prior to the March show, the BCD threesome had turned sour. The day it opened Damien left Sellman, Hirst and Freedman 'somewhat acrimoniously', according to Carl. Still, the show was a huge hit. The street outside was jammed with chauffeur-driven cars. 'It was more or less a history of who's who in the contemporary art world,' Carl remembers, most of the gallerists having a financial stake in the show. Neighbours called the police, suspecting an illegal rave, but they quickly left. Like raves, these warehouse art shows exuded a frisson of danger in their rugged industrial ambience and location in run-down areas earmarked for redevelopment. In terms of exhibits, Goldsmiths graduate Craig Wood covered a vast area with water bags fitted around the architecture; Angus Fairhurst displayed fragments

of faces from magazines, magnified to near abstraction in a pixelated style reminiscent of American artist Chuck Close.

As in 'Freeze', Mat Collishaw contributed the showstopper, this time with a slide piece called *Crucifixion* projected over rough walls and exposed pipework. Viewers peered through a peep hole at a colossal triptych showing a scantily clad woman from different angles apparently suspended from the ceiling, mimicking the pose of Christ and the two thieves on the cross. The artist had taken the images from 1950s bondage porn photos of a woman with her legs tied to the ceiling and inverted them to unsettling effect. Brought up in a strictly religious household where television, fashion and Christmas celebrations were banned – his parents were members of a small Christian sect called the Christadelphians – Mat has often chosen morally suspect imagery, forcing the viewer into a voyeuristic collusion. 'I wanted to make work about life and death, and men and women and viscera and these things which are part of the world that I experience out there. And I wanted to make work that engaged people whether they liked it or not,' he explains. 'Modern Medicine' 'totally blew away' Matthew Slotover, freshly graduated from Oxford University, who co-founded the art magazine *frieze* the following year in 1991.[3] 'I got it immediately...it was like it had landed from another planet.' Like many British people, Slotover had subscribed to the stereotypical view of artists as craftspeople who were not intellectuals. 'But the way these people talked about the world was absolutely as intellectual as anything I'd encountered in my quite sheltered, academic upbringing,' he admits.

'Modern Medicine' proved profitable, enabling Carl and Billee to rent Building One for another three months. Daunted without Damien, Carl took responsibility for curating and called the next show 'Gambler' to convey the common feeling of winging it in those early days. As well as Dominic Denis, Damien Hirst and Angus Fairhurst, Carl brought in four non-Goldsmiths artists.[4] Until this point, curatorial slog had consumed Damien's energies and his peers seemed to be advancing faster than him. Damien now came up with what is often regarded as his best work yet. *A Thousand Years* (1990) presents the life cycle

> I wanted to make **work about life and death, and men and women and viscera** and these things which are part of the world that I experience out there.
>
> MAT COLLISHAW

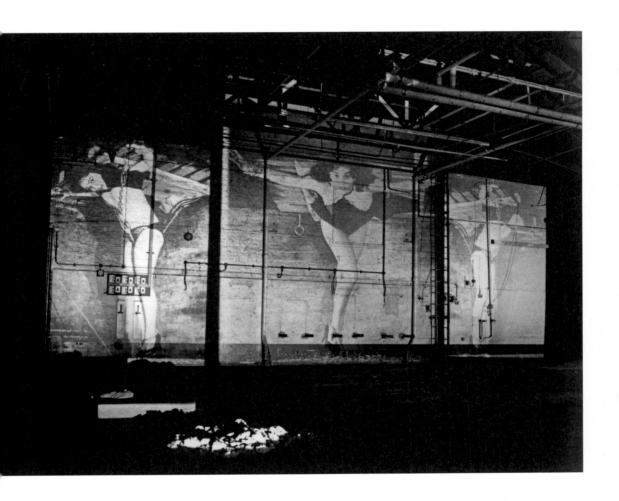

Mat Collishaw, *Crucifixion*,
1990. Slide projection,
dimensions variable

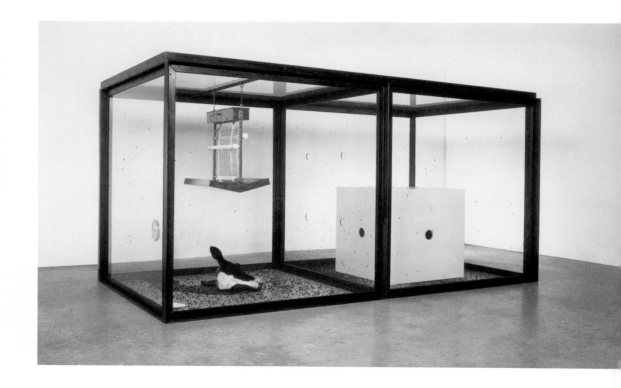

Damien Hirst, *A Thousand
Years*, 1990. Glass,
steel, silicone rubber,
painted MDF, Insect-O-
Cutor, cow's head, blood,
flies, maggots, metal
dishes, cotton wool,
sugar and water,
207.5 × 400 × 215 cm
(81 ¾ × 157 ½ × 84 ⅝ in.)

of flies, from birth to death, and can be seen as a metaphor for human existence. Carl was dispatched to a maggot farm in Kent and returned with a large bin bag filled with maggots in their chrysalises. Damien's plans worked perfectly in practice: 'It just totally surprised me. It was alive, more than anything I'd ever made before. And it was complicated. Some of the ingredients were just so much more than I'd even intended.' Within a Minimalist formal framework of two glass boxes with holes between, the installation amounted to a game of chance. Flies would hatch from a die-like box in one vitrine, then fly into the second where some would be zapped by an Insect-O-Cuter and others feed on a decomposing cow's head and sugar water and reproduce, continuing the cycle. 'I was trying to make art that was real...and presenting it in a real way in a gallery, so people are thinking, "What is it?" Questioning themselves. It was confrontational as well,' says Damien. Inspired by the Russian Constructivist Naum Gabo's weightless string sculptures, he wanted the flies to create an unpredictable three-dimensional pattern like 'points in space'. 'And then I thought if I put flies in a box you'd get that random arrangement.'

It just _totally surprised_ me.
**It was alive**, more than anything I'd ever made before.

DAMIEN HIRST

To say people were wowed is an understatement. 'There are occasional times in your life where you say that you're jealous of something and I'm jealous of that piece. Wish I'd done it,' the Scottish artist Douglas Gordon says. Charles Saatchi snapped it up for £4,400, according to Carl. Damien's hero, the notably acerbic painter Francis Bacon, was reportedly mesmerized when he later saw it at Saatchi's gallery and mentioned it in a letter to a friend.[5] Unfortunately, after a few days, the putrid odour from the rotting cow's head pervaded the vast space. Carl told Damien that visitors were rushing round holding their noses without looking at the other works: 'Typically he didn't sympathize with the fact that all the other artists' works were suffering.' Eventually Damien removed the cow's head and they had a ceremonial burning in the back yard, after which they put the charred skull back in the vitrine. Since then, according to Carl, the head has always been prosthetic, covered in fake blood and sugar to attract the flies.[6]

In such visceral works, Liam Gillick saw the shadow of AIDS that was starting to make its presence felt in the UK. The disease had

claimed victims in the arts in America, but would strike closer to home with the deaths of the filmmaker Derek Jarman and the transvestite performer Leigh Bowery. With knowledge of AIDS limited at the time, a sense prevailed that pleasure was deadly. Damien's *A Thousand Years* was 'like a horrific machine of procreation without desire, like an image from an AIDS advert from the mid-1980s,' says Liam.

Following 'Modern Medicine' and 'Gambler', Billee Sellman and Carl Freedman were on a roll and invited Michael Landy to mount a solo show in September 1990. Michael called it 'Market' and bought hundreds of brown plastic bread crates from Allied Bakeries, which he stacked and arranged as stalls draped with artificial grass like those found in a British marketplace, but left them devoid of products. Visitors encountered a bleak vista in which the empty stands themselves became the artwork, stretching on interminably. 'People couldn't make head or tail of that', says Michael, 'because it was a hundred works and they all looked the same.' A Duchampian readymade on a massive scale evoking Minimalist sculpture in its austere stepped forms and limited colour palette, the work prompted questions about the value of people and products, a British way of life threatened by capitalism and the commodification of art. 'Market' assumed legendary status in the art world and was deemed a resounding success. Except that out of nearly 100 sculptures just two sold. For Carl and Billee it spelled financial disaster and the end of Building One.

Besides these shows, Henry Bond, another Goldsmiths graduate, and Sarah Lucas curated the 'East Country Yard Show' in a Rotherhithe warehouse in 1990. The seven exhibitors comprised the curators, Bond's then girlfriend Anya Gallaccio, Gary Hume, Michael Landy and two outsiders, Virginia Nimarkoh and Tom Trevor. Each had a cavernous space to fill. Gary opted for a gigantic green textile hanging version of his doors, while Anya covered the floor with a ton of oranges laid out in a rectangle and plastered the walls with images of the fruit. The work *Tense* conjured myriad associations, from the geometric forms of Minimalism and Paul Cézanne's still lifes to the invisible labour behind the industrial production of foodstuffs. In the course of the exhibition the fruit

> People couldn't make head or tail of that because it was **a hundred works** and they **all looked the same**.
>
> MICHAEL LANDY

Michael Landy, 'Market',
1990. Bread crates,
dimensions variable.
Installation view, Building
One, Bermondsey, London

Anya Gallaccio, *Tense*,
1990. Installation view,
East Country Yard Show,
Surrey Docks, London.
One ton of Valencia
oranges, silkscreen on
paper, dimensions variable

degraded, heightening the contrast between the images' perfection and the reality of the organic matter. 'It looked beautiful, these perfect bright orange spheres…and then as they decayed, they became more like worlds because they got all this green and white mould on them,' says Anya. 'As it rotted and visually became more interesting as a surface, the smell of orangeness got more intense…and I was interested in that as well, in terms of memory and different ways of experiencing something.'

As it <u>rotted</u> and <u>visually</u> <u>became more interesting</u> as a surface, **the smell of orangeness** got more intense.

ANYA GALLACCIO

The curation of these big spaces was rough and ready, bringing together artists who shared few concerns except the desire to showcase their work. 'It wasn't that we actively…wanted to be in a non-commercial space, but commercial space wasn't available to us, so we were like fuck it, we're going to do a show, rather than it being…a political statement,' says Anya. In the *Independent*, critic Andrew Graham-Dixon praised the 'striking' exhibitions staged by self-promoting Goldsmiths graduates.[7] 'This has given them a reputation for pushiness, yet it should also be said that in terms of ambition, attention to display and sheer bravado, there has been little to match such shows in the country's established contemporary art institutions,' he wrote.[8]

Artists were also taking over makeshift spaces throughout the city – depots, tower blocks, garages, people's front rooms – and putting on hit-and-run shows with little or no financial support. 'You could feel this buzz really,' says Matthew Slotover. 'It just grew and grew.' Saint Martins graduates William and Tanya Ling opened a space in their Docklands flat called Bipasha Ghosh, site of Gavin Turk's first solo show; artists turned a former betting shop, City Racing, into a gallery, giving unknown names such as Gillian Wearing and Sarah Lucas a leg-up. Other artist-run galleries – Cubitt, Cabinet, Milch – sprang up around London; artists formed collectives such as BANK and Nosepaint, the latter evolving into Beaconsfield. Significant artist initiatives also sprouted outside London, such as Catalyst Arts in Belfast, Transmission Gallery in Glasgow and Locus+ in Newcastle.

Milch, described by Simon Patterson as 'a squat full of weirdos, tattooists and taxidermists' in a grand Georgian house, was a classic

example of the alternative spaces artists commandeered. Set up by
a Canadian punk artist, Lawren Maben, Milch was forever short of cash
but long on imaginative ideas. It partly funded its activities through
its rowdy basement bar run by Mat Collishaw and the Goldsmiths artist
Adam Chodzko (until Mat ran off with Adam's wife Tamara). Simon had
drifted since the success of his name portraits exhibited at 'Freeze',
but found his feet at Milch, where he had a studio. He extended his
interest in names as definitions to create whole constellations of
language by connecting categories of people in new and incongruous
ways. It was at Milch that Simon debuted his best-known work
*The Great Bear* (1992). It was displayed in a window of the building
as part of the show 'A Modest Proposal' with the artists Douglas
Gordon and Anand Zenz. Simon reproduced the iconic 1931 London
Underground map designed by Harry Beck, replacing train stops with
names of philosophers, film actors, Italian artists, footballers and
saints, each category representing a tube line. The work transforms the
familiar design into an engrossing word game of strange associations.
'I like disrupting something people take as read….What interests
me is juxtaposing different paths of knowledge to form more than the
sum of their parts,' says Simon.[9] The artist would similarly rework
the periodic table, flight routes and star charts and rearrange Leonardo
da Vinci's *Last Supper* as a wall text diagram as though Jesus and
his disciples were a football team, with Jesus in goal.

Milch was evicted from its first site in Bloomsbury and
decamped several times from others, showcasing various artists
including Jane and Louise Wilson before its hedonistic founder Maben
died of a heroin overdose in 1995.

Like Simon Patterson, Sarah Lucas got her break in the
alternative scene. While the boys were given the shows, Sarah quietly
built up a body of work made at home using cheap materials: 'all sorts
of stuff that could fold down and be put away in a drawer'. Alongside
the self-portraits, Sarah 'religiously' read the *Sunday Sport* newspaper
for offensive chauvinistic material. This she found in abundance and
scaled up double-page spreads about randy obese women and 'midget
kiss-o-grams'. While some argue that placing the enlarged spreads
in a gallery implicitly criticizes the accepted sexism of British tabloids
and social attitudes, others feel these works elevate rather than
challenge the ideas espoused. 'That stance of sitting on the fence

Simon Patterson,
*The Great Bear*, 1992.
A four-colour lithograph
in a glazed anodized
aluminium frame,
109.2 × 154.6 cm
(43 × 60 7/8 in.)

ABOVE: Sarah Lucas,
*Sod you Gits*, 1990.
Photocopy on paper,
218 × 315 cm
(85 ⅞ × 124 in.)

OPPOSITE: Sarah Lucas,
*Two Fried Eggs and a
Kebab*, 1992. Table, fried
eggs, kebab, photograph,
151 × 89.5 × 102 cm
(59 ½ × 35 ¼ × 40 ⅛ in.)

about whether I liked it or not became part of what I was doing,'
says Sarah. 'I hate being told what to think anyway, so I'm certainly
not going to be doing that myself.'

Three opportunities landed in Sarah's lap consecutively
in 1992 that would change her fortunes. Michael Landy included her
in a show he curated at Karsten Schubert; then she had an exhibition
at City Racing called 'Penis Nailed to a Board' (taken from a tabloid
headline); shortly afterwards an empty shop in Soho came free. For
the third show, she toyed with displaying a table as a stage with a
mouse, a globe and an egg. 'And I just thought of it in the middle of the
night, two fried eggs and a kebab, literally like that it just came to me.'
A brilliantly economical parody of sexist slang that reduces women to
two breasts and a vagina, *Two Fried Eggs and a Kebab* was an instant
sensation, demonstrating Sarah's talent for combining materials to
form witty visual, often sexual, metaphors. 'It's not that I think I'll put
a load of sex in my work, it's just that that's what's sort of poking me
in the eye,' Sarah says about her highly charged sculptures. Charles
Saatchi, attuned to the slightest whiff of controversy,
turned up at the show just as Sarah bit into a
doughnut and a blob of jam spurted onto her jumper.
From that point he would become an ardent collector
of her work.

Damien Hirst would also stage his first solo
show, 'In and Out of Love', in an unconventional
space – a former travel agency – with the curator
Tamara Chodzko in summer 1991. From his fly
life-cycle piece, it was not a huge conceptual leap
for him to replace flies with butterflies, with
their evocation of freedom, innocence and greeting card clichés of
happiness.[10] Upstairs hundreds of pupae attached to white canvases
hatched into colourful butterflies, fed on plants and sugar water,
mated and flew around in a magical celebration of life; downstairs
this optimism was starkly countered by signs of death and decay in
overflowing ashtrays and lifeless butterflies trapped in bright gloss
paintings. The butterflies, drawing on Damien's central themes of
beauty, transience, life, death, art and collecting, would become a
key element of his iconography. Unlike many of the alternative shows,
Damien's was a commercial success and sold well.[11]

It's not that I think
I'll put a load of **sex in**
**my work**, it's just that that's
what's sort of poking me
in the eye.

SARAH LUCAS

## JOCKEYING FOR POSITION

As artists organized shows wherever they could, gallerists jostled for position, keen to get in on the action. Karsten Schubert had taken his pick of the new crop: Mat Collishaw, Anya Gallaccio, Angus Fairhurst, Gary Hume, Michael Landy and Slade graduate Rachel Whiteread. 'There was a moment when Damien and I were toying with each other, but what wasn't quite clear at that point was what Damien wanted. He wanted to be a curator and an artist at the same time…. He wanted basically my job,' says Schubert. Anthony d'Offay, whose artists were almost all over fifty, was also intrigued by the noise around this generation. He had earlier mooted a plan for a joint show with Schubert featuring Damien, Mat, Angus, Gary and Michael and even organized a portrait photograph that had the look of a boy pop band. The idea collapsed when d'Offay got 'screwy', according to Schubert. 'Anthony at the final meeting said, "Look, if this goes well I want to represent those people, if it doesn't I won't," and I said to him, "Well a) half of them are represented by me and b) why would I give you that right?" And that was the end of it.' After the collapse of Building One, d'Offay also contemplated backing Carl Freedman and Billee Sellman in launching a Building Two with a group of collectors. At d'Offay's urging, the duo found a four-storey building in the West End. However, the timing was not propitious, coming in 1991 at the end of the Gulf War, with the British economy in full-blown recession, and d'Offay got cold feet.

After a long period of heady economic expansion, the recession proved traumatic for many. For the first time, Karsten Schubert's gallery was fighting for survival. 'The idea that the music just stops, people cannot even conceive any longer,' says Schubert. 'And it's what happened….It was very, very scary.' In the midst of the crisis, Abigail Lane, who was earning extra cash cleaning the gallery, found a memo from Schubert to his backer Richard Salmon referring to Michael Landy as 'dead wood'. It was an unfortunate phrase and particularly resonant for Michael, whose father had been left disabled by an industrial accident and written off by medics as 'a total wreck case'. Had they read the memo through properly, according to Schubert, they would have understood that he was defending Michael's presence on the gallery's books. 'It was making a case for a loss leader. It was saying,

"Actually this [work] is so great, and gets us so much credibility that it's OK." In Michael's mind, the incident marked the beginning of the end of their collaboration; in due course Schubert, the dealer of the new generation, would see his artists slip through his fingers one by one.

The work was so different from what everyone else was doing.
It was collaborative.
It was anthropological. It was critical. It was photography.
It was maybe boring. It wasn't about sex and death.

LIAM GILLICK

But despite the recession, Schubert still managed to pull off a string of must-see shows. 'Karsten was *the* gallery. It was the place where it all happened,' says Matthew Slotover. Besides rising stars like Gary Hume and Michael Landy and international artists such as Martin Kippenberger and Ed Ruscha, Schubert made room for quirky cerebral exhibitions including Henry Bond and Liam Gillick's *Documents* series, consisting of photographs, texts and audio recordings taken from press conferences and events while posing as journalists. The idea was to examine the process of news-gathering from an artist's viewpoint. 'The work was so different from what everyone else was doing. It was collaborative. It was anthropological. It was critical. It was photography. It was maybe boring. It wasn't about sex and death,' says Liam.

Some of Schubert's most memorable shows were the least sellable. For Anya Gallaccio's *Preserve (Beauty)*, she hung the gallery's front window with a curtain of 800 red gerberas (1991). Arranged in a loose grid formation, these flowers disintegrated over weeks, transformed from a picture of order and beauty into ugliness and decomposition. 'A lot of people warned me to stay away from flowers, because they said I wouldn't be taken seriously as flowers are often associated with women,' says Anya, but that made her more determined to challenge the gender stereotyping. Anya would make geometric works with sunflowers, narcissi and roses, subverting the authoritarian, masculine language of Minimalism by using traditionally feminine, domestic materials that resisted taming into tidy structures. These poetic works, often presented on a monumental scale, dealt with similar themes to Damien's such as life cycles, decay and 'vanitas'.

Michael Landy's *Closing Down Sale* in 1992 also caused a stir. He filled the gallery with supermarket trolleys overflowing with unwanted goods and Day-Glo signs clamouring 'Everything Must Go!',

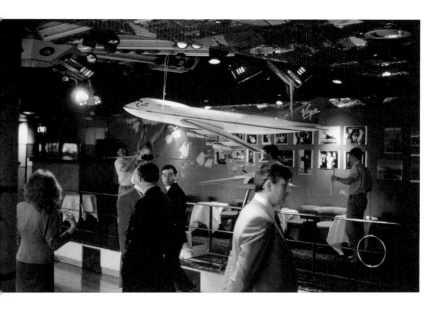

ABOVE: Henry Bond and Liam Gillick, 25 April 1991, London, England, 17.00. Reception to launch Super-Commuter, Fred Finn's ten million mile trip, Kensington Roof Gardens. From the series *Documents*, 1990–1993. 100 photographs in various formats and texts, dimensions variable

RIGHT: Anya Gallaccio, *Preserve (Beauty)*, 1991–2003. 800 red gerberas, glass, dimensions variable

ABOVE: Michael Landy,
*Closing Down Sale*, 1992.
Installation view. Mixed
media, dimensions
variable

OPPOSITE: Abigail Lane,
*Bottom Wallpaper (Black)*,
*Black Ink Pad*, 1992–1997.
Installation view of
'Making History', Karsten
Schubert, London, 1992.
Wallpaper: black acrylic
paint on lining paper,
each roll 56 cm × 10 m
(22 in. × 33 ft). Ink pad:
aluminium, cotton-covered
felt layers and ink,
235 × 289.6 × 2.5 cm
(92 ½ × 114 × 1 in.)

'Last Day!' and 'Bargains Galore', mirroring the desperate high-street scenes that confronted consumers daily in the dire economic climate.

Abigail Lane's first solo show 'Making History', at Karsten Schubert, explored the often arbitrary and fragmented construction of histories from physical traces left behind. She displayed clogs that left bare footprints when inked and worn; a detective game, Conspiracy, complete with police record, ink pad and rubber stamps bearing her fingerprints, challenging players to implicate the artist as mark maker in a crime; and a chair with an ink-pad seat facing a framed bottom print. Elsewhere, these buttocks became patterned wallpaper decorating the gallery alongside four giant open black ink pads. One was reminded of Yves Klein's *Anthropometries* performance paintings from the 1960s using naked women as human paintbrushes, while the oversize ink pads recalled Minimalist sculpture.[12] These attractive ink pads, intended to be 'paintings of endless possibility', would become a trademark of Abigail's work.

For a brief time, Schubert enjoyed pole position among gallerists in the emerging scene, but waiting in the wings was the dealer Jay Jopling, the Eton-educated son of Lord Michael Jopling, who had served in Margaret Thatcher's government. Tall, immaculately

ABOVE: Marc Quinn and Darren Almond, 1997. Photograph by Johnnie Shand Kydd

RIGHT: Jay Jopling and Damien Hirst, 1992. Photograph by Jillian Edelstein

turned out in suit and tie, with distinctive Clark Kent glasses, Jopling oozed upper-class confidence and can-do. While still a student at Edinburgh University, he had precociously organized a charity art auction to which he persuaded hotshot American artists such as Julian Schnabel and Jean-Michel Basquiat to donate work.[12] Jopling reportedly sold fire extinguishers as a summer job and would prove their efficacy by setting fire to his sleeve: an early sign of his innate gift for selling and showmanship.[13] Jopling declined to be interviewed for this book.

> I think **we were both**
> **inventing ourselves at**
> **that same time in London.**
> And I guess we were both
> what each other needed.
> He enjoyed selling art in the same
> way that I enjoyed making it.
>
> DAMIEN HIRST

After a spell dealing American Minimalist art post-graduation, Jopling decided to work with artists of his generation and took on his first, Marc Quinn, in the late 1980s. Marc was making sculptures out of bread and had studied art history at Cambridge instead of following the art school route, which partly explains why he is regarded by the group as an outsider. 'I think it's obviously more difficult as a middle-class person who's been to university to be part of it when half the angle was a working-class hero angle to the whole movement,' says Marc. 'It's definitely easier to have been in the Goldsmiths group.' Whereas the others would scruff around in jeans and T-shirts, Marc sported linen suits. He was also a serious alcoholic. Things reached a nadir in 1989 when he effectively became a prisoner for about a year at the Groucho private members' club, where he had run up a huge tab on the basis he would settle up with the proceeds of a scheduled show in Washington. However, the dealer absconded without paying. 'A bit like a Third World debtor country, my bill got to such an extent that they couldn't actually throw me out because... they'd never get any money,' Marc recalls.

The second artist Jopling took on was Damien Hirst, whom he met at an opening at Karsten Schubert in 1991. The connection was immediate. The pair discussed art and life over pints, and early the next morning Damien appeared on Jopling's doorstep clutching a sheaf of plans for far-fetched projects.[14] Although they were both from northern England, their backgrounds could not have been more different. Jopling was a scion of privilege; Damien hailed from a broken family in Leeds and looked to the Beatles as role models of working-class boys made good. But the two shared a magnetic charisma, fierce

ambition and a zest for risk. 'I think we were both inventing ourselves at that same time in London. And I guess we were both what each other needed. He enjoyed selling art in the same way that I enjoyed making it,' says Damien. Jopling would say, 'Let's sell some work before we go out,' recalls Liam Gillick. '...Jay would be on the phone...saying, "I've got a work here by Damien, it's the only one".... And then halfway through the conversation, Damien would be on the other extension and go "Fuck off", or start shouting....People just didn't know what to do....It was like another way of doing things.'

It's quite **a paranoid sculpture,** it's a sculpture on life support.

**MARC QUINN**

By this time, Marc Quinn was living in Waterloo in a rat-infested flat (they liked his bread sculptures). Jopling's girlfriend Maia Norman, a Californian designer, left him for Damien and moved in with Marc during the transition. However, the switch, like much of the group's partner-changing, appears to have been painless, with negligible impact on the blossoming bond between Jopling and Damien. 'It was unbelievable,' says Matthew Slotover. 'I remember going to Jay's house in Brixton and Damien had cooked a curry....And Maia came up to me and said, "...by the way, just wanted to let you know, I'm Damien's girlfriend now."' Sam Taylor-Wood, now Taylor-Johnson, who was married to Jopling from 1997 to 2008, says his relationship with Damien was 'highly emotional and volatile'. 'I always described Damien as Camilla [Parker-Bowles]...he was the third person,' she laughs, echoing Princess Diana's much-publicized comment about the failure of her marriage to Prince Charles because of his long-time lover.[15] So Maia went out with Jopling, then Damien, who had been with Angela Bulloch and Billee Sellman. Sarah Lucas left Gary Hume and lived with Angus Fairhurst. Tracey Emin, who appears later, went out with Carl Freedman and then Mat Collishaw. Sam Taylor-Wood passed from Jake Chapman to Henry Bond (who had been with Anya Gallaccio) to Gary before marrying Jopling. Michael Landy went out with Abigail Lane followed by Gillian Wearing, who was Mark Wallinger's girlfriend previously. Fiona Rae went out with Stephen Park and then Richard Patterson.[16] 'Damien did actually once do a chart showing how if one of us was sick we were all going to die,' jokes Liam Gillick.

It is extraordinary to think that in 1991, while working with Jopling, both Damien Hirst and Marc Quinn produced two of the most

Marc Quinn, *Self*, 1991. Blood (artist's), stainless steel, perspex and refrigeration equipment, 208 × 63 × 63 cm (81 7/8 × 24 3/4 × 24 3/4 in.)

iconic works of the decade. Marc created *Self*, a frozen cast of his head made with nine pints of his own blood, and Damien a 4-metre (13-foot) tiger shark suspended in a tank of formaldehyde titled *The Physical Impossibility of Death in the Mind of Someone Living*.

Both works presented death and horror wrapped in an unemotional Minimalist aesthetic. Both involved bringing shocking organic matter from the real world into the gallery in a matter-of-fact way. 'There was this idea that you don't justify what you do. You don't want to pin yourself down too much, it's all an idea of being ultra cool really. And if you don't get it, you're not in the game,' says the critic Adrian Searle. For Damien, 'It was the ability to say and deny something at the same time. As an artist, if you wear your heart on your sleeve, you end up putting yourself into an uncomfortable position. Whereas if you don't...then you... take responsibility away from yourself and you give it to the viewer.... And that's what was exciting.' Some critics have lambasted the blood head and shark as one-liners, yet they undeniably caught something of the zeitgeist with their in-your-face appeal and accessibility to a mass audience.

> If art doesn't assault you visually, then **it's not going to get your attention**. It's not going to get through to you….
>
> **DAMIEN HIRST**

According to Marc, the inspiration for *Self*, which sits atop a steel refrigeration unit-cum-plinth, derived from several sources: Rembrandt, Samuel Beckett's *Happy Days*, whose protagonist is a disembodied head, and the idea of using his body to make art 'without injuring or killing the host in any way'. 'I wanted to push the limit. I'm quite extremist,' he explains. 'I felt art was too boring and too hermetic and self-contained.' Charles Saatchi was reportedly smitten by the piece and promptly bought it for £12,000. Blurring the boundaries between portraiture and still life, *Self* can be interpreted as both a depiction of the artist and of Everyman. Yet the medium of blood also conjures associations with Frankenstein, the Aztec tradition of human sacrifice, genetics and the Eucharist. 'It's quite a paranoid sculpture, it's a sculpture on life support,' Marc says. There was even a story that builders in Saatchi's home accidentally unplugged the work's refrigeration unit, causing it to dissolve into a pool of blood, although this was denied as apocryphal by both Marc and Saatchi.

Damien Hirst, *The Physical Impossibility of Death in the Mind of Someone Living* (sideview), 1991. Glass, painted steel, silicone, monofilament, shark and formaldehyde solution, 217 × 542 × 180 cm (85 7/16 × 213 7/16 × 70 7/8 in.)

As for the shark, Damien had jotted sketches on beer mats and
envelopes but needed funds to make it a reality.[17] 'I wanted to make
it so that you walk into a gallery and are confronted by something
that would tap into your real fears, genuine things that you're afraid
of. A painting of a shark would never have done it for me,' he says.[18]
Saatchi had already bought Damien's fly piece and some medicine
cabinets,[19] so when the artist needed a backer he was the obvious
port of call. Damien phoned all the post offices around the Great
Australian Bight, asking them to put up adverts for shark fishermen.[20]
He finally located one (through a recommendation rather than the ads)
who could deliver the requisite shark to his doorstep for £6,000, and
Saatchi paid £50,000 upfront for the work.[21]

Now we are inured to its shock value, it is easy to look at the
creature, these days a little worse for wear, and wonder what the
fuss was about. One sees preserved animals and fish in natural history
museums. But this was installed in a gallery as art, in a formidable
blue-tinted glass and steel tank of formaldehyde weighing 23 tons,
the ultimate death fantasy readymade, a literal *nature morte*.
According to the journalist Lynn Barber, 'The Shark actually changed
the whole landscape...of British art.'[22] Damien felt that art needed to
reflect the visual information barrage of modern life. 'If art doesn't
assault you visually, then it's not going to get your attention. It's not
going to get through to you....I looked a lot at advertising,' he says.
The shark's legendary status would be further compounded by its
sale for $12 million in 2012. By the age of twenty-six, Damien had
produced most of his signature works: spots, flies, shark, medicine
cabinets and butterflies. 'He's one of those artists who's lived life
backwards really: you do your mature work first and your juvenilia
later,' says Adrian Searle.

## THE PUBLIC GALLERIES' CAUTIOUS EMBRACE

Institutions were slower than commercial galleries to embrace the
new generation of artists but a few took risks. The non-profit
Chisenhale in London's East End exhibited Slade graduate Rachel
Whiteread's haunting plaster cast *Ghost* (1990) of the interior of
a living room. Rachel had found a Victorian terraced house in north

Rachel Whiteread,
*Ghost*, 1990. Plaster
and steel frame,
269 × 355.5 × 317.5 cm
(106 × 140 × 125 in.)

London and cycled there each day through the freezing winter, spending hours casting the unheated room piece by piece. 'It was really an exercise in pure bloody-mindedness,' she says. 'I felt like a nun half the time, bricking myself into a room because each piece I cast I had to put back against the wall.' As the name suggests, *Ghost* bears an eerie sense of generations of occupants, its silent, solemn mass encasing memories of past lives. With details such as its inside-out fireplace, window and door, it prompts associations with one's own home and childhood, emptiness and, inevitably, death.

> There was quite a
> **Minimalist aspect**...and
> quite an **architectural** aspect
> to the work, but there
> was always <u>some emotional</u>
> <u>aspect</u> to it as well.
>
> RACHEL WHITEREAD

This ambitious monument was the culmination of a journey that began during a metal casting workshop around 1982 while Rachel was studying painting at Brighton Polytechnic. She discovered that when she pressed a spoon into sand and poured molten lead into the space, a perfect spoon was produced on one side but on the other the 'spoonness' was lost. 'It made me realize how you could change a very, very simple object...that one absolutely takes for granted and make it uncanny,' she says. The idea percolated and in 1988 Rachel had her breakthrough with *Closet*, cast from the inside of a wardrobe similar to the kind she had played hide-and-seek in as a child, and covered in black felt. From there, she cast other ordinary domestic objects such as the space inside a dressing table and a water bottle, endowing them with a melancholic poetry in their encapsulation of absence. 'It was really for me in quite a pragmatic way about...dealing with the overlooked and making those things concrete literally and trying to have a way of making them real,' she says. Among the most poignant of these sculptures was *Shallow Breath* (1988), a reference to Rachel's father who had recently died. Cast from the space underneath a bed, it evokes the deathbed, its ribs and dents suggesting human traces and shape reminiscent of a tombstone. Rachel explains, 'There was quite a Minimalist aspect... and quite an architectural aspect to the work, but there was always some emotional aspect to it as well. People used to say "Minimalism with a heart", which is pretty naff but quite a good way to describe it.' With each piece Rachel's ambition grew and it became clear to her that, having cast a bedsit's elements, the next step should be to cast

Rachel Whiteread,
*Shallow Breath*, 1988.
Plaster and polystyrene,
185 × 90 × 20 cm
(72 ¹³⁄₁₆ × 35 ⁷⁄₁₆ × 7 ⁷⁄₈ in.)

the room itself. She was not the first person to cast negative space.
The American artist Bruce Nauman made *Cast of the Space under
My Chair* in 1965–1968, but Rachel would develop the idea further,
making it the foundation of her practice.

The Whitechapel Gallery, another beacon of excellence in
London's East End, had presented Canadian-born Angela Bulloch with
its Artists' Award and invited her to contribute to its 1990 exhibition
'Seven Obsessions'. Angela invested the money
in her first drawing machine, *Blue Horizon* (1990),
which marked a grid of blue lines directly onto the
wall for the show's duration. 'I had the idea to make
a piece which would take as long as the exhibition
to make....And that people could influence along
the way,' she says. Visitors passing in front of it
affected the direction of the line drawn and the ink
faded over time, so the artwork was in a constant
state of flux. Highly computer-literate, Angela was interested in using
technology to create artworks that she describes as 'interpassive'
rather than interactive, inviting the viewer's often unknowing
engagement. 'It's more interesting to think about things which you're
not aware that you're actually causing because it dawns on you
later that it actually was something to do with you,' Angela explains.
'The response to the work becomes part of the work. And that's
where you can recognize yourself. That shows you something
about your own expectations.' *Blue Horizon* would give rise to more
elaborate drawing and even mudslinging machines. These playful
yet conceptually rigorous works illustrate Angela's core concern with
systems that organize our behaviour; the viewer has the illusion of
free will but always within predefined parameters, as happens in life.

With a reputation for groundbreaking exhibitions, the Institute
of Contemporary Arts (ICA) in Pall Mall would show the work of many
of the new generation through the 1990s, including the Chapman
brothers, Damien Hirst, Fiona Rae and Mark Wallinger. For his 1991
exhibition Mark displayed *Capital* (1990), his series of realist paintings
of homeless people (in fact, friends dressed as down-and-outs).
A committed leftist, the artist was angered by the growing army of
destitute around London. 'We were being fed this almost Darwinian
economics by Margaret Thatcher and this was certainly the bottom of

> The response to the work
> becomes part of the work....
> That shows you something
> about your own expectations.
>
> ANGELA BULLOCH

Angela Bulloch,
*Blue Horizon*, 1990.
Drawing machine,
infrared detectors,
ink. Installation view,
Whitechapel Gallery,
London

that pile,' he says. Mark dignified the dispossessed in seven full-length oil portraits whose subjects stand in front of City banks staring at the viewer, rather than crouched, abject, in doorways. 'It felt like my first public work; it was meant to be seen,' he says. 'So I thought, let's use the language of swagger portraits found in the boardroom or in the homes of the landed gentry.'

The Serpentine Gallery held the first survey of the group in 1991, three years after 'Freeze'. 'Broken English' profiled Goldsmiths graduates Angela Bulloch, Ian Davenport, Anya Gallaccio, Damien Hirst, Gary Hume and Michael Landy, plus Rachel Whiteread and Saint Martins graduate Sarah Staton. Damien exhibited a cabinet with rows of fish in formaldehyde, and Jay Jopling rang the *Daily Star* to suggest they send a reporter with some chips.[23] The result was the splash 'Daily Star takes the chips to the world's most expensive fish'.[24] This sense of savvy among some of the group raised hackles in the establishment. Indeed, Serpentine director Julia Peyton-Jones had to fight to exhibit these artists because 'the general feeling in the curatorial world in this country was that the YBAs were so exposed there wasn't a need for a show for them'. 'There was virtually a fear of contact from the institutions....The Tate was completely not interested and disengaged, to the point of negligence,' according to Karsten Schubert. Nicholas Serota, former director of the Whitechapel Gallery, had only taken over the reins at the Tate in 1988, where a policy rethink was needed to increase public engagement with the arts. He redirected the Turner Prize towards younger artists to reinvigorate it and awaken media interest. After a break in 1990 when sponsorship fell through, the prize returned in 1991 with backing from Channel 4 Television, heralding much greater visibility for the nominees, who now had to be under the age of fifty.

ABOVE: Tate Turner Prize, 1991. Back row, L–R: unknown woman, Peter Chater, Alex Hartley, Marcus Taylor; front row, L–R: Ian Davenport, Rachel Whiteread, Sue Arrowsmith, Karsten Schubert, Fiona Rae

OPPOSITE: Mark Wallinger, *Capital*, 1990. Oil on canvas, framed, seven parts, each 266.5 × 144.7 cm (105 × 57 in.). Image one of seven parts

In a nod to the new generation, Ian Davenport, Fiona Rae and Rachel Whiteread were put up for the prize against the internationally established artist Anish Kapoor. Writing in the first issue of *frieze* magazine, the respected critic Stuart Morgan slammed the contest as a one-horse race.[25] 'Once more,' he fumed, 'an institution with a reputation for doing almost nothing to help young artists in Britain gives them one more kick in the groin, continuing its policy of being completely out of touch with public feeling.'[26] Fiona remembers receiving a phone call from Serota: 'I was in my studio and he said, "Would you like to be a guinea pig?" which should have been a red warning light.' An ambitious but fragile ego, Fiona had taken part in prestigious shows since 'Freeze', yet tracked her peers' progress anxiously. 'It seemed like everyone else had galleries, but not me,' she says. She was finally taken on by Cork Street grandee Leslie Waddington. Since the calligraphic-style works seen at 'Freeze', Fiona's paintings had evolved into lively conversations, pitting expressionistic brushstrokes against jabs, drips, squiggles and impasto in a self-conscious orchestration of art-historical references. 'I think I make complex, subtly layered paintings because this is a

ABOVE: Fiona Rae,
*Untitled (yellow)*, 1990.
Oil on canvas,
213.4 × 198 cm
(84 × 78 in.)

RIGHT: Fiona Rae,
*Untitled (red, yellow
and blue)*, 1991. Oil on
canvas, 206 × 457.5 cm
(81 × 180 in.)

way of representing and containing the chaos and anxiety of the contemporary world and of my inner reality. I also want there to be something for everybody. I have an attitude which is, well, if you don't like this bit, how about this bit,' she says.

Ian Davenport was also garnering attention for his new series of sensuous black monochromes using gloss and matt pigment to explore the surface qualities of paint. After college Ian had created sparse, spontaneous paintings using electric fans and nails, influenced by the Minimalist composer John Cage's experiments with chance. Ian's reflective black paintings were created by pouring large blobs of gloss paint onto the matt canvas on the floor, then tilting it to let the gloss drip down, and repeating the procedure with different textures, almost covering the original forms. Serota called the day before Ian's twenty-fifth birthday to tell him he had been shortlisted. 'I did a lot of Tarzan impersonations around the house,' says Ian. But Rachel, Ian and Fiona found themselves thrust into the glare of a hostile media, despite their impressive brief careers. 'We really got attacked for being young and how dare we,' says Fiona. As the winner was announced, Waddington leaned over and said, 'I'm going to take you and Steve [Park] on holiday to Paris.' 'It was an incredibly kind thing to do to make it all all right,' she says. But it wasn't all right. She had a breakdown from the pressure. 'I couldn't really work properly for a year or two....I just fell apart.' Yet although the prize had gone to Anish Kapoor, who already had an international reputation, it succeeded in two crucial ways: it generated public interest in contemporary art and paved the way for a raft of future nominations from the new generation. 'After that it became normal for young people to be shortlisted for the Turner Prize. But we were the first,' says Fiona.

The American gallerist Barbara Gladstone introduced the new British phenomenon to New York in September 1992 with her show 'Twelve British Artists', another important milestone. American critics were circumspect. 'All the artists...came across as skilled, smart, and inventive, though mildly so,' wrote Peter Schjeldahl in *frieze*, who also noted the group was 'spectacularly well informed' about recent art strategy.[27] Gladstone was struck by the bond between the group, which included Anya Gallaccio, Liam Gillick, Damien Hirst, Gary Hume,

> We really got **attacked**
> **for being young**
> and how dare we.
>
> FIONA RAE

Ian Davenport, *Untitled
Matt Black, Gloss
Black, Satin Black*, 1990.
Household paint on
canvas, 213.4 × 213.4 cm
(84 × 84 in.)

Abigail Lane, Sarah Lucas, Marc Quinn and Rachel Whiteread.[28] 'They were so proud of one another and enthusiastic about each other's work, they were all very, very supportive,' she says. The exhibition would provide the blueprint for 'Brilliant!' in Minneapolis in 1995, featuring an expanded group of many of the same artists.

To give a sense of the international context in those early days, New York and Cologne were the two big art centres, each with a strong gallery infrastructure. Unlike the London scene, where no market existed for emerging artists, young American artists, according to the ex-Goldsmiths painter Glenn Brown, 'were very aware of the market. And...were making work which they thought might fit into Pace Gallery, Barbara Gladstone, Matthew Marks.' New York had witnessed an explosion of talent in the 1980s, with women artists such as Barbara Kruger and Jenny Holzer, the so-called Metro Pictures group including Cindy Sherman and Richard Prince (on the Metro Pictures gallery roster), the Neo-Geometric Conceptualists such as Jeff Koons, and Neo-Expressionist painters like Julian Schnabel, who formed part of a broad international reaction against the emotional sparseness of Minimalism and Conceptualism. 'The parallel to what happened in the '90s in London is what happened in the '80s in New York when there was a huge new influx of artists,' says Barbara Gladstone. In Germany, painters like Georg Baselitz, Anselm Kiefer, Sigmar Polke and Gerhard Richter had significant international reputations, but by the early 1990s the electric Cologne scene was dominated by the provocateur Martin Kippenberger's circle and another artists' group known as the Mulheimer Freiheit. 'The real model for us was Cologne,' says Liam Gillick. The galleries there seemed 'loose and prepared to take a risk' and the British artists took their cue, he notes, from people like Kippenberger, who combined a hard-drinking persona with prolific, irreverent output, across media, styles and disciplines.

Exchanges would occur between the BritArtists and their foreign counterparts, notably in 1993 with the two-way British/American show 'Lucky Kunst' curated by Gregor Muir, now head of the ICA,[29] and with the 1994 British/German show 'WM Karaoke Football', curated by

> Going from a student and seeing shows there like **'New York Art Now'**...and actually getting a show there.
> It was unheard of. **It was beyond my wildest dreams**.
>
> DAMIEN HIRST

the German artist Georg Herold and styled as a friendly match between the two 'sides'.[30] In New York, young gallerists such as Gladstone, Matthew Marks and Jim Cohen took an interest in the BritArtists, while in Cologne they were shown at Tanja Grunert, Aurel Scheibler and Esther Schipper. From the start Angela Bulloch and Liam Gillick gravitated towards Europe, feeling more affinity with the critical rigour of the Continental scene than the British one.

The year 1992 closed with Damien Hirst and Rachel Whiteread pulling ahead of the group in terms of international recognition. Damien was nominated for the Turner Prize but lost to an older Goldsmiths graduate, Grenville Davey. Significantly, Charles Saatchi singled out Rachel and Damien to take part in his first Young British Artists show at Boundary Road. 'Going from a student and seeing shows there like "New York Art Now"…and actually getting a show there. It was unheard of. It was beyond my wildest dreams,' says Damien, who had been turned down by Anthony d'Offay and the Lisson Gallery. The *Daily Mail* headline ran 'Celebrities Flock to Gaze at a Cow's Head and a Dead Shark'.[31] That the paper, weathervane of Middle England, deemed the show newsworthy enough to cover – even with likely prodding from Saatchi's PR machine – demonstrated how the once esoteric realm of contemporary art had begun to cross over to general interest within a few years. It marked the first time Damien's generation had been formally categorized as Young British Artists. Saatchi staged six of these shows, sealing the label in the public consciousness to describe a diverse group of artists, many of whom were never even collected by him. For possibly the first time ever, a collector had created a movement.[32]

In this still small artists' community, everyone would turn up to support each other's shows and down the ubiquitous Beck's beer: Beck's sponsored many shows through the 1990s. 'We were all on such a bloody budget, if there was a degree of hedonism it was because you were just going to sign on the next day and so you were hitting as much free beer as you could the night before,' says Louise Wilson, who with her twin sister Jane was part of a second wave of Goldsmiths graduates that came on the scene at this time. In their collaborative film and photography the pair explored marginalized domestic spaces that exuded menace, such as motel rooms, bordellos and bed and breakfasts. Their shared bedsit in London's red-light district, King's Cross, gave them a perfect vantage position. On one occasion, the threat of violence implied in their work materialized literally on their doorstep when a man tried to smash the front door down. 'It was really quite aggressively done and really quite serious and then two weeks later this note arrived,' says Jane. 'They'd come back to the door and bloody left a note on the back of a gyro receipt apologizing, saying they had a psychiatric illness and if you wanted to contact them see overleaf.' Naturally the artists incorporated the note in their artwork, *Construction and Note* (1992).

The art juggernaut was by now rolling inexorably forward as the original 'Freeze' core expanded to a new batch of Goldsmiths graduates: Sam Taylor-Wood and Gillian Wearing from the BA course;[1] Glenn Brown, Adam Chodzko and the Wilson twins from the MA. They were joined by Chris Ofili from Chelsea College of Arts, Georgina Starr and Rachel Whiteread from the Slade, Royal College graduates Jake and Dinos Chapman, Tracey Emin and Gavin Turk, and Scottish artists such as Christine Borland and Douglas Gordon from the Glasgow School of Art.

The period 1993 to 1994 saw frenetic activity and hustling as British artists sought to establish themselves. Outside the system, Sarah Lucas and Tracey Emin opened their shop and the young gallerist Joshua Compston organized bohemian village fetes; within it, Jay Jopling launched his White Cube gallery, the Chapman brothers entered the fray and Rachel Whiteread became the first woman to win the Turner Prize with her remarkable sculpture *House*. As Damien cleaved animals in two, another strand of art was emerging that explored human relations. Women artists would enjoy a brief sensation

of empowerment in the notoriously patriarchal art world, prompting
critics to proclaim a loud new female voice in British art.

## THE HUSTLE

Sarah Lucas and Tracey Emin opened 'The Shop' on Bethnal Green
Road in January 1993 on a six-month lease as a sort of performance-
cum-studio-cum-social-venue. Tracey had worked as a youth tutor and
done a philosophy course after finishing her Royal College MA in 1989.
She had stopped making art, finding that her paintings of the time,
inspired by Byzantine frescoes in Turkey and the Expressionist painter
Edvard Munch 'didn't fit in anywhere'. It was only when she met Sarah
that Tracey finally felt she had found a kindred spirit.
'Sarah was just really refreshing….Everybody at that
time was wanting to be like Jeff Koons, they wanted
to use a lot of Perspex…and polish…and Sarah
was using glue and photos and cutting them out and
that was much more my kind of thing,' says Tracey.
Sarah was attracted to Tracey's mix of toughness
and femininity, 'like the fact that she would always
have a cleavage and I don't', she jokes. They rode around together
on bikes and quickly developed an intense friendship. 'It was quite
heady,' Sarah recalls. 'A lot of people thought Tracey was a complete
nutter in those days and gave her a wide berth…so it was fun to turn
that into a positive thing.'

> The **girls were sexy**
> but I felt I was the object
> of a sort of <u>sexual sadism.</u>
>
> MATTHEW COLLINGS

Calling themselves 'The Birds', the two women would drink
beer and make trinkets to sell, such as mobiles of Sarah's self-portrait,
badges, ash trays with a photo of Damien's face on the bottom, mugs
and T-shirts bearing slogans like 'Have You Wanked Over Me Yet'
(Tracey's) and 'Complete Arsehole' (Sarah's).[2] 'That was when I first
started drinking in the daytime,' says Sarah. 'Me and Tracey used to
go to the pub and have half a Guinness, which would sometimes run
on to quite a few half Guinnesses.' Open six days a week and all night
on Saturdays, The Shop became a Mecca for artists, curators and
bohemians of all sorts. 'I met a hell of a lot of people through it, so
many people came through there that it felt like it expanded the art
world, well my own art world, massively,' says Sarah.

Sarah Lucas and Tracey
Emin at 'The Shop' on
Bethnal Green Road,
London, 1993. Photograph
by Carl Freedman

Like many ventures by this generation, the concept was not new: the American artist Claes Oldenburg had set up his Store in New York in 1961, but The Shop embodied the pioneering spirit of artists' making art on their own terms, outside the system's constraints. 'It was quite makeshift and matter-of-fact, but there was something very charming about it because of that,' says the gallerist Maureen Paley. Not everyone felt at home in the arty love-in. 'The girls were sexy but I felt I was the object of a sort of sexual sadism,' says the artist and television commentator Matthew Collings. Some felt intimidated by the brassy duo's public display of art-making. 'It was a very strange energy in the shop. It was really self-conscious. Everyone was trying so hard to be cool,' remembers Gavin Turk. 'It was weird that that never really got written into the story...that ...you used to go in there and it was actually quite nerve-racking.'

ABOVE: Gavin Turk at White Cube, Duke Street, St James's, London, September 1996. Photograph by Johnnie Shand Kydd

OPPOSITE: Sam Taylor-Johnson, *Fuck, Suck, Spank, Wank*, 1993. C-print, 144.8 × 114 cm (57 × 44 ⅞ in.)

For Sam Taylor-Wood, who had struggled to find her way since graduating from Goldsmiths in 1990, the creative freedom she encountered in the cottage industry atmosphere of The Shop was a revelation. 'It was like a spiritual awakening in a sense. Of suddenly feeling like, "It doesn't matter. Just put everything out there that you're thinking and feeling, and see what happens,"' she says. Sam did just that with her self-portrait with her trousers round her ankles and T-shirt saying *Fuck, Suck, Spank, Wank* (1993). At the time she was working nights at the Camden Palace club and trying to make art during the day. 'I was just having a really miserable, shit time,' she says. The Birds offered inspiration in their contrasting role models of ballsy women: Sarah cultivating a studiously unfeminine appearance with hairy legs and holey jumpers, and Tracey a busty, girlish, mouthy, boozy ladette. While Sam's T-shirt may not have been the most profound artwork, 'it got enough attention for me to get the next exhibition', she says.

By June the following year, Sam was showing her four-screen video *Killing Time* (1994) at the non-profit gallery The Showroom, which caught Jay Jopling's eye and would land her a White Cube exhibition. Inspired by a stint in the wardrobe department at the

ABOVE: Joshua Compston
at the first 'A Fete Worse
than Death', 1993.
Photograph by Guy
Moberly

RIGHT: Damien Hirst
and Angus Fairhurst
dressed as clowns at
'A Fete Worse than Death',
1993. Photograph by
Guy Moberly

Royal Opera House, *Killing Time* features four casually dressed, bored-looking individuals, who come to life in turn to lip-synch a role in Richard Strauss's bloodthirsty opera *Elektra*. The opera's passionate content is at variance with the mundane appearance of the actors who smoke, chew and fidget in domestic settings waiting for their moment to perform, suggesting that beneath the calm façade of modern life lies turbulence. With *Killing Time* Sam felt she was connecting to her work for the first time. 'I think we were all unemployed by the time I made that….So it was that sense of dissatisfaction and slight anxiety about, at what point do I get to sing?' The piece was to be the prototype for many of her films and photographs evoking the louche alienation of middle-class urban existence in their disjointed format and content.

Like Sarah, Tracey and Sam, everyone was living by their wits during this time, few more so than Joshua Compston, an energetic young dreamer and dandy who ran a precarious gallery called Factual Nonsense in London's East End and conducted his life as something of an art performance.[3] In 1993 he arranged a street fair in Shoreditch called 'A Fete Worse than Death', modelled on the Victorian idyll of the English village fete but with artists running the stalls, which lent it a creative, anarchic feel. Damien Hirst and Angus Fairhurst dressed as morose clowns, charging £1 to make spin paintings on a rickety machine and, in a twisted subversion of the funny man role, £1 to pull out their penis and testicles, which had been painted with spots by the transvestite performer Leigh Bowery. Damien has said they made more money from showing their tackle than from the spin paintings, which went on to become a signature part of his practice. Gary Hume manned a popular tequila slammer stand, Gavin Turk made a 'bash the rat' apparatus with tube piping, Goldsmiths graduate Adam Chodzko and another artist Brendan Quick had a 'pubic hair exchange', while Tracey Emin read palms.[4] The event was rounded off by a raffle whose top prize was a bag of dildos.[5]

Compston, despite being the son of a judge, was permanently impecunious. He is credited with spearheading the regeneration of the Hoxton/Shoreditch area through numerous one-off events and spectacles.[6] Compston attended the Courtauld Institute, where at the precocious age of twenty-one he overcame fierce resistance to put contemporary art on the walls of the august institution.[7] Friends say he

was a passionate, infuriating, authoritarian idealist with no sense of business but grand ambitions to revolutionize the lives of the working classes and unite the spheres of advertising, art, entertainment and retail under the banner of Factual Nonsense.[8] His distinctive posters and manifestos always had flair, exploiting agitprop as the Futurists had before.[9] 'I never knew really what he was up to,' says Gary Hume, who was close to him. 'I thoroughly enjoyed not knowing what he was up to, you know, and the weird...global, communist, fascist, anarchist state that he wants to make.' Compston pulled off a second 'A Fete Worse than Death' in 1994 and an outdoor exhibition in Hoxton Square in 1995 called the 'Hanging Picnic', which were tremendous successes in terms of publicity and kudos but never translated into money in his pocket. It depressed him to be left in the dust as YBAs he had shown started to make it big.[10] 'I am like an aircraft carrier, people land on me then take off,' he said.[11] 'He was like a young guy who just wanted to change the world and he went for it in lots of different ways. He was very unafraid of stuff. And I suppose that was inspirational,' says Gavin Turk, another friend. But Compston had a dark side, possibly exacerbated by mental illness, which tinged his highs and his lows with danger.[12]

Compston was not alone in his struggle to make it. As Sarah Lucas spread her wings, her boyfriend Gary Hume found himself trapped by his own success with his Door Paintings. He embarked on a new direction, making sculptures out of chicken wire and odd paintings of Madonnas. Karsten Schubert, in financial straits following the recession, was appalled. Gary recalls, 'He said, "Make doors again, and I'll show the doors, I can't show these...." And I couldn't do it. I was determined to be an artist, which meant being courageous.' So he gave Schubert an ultimatum: show his new work or he would leave the gallery. They parted ways in early 1993. 'It was a big trauma because I was very fond of him,' Schubert acknowledges, 'but I couldn't show work I couldn't explain.' Gary went through a bleak patch, living in a tent in his unheated studio in the deserted wasteland of Hoxton. He made a home video, *Me as King Cnut*, which showed him fully dressed in an overflowing bath, smoking and wearing a Burger King crown, comparing himself to King Canute who couldn't hold back the tide: was he a deluded fool or wise in being true to himself?

Gary's New York dealer Matthew Marks sent him £400 a month, which kept him going. Gradually Gary got into his stride, creating abstracted figurative paintings that began as one thing and veered off on a tangent to end as another. *Tony Blackburn* (1993), named after the B-list Radio One disc jockey who had fallen on hard times, shows what looks like a black helmet of hair or headphones over a black three-leaf clover. For Gary, the clover summed up his situation: 'That's how poverty-stricken I am, I'm on the grass around the canisters, looking for a four-leaf clover...and all I can find is...this fucking three-leaf clover, that's it.' He explains, 'I liked the...Englishness of his fame, in comparison to what an American Pop artist would depict. They had access to real glamour and real stardom, whereas I felt like we have Tony Blackburn, and that was our world.' Another painting, *Vicious* (1994), depicts a muscular silhouette against a vibrant background of flowers, inspired by Italian fascist sculpture and Lou Reed's song *Vicious*, which opens with 'You hit me with a flower'. Desperate, Gary rang Charles Saatchi's office to offer him the painting. 'Half an hour later they phoned up and said, "How good is it?"...And I said, "Very good" and "All right, we'll buy it,"' Gary remembers. 'I got 1,200 quid, so now I'm like: "Now I've got time."'

Charles Saatchi was crystallizing his position as the group's main benefactor at this time and launched his second Young British Artists show in February 1993, which included Sarah Lucas's *Two Fried Eggs*, Marc Quinn's *Self*, Mark Wallinger's homeless portraits and his series of racehorse paintings, *Race, Class, Sex* (1992). A passionate race-goer and lover of horses, Mark describes the stallion portraits, painted side-on in the manner of the eminent eighteenth-century British equine painter George Stubbs, as a homage to racing and the majesty of horses. 'I wanted them to look like sleek race horses, but very sleek paintings as well that were very covetable and like trophies in themselves.' The paintings serve as a metaphor for Britain's class system, drawing parallels between the aristocracy and horse breeding in their common emphasis on purity of stock. In his practice Mark would explore the anthropological implications of British horse racing, from the jockey colours to the royal pageantry, culminating

That's how poverty-stricken I am, I'm on the grass around the canisters, looking for a four-leaf clover...and all I can find is...this fucking three-leaf clover, that's it.

**GARY HUME**

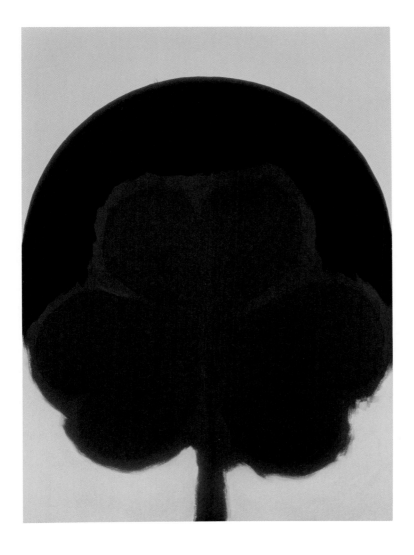

ABOVE: Gary Hume,
*Tony Blackburn*, 1993.
Gloss paint on panel,
194 × 137 cm
(76 ³/₈ × 53 ¹⁵/₁₆ in.)

OPPOSITE: Gary Hume,
*Vicious*, 1994. Gloss paint
on panel, 218 × 181 cm
(86 × 71 in.)

Mark Wallinger,
*Race, Class, Sex*, 1992.
Oil on canvas, four parts,
each 230 × 300 cm
(90 ½ × 118 in.). Image
one of four parts

in the 1994 syndicated purchase of an actual thoroughbred, which he named *A Real Work of Art*. True to Duchamp's original gesture of exhibiting a readymade urinal, *A Real Work* asserted the artist's right 'to denote something as art without the benefit of being within a recognized institution that would confer that value'.

Saatchi would trawl exhibitions constantly for inspiration and was enthralled to discover the blankly comical visions of barbarity and deformity in the work of Jake and Dinos Chapman, who blasted to prominence with their 'Disasters of War' show at Victoria Miro's gallery in spring 1993. For their exhibition the brothers painstakingly recreated in three-dimensional miniature tableaux each of Francisco de Goya's eighty-three *Disasters of War* etchings (1810–1820) graphically depicting the carnage caused by the Napoleonic invasions of Spain in 1808. Yet their use of cheap plastic toy soldiers deflated any expressionistic or emotional reading of the brutal scenes. The Chapmans' fascination with Goya stemmed from their irritation with the conventional art-historical interpretation of his *Disasters* series as exemplifying man's struggle towards civilization; their reading of his work, by contrast, homed in on the ambiguity around the frenzied excess of Goya's vision. 'When you actually look at the work, the degree to which there's an economy inside the work that undermines the framework, some of the violence and some of the castration and atrocity in the drawing appears to have a libidinal quality to it that verges on pleasure,' explains Jake. The installation marked the start of the brothers' rich exploration of Goya in their practice, a combination of homage, critique and appropriation. *Great Deeds Against the Dead* (1994) portrayed an individual life-size scene of gore from Goya's *Disasters* series and prompted a visit from the vice squad when shown at Victoria Miro. 'We were trying to rob the original Goya print of the magnitude of its pathos by turning it into this superficially flat Spanish pimps on a tree, with crap wigs and awful moustaches. There's no way you could look at that and feel moved,' says Jake.

At once puerile and sophisticated, the pair employ humour and abjection as subversive tools in their works, which they have described as 'moral hand grenades'.[13] Around the same time, the iconoclastic duo created *Mummy and Daddy Chapman* (1993), the first of their infamous mutant shop mannequins arrayed with misplaced genitalia. This they followed up with the quickly iconic *Fuck Face* (1994), a child

ABOVE: Jake and Dinos
Chapman, *Disasters of
War*, 1993. Polyester resin
and mixed media,
130 × 200 × 200 cm
(51 ³⁄₁₆ × 78 ³⁄₄ × 78 ³⁄₄ in.)

OPPOSITE: Jake and Dinos
Chapman, *Great Deeds
Against the Dead*, 1994.
Fibreglass, resin, paint and
wigs, 277 × 244 × 152.5 cm
(109 × 96 × 60 in.)

mannequin with a penis nose and an anus for a mouth. 'We thought,
"What is a fuck face?" It's a term that's used so often, but what is it?
What does it look like?' says Dinos, who was tasked with delivering
the piece to Victoria Miro's genteel blue-chip gallery. 'I unwrapped
it and I've never been in such a silent place. I was told that as soon
as I walked out she put a tea towel on its head.' But the elegant
gallerist gave the brothers her full support, engaging in discussions
'that would sound like she actually had Tourette's', according to Jake.
'The radicality was inverted, we were just subordinate slaves to her
offensive expletives, and her limitless ability to appropriate anything
that we chucked at her,' he jokes. 'I think she quite liked the fuss,'
Dinos says.

Some critics have associated the deformed mannequins with
child abuse, earning the derision of the artists who say their work
highlights such hardwired responses. With *Fuck Face*, Jake explains,
'we were thinking how can you make a work of art that isn't always
already recuperated to some sort of moral purpose? Even the nastiest
work…gets appropriated into the logic of positivity in the same way
as the *Disasters of War*, these horrific images of castration, of murder
and mutilation, the way it's talked about is that it embodies this notion
of human civilization. How the hell does that happen?' *Fuck Face* led to

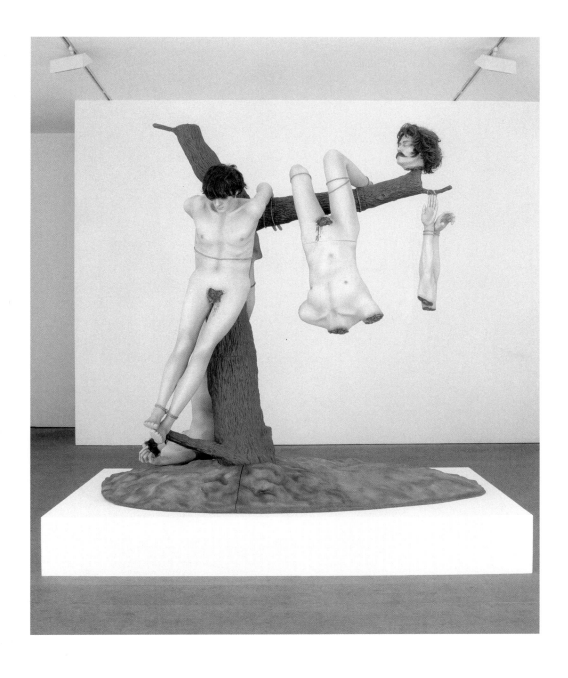

*Two-Faced Cunt* (1995) and eventually, as the brothers' imaginations ran wilder, to a deranged mass of naked conjoined child mannequins, *Zygotic Acceleration, Biogenetic, De-Sublimated Libidinal Model (enlarged x 1000)* (1995), which appeared in the blockbuster YBA show 'Sensation' at the Royal Academy in 1997.

> We thought, 'What is a fuck face?' It's a term that's used so often, but what is it?
>
> **DINOS CHAPMAN**

The Chapmans would leave Victoria Miro – 'she just became so offensive with her language', Jake quips – to throw in their lot with Jay Jopling. In May 1993 Jopling launched his new gallery, White Cube, named after the Irish artist/critic Brian O'Doherty's influential 1976 essay 'Inside the White Cube: The Ideology of the Gallery Space'. Until that point, Jopling had organized shows for artists in alternative spaces: a flat, a vacant house, a disused factory, but he persuaded Christie's to lend him a tiny space rent-free in the discreet moneyed heart of St James's.[14] Jopling's suave sales patter, immaculate suits and decision to locate among the Old Masters dealers and antique shops all sent out one clear message: he meant business. With Karsten Schubert still reeling from the recession and less of a salesman, Jopling would gradually assume his mantle as dealer of the YBAs. 'Jay was just like, "I'm in this for the money", and he still is. And he didn't make any

RIGHT: Jake and Dinos Chapman in their studio

OPPOSITE: Jake and Dinos Chapman, *Fuck Face*, 1994. Fibreglass, resin, paint, fabric, wig and trainers, 103 × 56 × 25 cm (40 ⁹⁄₁₆ × 22 × 91 ³⁄₁₆ in.)

secret about it whatever,' says Rachel Whiteread, whose partner Marcus
Taylor was with White Cube at the outset, along with Marcus Harvey,
Damien Hirst, Marc Quinn, Gavin Turk and the Israeli artist Itai Doron.
Jopling's support of the group, coming from a position of privilege and
status, gave it further legitimacy. 'I think it was really important that
a favourite son, as it were, opened a gallery,' says
Maureen Paley. 'He was the new young British person
with vision and I think that his partnership with
Damien meant that they could…really take a broom
and sweep in the new – it gave it a momentum that
it needed at the time.' White Cube opened with an
ambitious multimedia show by Goldsmiths graduate
Itai Doron across two venues: a football-field-sized
space in Docklands and Jopling's St James's gallery. However, the work
didn't sell, despite a huge fanfare and crowds, and Doron slipped off
the gallery's books. 'I mean wow,' remembers Rachel, 'it's like some
people just shot their load too early. And they just couldn't keep up
the momentum afterward.' Thereafter Jopling ushered in a fast turnover
of one-off shows: seventy-five over the next ten years, including YBAs
and international artists such as Luc Tuymans and Doris Salcedo.
Openings were always packed. 'The best memories are of two, three
hundred people trying to cram into a 13-square-foot [1.2-square-metre]
room and the thrill of just that fervent attention and excitement and
madness,' recalls Taylor-Wood, who would join White Cube and later
marry Jopling. 'There was a real energy and a thirst and lust for ideas
and art.'

Jopling gave Tracey Emin her first solo exhibition in late 1993,
which she called 'My Major Retrospective 1963–1993' thinking
it might be her only shot. He had taken part in an earlier scheme
of Tracey's inviting people to invest £10 in her creative potential
in return for four handwritten letters. He originally envisaged a
conceptual show based around her letter-writing but Carl Freedman,
her then boyfriend, suggested she incorporate the mounds of
memorabilia that crowded her tiny flat and provided keys to her
personal stories. This showed Tracey an effective way to mine her
biography by combining her storytelling talent with photographs,
diaries, letters and drawings to give a frank self-portrait that has
become the essence of her practice. 'A lot of people turned their nose

> There was a **real energy**
> and a thirst and lust
> for ideas and art.
>
> SAM TAYLOR-JOHNSON

up at it because it was too personal...and there was a snobbishness about her being a working-class Turkish-Cypriot girl who was open about her sexual history,' says Carl. Tracey's gift for narration came to the fore on a 1994 road trip with Carl around America, during which she performed readings from her autobiographical book, *Exploration of the Soul*, detailing her dysfunctional upbringing in Margate. 'Tracey was not driven but she certainly had a belief in the moral constructive possibility of her message, in the transformative power and the desire to be the brave one that could be an example for other people,' says Carl.

## VISCERAL ART VERSUS RELATIONAL AESTHETICS

In contrast with the visually grabbing, readable sculptures of Sarah Lucas, Damien Hirst and the Chapmans, another type of art was emerging that was open-ended and collaborative, involving making connections between people. Among its practitioners were Goldsmiths graduates Angela Bulloch, Adam Chodzko, Liam Gillick and Gillian Wearing, and Scottish artists such as Christine Borland and Douglas Gordon. This art, which harked back to 1970s Conceptual art, was especially popular in Continental Europe and would subsequently be defined as 'Relational Aesthetics' by the French curator Nicolas Bourriaud.[15] The artist-run space City Racing hosted Gillian's debut solo show, featuring her series of arresting photographs called *Signs that say what you want them to say and not Signs that say what someone else wants you to say* (1992–1993). Gillian asked random people in the street to write their thoughts on a sheet of paper and hold them up for the camera. Pre-dating the internet, social media and reality TV, the photographs revealed unexpectedly intimate insights into the subjects' emotional states that were often at odds with their outward appearance and forced the viewer to re-evaluate their preconceptions. A policeman wrote 'HELP', a dippy-looking girl declared 'My grip on life is rather loose', and a man with a tattooed face announced 'I have been certified as mildly insane'. 'It was a complete breakthrough,' admits Gillian.

> It was a complete breakthrough. I hadn't expected people to be so open and write such extraordinary things about themselves or the world.
>
> GILLIAN WEARING

ABOVE: Gillian Wearing, I'M DESPERATE from the series *Signs that say what you want them to say and not Signs that say what someone else wants you to say*, 1992–1993. C-type print mounted on aluminium, 44.5 × 29.7 cm (17 ½ × 11 ¾ in.)

RIGHT: Gillian Wearing, *Dancing in Peckham*, 1994. Colour video with sound, 25 minutes

OPPOSITE: Gillian Wearing, *Confess All On Video. Don't Worry, You Will Be In Disguise. Intrigued? Call Gillian...*, 1994. Colour video for monitor with sound, 30 minutes

'I hadn't expected people to be so open and write such extraordinary things about themselves or the world.'

Gillian turned this exploration of the thresholds of reserve onto herself with her 1994 video *Dancing in Peckham*, in which she

grooved in silence in a Peckham shopping mall for 25 minutes: a work by turns funny and touching as the viewer cringes and admires her uninhibited public display, normally the preserve of the mad or blind drunk. Given her interest in self-revelation, it was a natural step to a powerful work, which began with an ad in *Time Out*: *Confess All On Video. Don't Worry, You Will Be In Disguise. Intrigued? Call Gillian….* She filmed those who responded in wigs, false beards and masks as they recounted burdensome secrets: one man found his sexual relationships blighted by memories of his brother and sisters 'snogging'; a woman admitted drugging her cheating ex-boyfriend and stealing his credit card. 'I was interested how in the Catholic confessionals people are shielded by a curtain or netting. But I wanted to do something where the concealment was part of the person and the mask was the perfect prop,' Gillian explains. Verging on documentary, voyeurism and therapy, the work tested the boundaries of art. Maureen Paley was certainly intrigued and gave Gillian a solo show in 1994 at her Interim Gallery.

Fellow Goldsmiths graduate Adam Chodzko was making work in a similar vein, questioning the nature of art. 'Can the art object be in a scrap of newspaper, in the classified advertisement? Or is it in the thing that that produces? Or is it in the event that took place as a result of that?' he asks. Adam created *The God Look-Alike Contest* in 1992 from an ad he placed in *Loot* magazine: 'Artist seeks people who think that they look like God, for interesting project.' Photos of the thirteen respondents – including a woman in a red basque, a man posed as an Indian guru and a would-be matinee idol – revealed a comical cross-section of contemporary society. The work underscored both the absurdity of the aspiration and the diversity of interpretations of God's appearance. 'There's lots of generic stereotypes about him, but in a way it's a completely pointless task in that there isn't an image,' says Adam. 'It was about what would be prompted by that question.'

ABOVE: Adam Chodzko installing *Secretors* at Stichtung de Appel, Amsterdam, 1997. The jars on the shelf contain the excess 'manifestation juice' that fills *Secretors*

OPPOSITE: Adam Chodzko, *The God Look-Alike Contest*, 1992. Thirteen framed images, mixed media, dimensions between 9 × 12 and 48.5 × 21 cm (3 ½ × 4 ¾ and 19 ⅛ × 8 ¼ in.)

This work and Adam's gothic-looking *Secretors,* resembling giant drops of blood oozing from the wall (1993–1996), were acquired by Charles Saatchi, perhaps attracted by their visual wackiness. In fact, the ideas behind both works tie in more to relational art than the visceral. 'With both of them is the idea that into an ordinary space, you can get the suggestion of another kind of reality that somehow is about to transform it,' says Adam, whose art functions surreptitiously, in the cracks and edges of culture. Inspired by horror film scenes of buildings leaking blood, the *Secretors* embody an uneasy anticipation of transition, a suspended moment where everything seems stable but for these telltale drips. To the bafflement of YBA contemporaries who sought maximum visibility for their work, Adam would place his *Secretors* in overlooked nooks where they might register in people's peripheral vision. This sort of nebulous relational art is incompatible, in Adam's view, with the visceral YBA art: 'A lot of the way that the YBA stuff was marketed was just this incredibly clear work,' he says. 'It's a shark....It's a mannequin with a penis coming out of it....Although it looks strange, you don't need to worry about anything that's beyond it.'

Of course, a lot of art did not fit neatly into either category. Angus Fairhurst's practice overlapped with both, encompassing installation, performance, animation and wall-works. In 1994 Karsten Schubert exhibited Angus's playful piece *Gallery Connections* in which he hooked up leading galleries' phone lines to each other, resulting in confusion and annoyance. The inspiration came from his experience of approaching galleries about showing his work, prompting him to think about loops and interconnections, a recurrent motif in his work.[16] Angus's mischievous streak – along with a certain commercial disinterestedness – come across in this incident post-'Freeze', as told by Damien Hirst: 'When Maureen Paley asked him to send her some slides, meaning slides of his work, he got me to take pictures of him lounging around and he sent her like twenty-five slides with captions of himself. She didn't get it and I don't think she even kept them. It's a shame because it's a great early Fairhurst piece.'

In parallel to the YBA phenomenon in London, a similarly supportive scene developed in Glasgow in the early 1990s, where artists staged their own revolution that would overturn the Scottish art establishment with its blinkered fixation on heroic figurative painting.

Adam Chodzko, *Secretors (9605 km/hr & 3588 km/ hr)*, 1993. Lead crystal and manifestation juice, each approx. 60 × 10 × 7 cm (23 5/8 × 3 7/8 × 2 3/4 in.)

Many of these artists were pursuing a socially engaged practice more akin to Relational Aesthetics than art based on material objects. The spark began with the fabled environmental art course at the Glasgow Art School, whose alumni include Christine Borland, Martin Boyce, Roderick Buchanan, Nathan Coley, Douglas Gordon and Ross Sinclair. As with the Millard Building at Goldsmiths, the environmental art course (which had nothing to do with ecology but everything to do with extending art practice into new environments beyond the gallery) was set apart from the rest of the college, in a part-derelict former girls' school. It offered a wonderland of creative opportunities amid absolute freedom since the students had the keys to the building. The artists, dubbed Scotia Nostra, socialized together and shared an ethos of debate and participation in their work, according to Christine Borland. Shunned by the conservative Scottish art institutions, they mounted their own shows and engaged with artists in Europe and America, often bypassing London. Europe was far more receptive to their ideas. 'It's why everybody got on the train, got on the plane....The rest of Europe was open for us,' says Douglas Gordon. The phenomenon, named the Glasgow Miracle by the super-curator Hans Ulrich Obrist, would acquire its own mythology, like its London counterpart.

Douglas Gordon would become a major player in relational art but also straddled the BritArt scene. In one early work, he arranged for unsuspecting customers in a bar in Rome to receive cryptic phone calls; in another, he sent letters to acquaintances with ambiguous messages such as 'I am aware of what you have done':[17] a sort of guerrilla art intervention in people's private lives. One of his first, and ongoing, pieces was a wall list of all the people Douglas could remember meeting in his life, demonstrating the randomness and fallibility of memory, as well as the way we categorize and exclude others. With the lists, letters and phone calls, the social responses to these self-conscious acts form part of the work. Douglas did an MA at the Slade in London and in the spring of 1993 hit upon the work that would make his name and propel him to a different level of fame from his contemporaries: *24 Hour Psycho*. Alfred Hitchcock's

ABOVE: Douglas Gordon. Photograph by Johnnie Shand Kydd

OPPOSITE: Douglas Gordon, *24 Hour Psycho*, 1993. Video installation, dimensions variable

horror classic *Psycho* had always been forbidden fruit, banned as immoral by Douglas's mother, a strict Jehovah's Witness. He removed the sound and slowed the film down to last an entire day, creating a work that combined both the autobiographical emphasis of his Glasgow training and the Post-structural theory absorbed at the Slade. 'It's just the classic academic trope – to get to the truth, watching something one frame at a time will lead you to the truth, except actually it doesn't. You end up with...a myriad of mini-narratives within the large story,' explains Douglas. 'By the time you watch Norman (Bates) mopping up the blood in the bathroom, you've already lost the point where you started...but it reveals the fact that academia can actually open things up into a more sensual dimension.' Perhaps surprisingly for a tense thriller, when *24 Hour Psycho* was shown at the pioneering Tramway gallery, 'it was one of the most erotically charged events in Glasgow', according to Douglas. 'It was a love fest....

ABOVE: Christine Borland, *From Life*, production details, 1994. Mixed media (female human skeleton, slide show, bronze bust, vinyl text), dimensions variable

OPPOSITE: Christine Borland, *Small Objects That Save Lives*, Chisenhale Gallery, London, 1993. Installation (donated small objects, text), dimensions variable

The presentation is so casual…and because everything isn't happening the way it should be, I think everybody feels free to behave however they want….It's a very permissive work.' Douglas's appropriated version of Hitchcock's cult film brings up several core themes of his practice such as authorship and authenticity, good and evil, time and memory, recognition and duplicity. Made when video art was in its infancy, *24 Hour Psycho* was 'probably the most brave move that I had made up until then', he says.

Christine Borland, like Douglas one of the few Glasgow artists to bridge the London scene (they were both taken on by the Lisson Gallery), took her practice beyond gallery boundaries into morally grey areas of science, medicine and forensics. At London's Chisenhale Gallery, in a joint exhibition in 1993, she presented *Small Objects That Save Lives* (1991–1999), consisting of neatly arranged objects – a crucifix, a football mascot, spectacles, a thimble – sent by people on the gallery's mailing list whom the artist had invited to contribute. This work, like that of Adam Chodzko and Gillian Wearing, relies on the participation of a random group of people and questions when

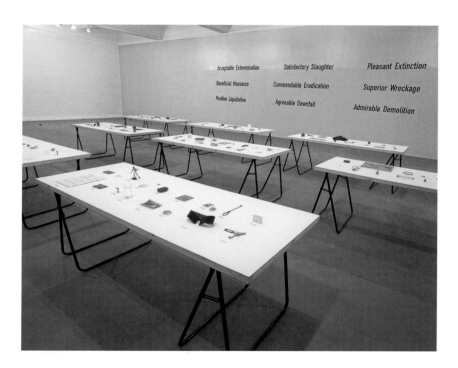

the art itself happens. Christine made her breakthrough at Glasgow's Tramway gallery with her work *From Life* (1994), which deals with her recurrent theme of piecing together literal or metaphorical fragments to construct a human narrative. It started with her buying a human skeleton from a mail-order catalogue and ended with the reconstruction and bronze casting of the face of its owner, a 25-year-old Asian woman. Throughout the process, Christine had no idea what the outcome would be and the journey became central to the work. 'So I was always taking pictures and recording, with the realization that I might never get to an end point in time for the exhibition. I might just have to show this amazing object, and these dialogues and conversations,' she says. In the event, that was what happened as the forensic reconstruction remained unfinished. Christine felt she had found a new language at the crossroads of art and science. 'It possibly was the first time that I would have articulated that there were moments where the science...and art...were really overlapping or butting up against each other and clashing in a way I found incredibly exciting.'

Christine would participate in an important group show in the summer of 1993 that brought these strands of visceral and relational art together: the Aperto, an international showcase for emerging talent at the Venice Biennale. In June, *frieze* magazine co-editor Matthew Slotover curated the British section of the Aperto, featuring Henry Bond, Angela Bulloch, Mat Collishaw, Damien Hirst, Simon Patterson, Georgina Starr, Chelsea-trained Steven Pippin, Laos-born Vong Phaophanit, and the Scottish artists Christine Borland and Julie Roberts. Damien wowed the art world with his sculpture *Mother and Child (Divided)*, a subversive take on the Christian iconography of Madonna and Child that abounded in Venice's churches. Consisting of a cow and a calf sliced in two, suspended in formaldehyde within four turquoise vitrines so that one could walk through the centre of each animal and view it from inside and out, the work pushed the boundaries of taste. Besides the influence of Jeff Koons's pieces in Perspex cases discussed in Chapter One, Francis Bacon was a major source of inspiration to Damien and his vitrines can be seen as three-dimensional variations on Bacon's paintings with their angst-laden

> Things really opened up for me when I gave up on trying to be original, when I realized it wasn't important in the world we live in today.
>
> DAMIEN HIRST

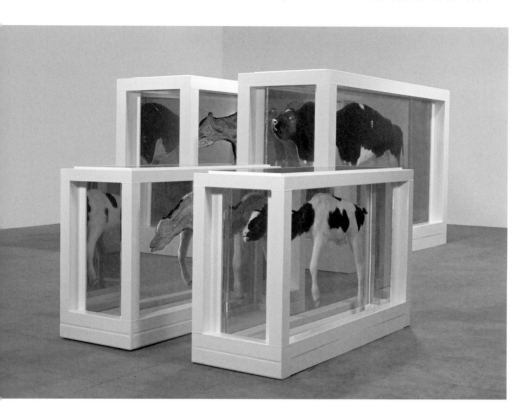

ABOVE: Damien Hirst, *Mother and Child (Divided)*, 1993. Steel, GRP composites, glass, silicone sealant, cow, calf and formaldehyde solution, two parts, cow: 190 × 322.5 × 109 cm (74 ¾ × 127 × 42 ⅞ in.); calf: 102.9 × 168.9 × 62.5 cm (40 ½ × 66 ½ × 24 ⅝ in.)

RIGHT: Damien Hirst working on *Mother and Child (Divided)* at his studio in Minet Road, Brixton, 1993. Photograph by Rachel Howard

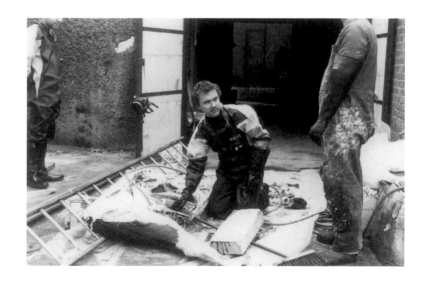

subjects framed in claustrophobic cages.[18] These pickled animals
would become Damien's trademark. He says, 'I was...taking ideas
from everywhere, and things really opened up for me when I gave
up on trying to be original, when I realized it wasn't important in the
world we live in today.'

Contrasting with the swagger of Damien's piece at the Aperto,
Georgina Starr's understated installation *Mentioning* showed two
statically charged paper figures on a TV monitor 'acting out' snippets
of random conversations between couples that the artist secretly
recorded around London. The phrases appeared transcribed as
subtitles to the performance and in a song sung by Georgina.
'I remember being really excited by how something so vulnerable

and fragile could still stand quite strongly in the exhibition,' she
says. Georgina had been plucked from her 1992 Slade degree show
by the dealer Anthony Reynolds before moving to Amsterdam's
Rijksakademie on a two-year scholarship. During this time she gained
notice with inventive works such as *The Nine Collections of the Seventh
Museum* (1994), a virtual museum of her memories and observations
meticulously documented while staying in The Hague for a public
commission. Depressed and suffocated by the city, she turned
her focus on her life in her hotel room, recording herself sewing

her alter ego doll 'Junior', writing a song on her hand and dining alone. Georgina ordered everything she had accumulated into nine collections relating to different emotions or experiences, around which she wove an elaborate fiction, presented on an interactive CD-ROM with photos, text, video and sound. 'It was clearly my collection of stuff in that room...but actually once I started writing, I started imagining myself as a collector who'd amassed all these objects...so I immediately took on another role,' she says. Much of Georgina's early work was characterized by the whimsical simplicity of *Mentioning*; later it would build on the complexity of *Nine Collections*, mixing live performance with multimedia to weave numerous layers of narrative across time and space.

I remember being really excited by how something so vulnerable and fragile could still **stand quite strongly** in the exhibition.

GEORGINA STARR

ABOVE: Abigail Lane,
*Misfit*, 1994. Wax, plaster,
oil paint, human hair,
clothing, glass eyes,
60 × 85 × 192 cm
(23 ⅝ × 33 ⁷⁄₁₆ × 75 ⁹⁄₁₆ in.).
Installation view of 'Some
Went Mad, Some Ran
Away', Serpentine Gallery,
London, 1994

OPPOSITE: Tracey Emin,
Gillian Wearing and
Georgina Starr, dancing
at the beach in Whitstable,
1996. Photograph by
Johnnie Shand Kydd

Damien Hirst returned briefly to curating, but this time it was a group show in the refined Serpentine Gallery as opposed to a derelict warehouse. 'Up until then, private views had been a polyester cup with some lukewarm cheap white wine, and suddenly it was champagne and supermodels,' says the photographer and friend of the group Johnnie Shand Kydd, whose 1997 book *Spitfire* chronicled their activities. In the 1994 show 'Some Went Mad, Some Ran Away', Damien included a few core mates such as Angus Fairhurst, Marcus Harvey and Abigail Lane, alongside international artists like Ashley Bickerton and Sophie Calle. Abigail exhibited *Misfit*, a life-size wax cast of Angus crawling along the floor naked from the waist down. It was intended to represent a personification of vulnerability rather than Angus himself, but in light of his suicide in 2008 the piece seems poignantly prescient. Damien contributed the show's centrepiece, a sheep in a tank of formaldehyde called *Away from the Flock*. An unemployed artist

called Mark Bridger poured black ink into the tank to create a 'black sheep'. Damien didn't appreciate the joke, leading to a court case that further fanned publicity for the show and for Damien. It was partly for this work that he would win the Turner Prize in 1995.

## STRONG WOMEN

As BritArt's star ascended, one of its most noteworthy features was the prominence of women: a welcome change from the machismo of major art movements of the twentieth century. 'It was part of a general optimism, class, gender, politics. There was a bit of a sense of everything's in the mix,' recalls Christine Borland. That optimism would later prove illusory in the real, male-dominated world of collectors and galleries, but while it lasted unlikely friendships blossomed among the women.

In this period the sculptor Rachel Whiteread produced her most ambitious project, *House* (1993), which won her the 1993 Turner Prize. With *Ghost* she had already cast the inside of a room; the logical progression was to cast a house. Aided by the arts organization

Artangel, Rachel found a Victorian three-storey house slated for demolition in the East End. After long negotiations with the council, they secured a temporary lease on the site for the sculpture to be built, after which point it would be knocked down.[19] Rachel cast the interior of the house by spraying the inside with concrete, a physically strenuous task in a traditionally male domain, requiring a team of engineers and builders. The original façade was then knocked down. *House* was unveiled in October, a mute memorial to everyday lives, exposing the transience and banality of our existence. But Rachel was unprepared for the media bombshell that descended. 'Before that, I couldn't remember anything being so scandalous apart from Carl Andre's bricks....

I would say, <u>without wanting to sound too arrogant,</u> **it changed the face of something** in this country **to do with art** and I'm extremely proud of that.

RACHEL WHITEREAD

I just didn't know how to deal with it and really went into my shell a bit after that,' she says. 'Suddenly I was a spokesperson for a generation about housing and about politics and about sculpture and about the street and about poverty.'

*House* became the subject of debate on television, of newspaper leaders and columns; tens of thousands of people visited

RIGHT: Rachel Whiteread working on *House*, 1993. Photograph by Stephen White

OPPOSITE: Rachel Whiteread, *House*, 1993. Mixed media, dimensions variable

it and Parliament even passed a motion to extend its life. 'It just really got to people either in an emotive happy way or an emotive sentimental way or an emotive angry way,' explains Rachel. 'It's all to do with everybody's home being their castle. Builders would come and go, "My God, I could've fucking made that, who do you think you are?" and then other people were going, "God, this is the most amazing thing I've seen in my life", and crying.' She couldn't even get to know her own sculpture because of the hordes of people permanently thronging it. Occasionally she would drive up in disguise and observe it from behind a newspaper in her car. One night Rachel, her husband Marcus Taylor and his dealer Jay Jopling had been out drinking and visited *House*, only to find a bunch of graffiti artists poised with ladders and spray cans. 'I went, "Oh God, don't do that", and they said, "Who are you?...You can't tell us what we can and can't do,"' Rachel remembers. 'I said, "I'm the artist", and they went, "Are you? This is brilliant! Of course we won't do it."'

That was the <u>great thing</u> about the group that **the girls were very hard core**. Not just in partying and drinking but outspoken, opinionated, intelligent, interesting.

MAT COLLISHAW

In the middle of the furore, Rachel won the £20,000 Turner Prize but that same night she learnt that the council had voted to proceed with *House*'s demolition. From the start, the council's chairman Eric Flounders had branded the sculpture 'a monstrosity' and resolved to destroy it.[20] Compounding the stress of weeks in the media glare and uncertainty over *House*'s fate, a group called the K Foundation, set up by the founders of the mega pop band KLF, awarded Rachel £40,000 as worst artist of the year. She initially declined the award, but faced with threats of burning the money on the Tate steps, she accepted it and distributed it to impoverished artists and a homeless charity. 'I threw up and was ill, and it was just horrible, it wasn't a night of great joy,' she says. Whether or not the K Foundation's Jimmy Cauty and Bill Drummond intended their actions as Situationist interventions or were just bored, rich pranksters is unclear.[21] *House* was unceremoniously bulldozed in January 1994, evidence of Britain's cultural immaturity at that time. Despite its destruction, *House* undoubtedly awakened an appetite among the British public for an art that spoke to ordinary people in a novel way, beyond the Henry Moore bronzes that typified civic sculpture in Britain. 'I would say, without wanting to sound too

arrogant,' Rachel suggests, 'it changed the face of something in this country to do with art and I'm extremely proud of that.'

As women artists came to the fore, commentators fastened on their hard partying ways and the more feisty works. Sarah Lucas and Tracey Emin's daily lush performance at The Shop and Sam Taylor-Wood's *Fuck, Suck* T-shirt, as well as *Slut* (1993), a commissioned photo for *The Face* lifestyle magazine showing Sam with a necklace of love-bites, contributed to a certain ladette image. *Sunday Times* art critic Waldemar Januszczak described the women BritArtists as 'urban, cocky, female, fearless'.[22] 'That was the great thing about the group that the girls were very hard core. Not just in partying and drinking but outspoken, opinionated, intelligent, interesting,' says Mat Collishaw.

Yet the BritArt women were not one homogenous voice; their art ran the gamut of cheeky sculpture, vibrant painting, multi-sensory installation and immersive video. Within this period 1993 to 1994, the diversity of their art is striking. There were Sarah Lucas's

Sarah Lucas, *Au Naturel*, 1994. Mattress, melons, oranges, cucumber, bucket, 84 × 167.6 × 144.8 cm (33 1/8 × 66 × 57 in.)

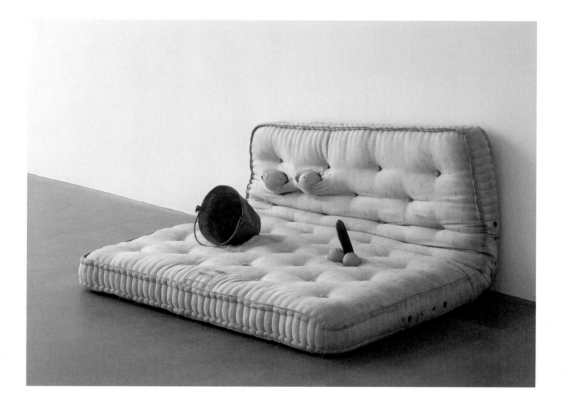

mordant gendered sculptures such as *Au Naturel* (1994), her witty arrangement of fruit and veg on a mattress evoking male and female genitalia, Rachel Whiteread's sculpture *House*, Angela Bulloch's drawing machines, Gillian Wearing's *Signs* and *Confessions*, and Christine Borland's collaborative work *From Life*. Abigail Lane made disconcerting installations, Georgina Starr constructed imaginative universes around her own experiences and Fiona Rae played out art-historical battles in her exuberant canvases.

Like Rachel, Anya Gallaccio was working with monumental scale and in 1994 staged her much-talked-about show 'Stroke' at Karsten Schubert, painting the gallery walls with chocolate. 'When it started to go mouldy...it looked quite depressing and quite dark and damp and it wasn't joyous in any way. It was repellent and slightly ugly,' says Goldsmiths painter Glenn Brown, who had a studio below Anya's in Shoreditch. Anya was experimenting with a bizarre range of organic materials at the time and late one night Glenn was alarmed to find blood dripping down onto his painting. 'I was like, "Oh my God...there's been a murder,"' he recalls. He rushed upstairs and fearfully opened Anya's studio door, only to discover she had gone away leaving behind huge vats of blood and some works made of glass panes sandwiched with the liquid that were leaking.

Such a scene was reminiscent of Jane and Louise Wilson's suspenseful videos from the time, set in marginalized spaces in which they played on stereotypical associations with twindom. Their 1995 video *Crawl Space*, for example, quoted horror classics such as Stanley Kubrik's *The Shining* and Brian de Palma's *Carrie* as the camera wound through the pulsating corridors and bleeding walls of a labyrinthine building amid slamming doors and ominous thuds. The identical twins compounded the spookiness: one giving birth to someone in a bubble from her mouth; the other revealing the film's title written in weals on her stomach. In *Hypnotic Suggestion 505* (1993) the sisters filmed themselves being hypnotized by a man in a subversion of clichéd male erotic twin fantasy. 'You've got to hand over control to this male voice momentarily...then the camera pans up and people are like, "Oh my God, they're going to be stripped naked", but no, we just wake up,' says Louise.

Sam Taylor-Wood too gained acclaim during this time for one of her most powerful video pieces, *Brontosaurus* (1995). The simple

Anya Gallaccio, *Stroke*,
1994. Dark chocolate,
cardboard, bench.
Installation view of
eponymous show at
Karsten Schubert

ABOVE: Jane and Louise
Wilson, *Hypnotic
Suggestion 505*, 1993.
Colour video with sound,
18 minutes, 8 seconds

OPPOSITE: Jane and
Louise Wilson, *Crawl
Space*, 1995. C-type print
mounted on aluminium,
with diasec, 195 × 195 cm
(76 ¾ × 76 ¾ in.)

Sam Taylor-Johnson, still
from *Brontosaurus*, 1995.
Video projection and
sound, DigiBeta Master,
10.01 minutes

work depicts a gaunt naked man in a sparse room convulsing wildly to techno music, but the video has been slowed down and the music replaced with Samuel Barber's *Adagio for Strings*. At a time when AIDS appeared as a scourge of the flesh and much literature focused on alienation in our secularized materialistic society, *Brontosaurus* seemed a eulogy to broken humanity. 'Now when I watch it, it's so much about frailty and vulnerability,' says Sam. 'At the time it was John and me laughing so much that I had to start again filming him, just in his bedroom.'

> We didn't have to be feminists....And that was a gift that we had been given by a generation of artists preceding us, feminist artists who had made works with sanitary towels and tampons and God knows what... so we could come along and we could do what we wanted.
>
> ANYA GALLACCIO

Most of the female artists in the BritArt generation did not overtly address gender in their work, perhaps sensing that the contested battleground had moved on since the 1970s when feminist artists like Catherine Elwes and Mary Kelly fought to recalibrate the chauvinistic discourse around art and particularly the representation of the female body.[23] Elwes spent three days in 1979 in a glass-fronted room menstruating and Kelly displayed her son's soiled nappy liners in her *Post-Partum Document* (1973–1976). None of the women artists in the 1990s broke ground in such radical and confrontational ways. 'I felt that me and my peers had the privilege of not being labelled as women artists,' says Anya. 'We didn't have to be feminists....And that was a gift that we had been given by a generation of artists preceding us, feminist artists who had made works with sanitary towels and tampons and God knows what...so we could come along and we could do what we wanted.'

As the media seized on the theme of 'girl power' in art, some men in the group like Damien Hirst and the Chapmans played up to the bad boy image of the artist. 'A lot of the identity that there was as a role model for British artists was actually a 1950s one of Francis Bacon, of the kind of unpredictable, mad, boozy genius,' says Adam Chodzko. Many of the YBAs would buy into this mythology and perpetuate it through their behaviour.

As the YBAs began consorting with rock stars and making headlines with their outrageous antics, it seemed appropriate that Angus Fairhurst should start his own concept band. Variously called Bandabandoned, Abandonabandon and Low Expectations, it had all the accoutrements of a rock band, but no one sang or played instruments: it was truly a band abandoned. Instead, they strutted and preened like rock stars to a playback track that Angus had built up from loops of music that never reached a resolution, but would simply shift to another loop, frustrating the audience's expectations. 'It was all posing, lots of sweat and hair flying around and recut looped music that went around and around, it's all circles really, quite a sculpture,' says Angela Bulloch. Pauline Daly, now a director at Sadie Coles's gallery, created the vibe with her legendary dance moves and long swishing hair. Jake Chapman and Goldsmiths graduates Philippe Bradshaw, Mat Collishaw and Gary Hume all performed at different points with the band, which even toured to Europe. Its biggest gig was supporting the Britpop band Pulp at the Brixton Academy in December 1995. 'It was totally brilliant,' recalls Gary. 'Backstage was utterly disgusting, you're hoping for some glamour…it just stank of piss…. We played…and it was absolute silence. Not one clap or anything…. And then we shuffled off and Jarvis [Cocker, Pulp lead singer]…said

Angus Fairhurst's concept rock band Low Expectations performing at 21 Dean Street, London, on 26 November 1996

he'd never seen anything like it in his life, to have absolutely no
response from the audience. Not even a boo. But we sounded good.
Angus made great music.'

The year 1995 saw several significant group shows including
'Minky Manky' and 'Brilliant!' that cemented the notion of BritArt as
a cultural phenomenon and the media image of the artists as rabble-
rousing rebels.[1] BritArt became identified with the 1990s indie music
genre Britpop: for the shared prefix, the perceived British working-
class focus of both BritArt and Britpop, and the fact the artists and
musicians often behaved badly together. The artists 'had that aura of
carefully styled rock and roll dishevelment. They were…becoming very
rapid superstars,' says the artist Grayson Perry, who emerged earlier
than the group but took longer to gain recognition. The label Young
British Artists began to stick, in tandem with a certain mythology
around the group. The YBAs monopolized the Turner Prize shortlist and
new artists came to the fore. The period culminated in the exhibition
'Sensation' (1997), the high-water mark of the movement.

## REBEL YELL

The Young British Artists were regularly touring abroad in different
group formations, thanks to heavy promotion by the British Council.
'It felt like we were like a rock band on the road. And we definitely
behaved like that too. I just look back and think, "God, how obnoxious
we all were,"' Sam Taylor-Wood remembers. The art scene by this
time had become enmeshed with fashion, music
and celebrity. Britpop was at its peak, with the
bands Pulp, Blur, Oasis and Suede vying for number
one in the charts, and many of the musicians were
friends with the artists. Lifestyle magazines like
*Face*, *I-D*, *GQ* and *Dazed and Confused* featured
regular splashes on them; they were wanted for
fashion shoots by *Harpers & Queen* and *Vogue*. Art
openings, events and dinners packed each week –
Fergus Henderson's restaurant St John, serving fare such as offal and
trotters, was a particular favourite. Nights often rolled into several-day
binges as people carried on the party at the Groucho private members'

> It felt like we were like
> **a rock band on the road.**
> And we definitely behaved
> like that too.
>
> SAM TAYLOR-JOHNSON

TOP: Rachel Whiteread with friends. Photograph by Johnnie Shand Kydd

ABOVE: L–R: Angus Fairhurst, Gary Hume, Michael Landy at a birthday party for Gary at his house. Photograph by Johnnie Shand Kydd

LEFT: Damien Hirst, Jane Wilson, Maia Norman and Louise Wilson at a fundraising party at the Serpentine Gallery, 28 June 1995. Photograph by Dafydd Jones

Tracey Emin, *Everyone
I Have Ever Slept With
1963–1995* (destroyed),
1995. Appliquéd tent,
mattress and light,
122 × 245 × 215 cm
(48 × 96 ½ × 84 ⅝ in.)

club, illicit Soho drinking dens, the Golden Heart pub in Spitalfields, where the landlady Sandra Esquilant would dance on tables and host lock-ins, or in artists' studios. 'It was crazy, it just went on and on every single night….I couldn't do the four-nighter which a lot of them did,' says photographer Johnnie Shand Kydd, Princess Diana's stepbrother. Bewitched by 'this great, great, great energy', he began photographing the group to record the moment.

> The tent was very clever.
> All the men that she's ever
> slept with would have to
> bow down to go into that tent.
>
> MATTHEW COLLINGS

'Minky Manky' at the South London Gallery marked the debut of Tracey Emin's tent *Everyone I Have Ever Slept With 1963–1995* (1995). The show, originally given the touchy-feely title 'Life Feelings', was intended as a personal attempt to map connections across the London art scene, says its curator Carl Freedman. Tracey, Carl's girlfriend at the time, was the least known among the exhibitors, who included the Goldsmiths crew Mat Collishaw, Damien Hirst, Gary Hume and Sarah Lucas, and the established older artists Gilbert & George.[2] According to Tracey, Carl initially said her work was too small-scale for the show and she was devastated, but he relented on condition she conceive a piece that would stand on its own. 'Carl is the most instrumental person in my career, just phenomenal….Carl just always made me think bigger,' she says. Tracey came up with a genuine camping tent, painstakingly sewn inside with personal stories and the names of everyone she had ever shared a bed with: lovers, friends, drinking buddies, her twin brother and two aborted fetuses. 'The tent was very clever,' says Matthew Collings. 'All the men that she's ever slept with would have to bow down to go into that tent. I think it's an unconscious thing…but it's a very profound effect that the work has.' People were supposed to lie inside the womb-like space, savouring the voyeuristic intimacy of Tracey's memories mingled with their own private associations. However, many interpreted it as an exhibitionist exposé of her love life. 'Almost from the outset it was sensationalized, written about wrongly by the journalists,' says Carl.

Sarah Lucas exhibited *One Armed Bandits (Mae West)* (1995), comprising a chair 'wearing' a white vest with a plaster arm masturbating a phallic candle next to a toilet with a fag end in the bowl, in a summation of yobbish masculinity. Considered godfathers

to the group with their revelling in abjection and self-absorption, Gilbert & George showed their 1974 photo montage *Human Bondage*, in which they sprawl drunk on the floor among cigarette butts and overturned glasses. '…There's a lurking suspicion that art-making is masturbation among the artists here,' the critic Adrian Searle wrote in the *Independent*, highlighting the show's 'solipsistic tone'.[3]

To the dismay of some, the group found themselves being exported as punkish young art entrepreneurs by the British Council, which sponsored shows of the group in America, Europe, Australia and Japan.[4] 'There was a mismatch between how the work was packaged as a Cool Britannia embodiment of all things British and the actual integrity of the work, which seemed to be more disdainful of the idea of Britishness,' says Jake Chapman. 'Even down to when you say British, is it monarchic? Well it was anarchic, not monarchic.'

The stereotyping of the BritArtists would reach its zenith in October 1995 with the exhibition 'Brilliant! New Art from London' at the Walker Art Center in Minneapolis, featuring twenty-two British artists,

although those from Scotland were glaringly absent. In a misjudged attempt at wit, the catalogue cover reproduced the debris-strewn scene of the IRA's deadly 1992 bombing of London's Baltic Exchange with 'BRILLIANT!' stamped across it, drawing an implied parallel with the supposed explosiveness of the new art. 'Walker Welcomes Brash Brits for Flashy Bash', a press release announced and, 'Witness work by a new generation of artists from the land that brought you Sid and Nancy, Chuck and Di, fish and chips, Hugh Grant and Cats.'[5] 'What was being marketed with "Brilliant!" was this punk sensibility and these cheeky chappie Brits', recalls the artist Adam Chodzko. Dinos Chapman remembers people in beefeater outfits saying 'Mind the Gap' in pseudo cockney accents. Middle America seemed like another planet, and many artists felt alienated by the culture clash.

The embarrassing cultural clichés and hipster tone of the catalogue unfortunately upstaged the diversity of offerings. The line-up included big players like Damien Hirst and Rachel Whiteread and less high-profile artists such as Adam Chodzko, Anya Gallaccio, Georgina Starr and Gillian Wearing. Glenn Brown, a second-wave Goldsmiths graduate, showed his flattened versions of thick impasto paintings by Frank Auerbach and Karel Appel, which were intended both as homage and an act of aggression towards the originals. While doing his MA at Goldsmiths, Glenn had developed his distinctive style of copying renowned portraits from bad reproductions; by emptying out their expressive content, he caught the loss in the transition from easel to print and debased the painter's heroic status. In the wake of the German Neo-Expressionists like Georg Baselitz, 'gesture seemed hackneyed...and impossible to use anymore,' Glenn explains. 'So I was trying to figure out whether the brushstroke could be reinvigorated in any way. And I thought the best way of reinvigorating...the expressive gesture was to first make sure it was thoroughly dead. And then rebuild it.' At Goldsmiths figurative painters such as Auerbach and Francis Bacon were deeply unfashionable, hence the attraction of Glenn to the former and Damien to the latter. It was 'part of the game. That you have to make an original statement for anyone to pay attention,' Glenn says. Later, a tough tutorial with

ABOVE: Glenn Brown. Photograph by Gautier Deblonde

OPPOSITE: Installation view of 'Brilliant! New Art from London', 1995–1996. In the background: Liam Gillick and Henry Bond's desk installation with *Documents*, Glenn Brown's paintings on far wall, Rachel Whiteread's mattresses, and Gillian Wearing's *Signs* on the right wall

ABOVE: Glenn Brown,
*The Day The World*
*Turned Auerbach*, 1991.
Oil on canvas, 56 × 51 cm
(22 × 20 in.)

OPPOSITE: Glenn Brown,
*Dali-Christ (after 'Soft*
*Construction with Boiled*
*Beans: Premonition of*
*Civil War' 1936 by Salvador*
*Dali)*, 1992. By kind
permission of the Gala-
Salvador Dalí Foundation,
Spain. Oil on canvas,
274 × 183 cm
(108 $\frac{3}{16}$ × 72 in.)

Michael Craig-Martin encouraged him to be more extreme and Glenn tackled the hallucinatory work of Salvador Dalí and science fiction illustrators. 'They're both trying to make almost photographically hyper-detailed paintings, but in a place that doesn't actually exist.... And I thought, "Well that's more interesting. I'm redescribing somebody else's imagination."'

Of Nigerian heritage, British-born Chris Ofili, a graduate of Chelsea and the Royal College of Art, was a new addition to the group, presenting vibrant canvases that referenced black culture and racial stereotypes. Following a British Council-sponsored residency in Zimbabwe in 1992, Chris had incorporated lacquered elephant dung in his paintings, disrupting their decorative beauty – taboo in the Postmodern 1990s – with earthiness and reality.

Among other highlights was Michael Landy's powerful installation *Scrapheap Services* (1995), a room-size representation of a fictitious Orwellian company that disposed of superfluous people in society. Comprising dustbins, a corporate video, posters, a disposal machine and mannequins sweeping up thousands of miniature cut-outs of people, the work took two and a half years to make. 'I used to go and raid McDonald's late at night and tin banks at Sainsbury's,' says the artist, who, according to his then girlfriend Abigail Lane, would stink from the rubbish he constantly stuffed in his pockets to be transformed into tiny figures. The piece reflects Michael's trauma over his father's consignment to the refuse heap following an industrial accident and his anger at the dehumanizing capitalist culture embraced by Margaret Thatcher, with its erosion of the Welfare State. 'I've always been interested in the value our society gives to things, whether that's a weed or a person or a bread tray,' says Michael.

ABOVE: Michael Landy working on *Scrapheap Services*, Clapham Common studio, c. 1994. Photograph by Abigail Lane

OPPOSITE: Michael Landy, *Scrapheap Services*, 1995. Installation view from 'Brilliant!' at the Soap Factory, Minneapolis. Mixed media

Tracey Emin found 'Brilliant!' 'just vile in every way'. 'Minni-fuckinghellholeshittingapolis,' she grimaces. The group had no daily allowance, and a transport strike meant they either had to walk miles from the hotel to the museum in freezing temperatures or take a sightseeing bus around the city to install their show. Moreover, the minibars in their hotel had been cleared out, their reputations

preceding them. And they lived up to those reputations. Liam Gillick remembers one occasion with a free bar when the bar staff walked off in disgust, prompting the artists to climb over the bar and help themselves to drinks.

'Everyone was badly behaved,' Michael recalls. 'I think Richard [Flood, the curator] found trying to hang everybody in this space together was a bit like herding cats…"Her video's too loud. You can't see this,"' says Glenn Brown. 'I had a wall which was painted bright green to hang my paintings on, which made all the other work nearby it look pretty awful and led to animosity.' Tracey was furious to discover she had been allocated a noisy spot for her tent and decided to withdraw it from the show. 'So I started taking it down the escalators and got told that I wasn't allowed to take it off the premises, and I said, "Oh yes I can because it's mine and I brought it here by plane,"' she says. Eventually the tent was rehoused in another part of the museum. 'I was told by the curator that with my attitude I would never show in an American museum again,' Tracey remarks. 'I think…the idea that the work itself was inherently shocking, or that this was the exciting stuff coming out of Britain, overshadowed the possibility of really being able to figure out what might have been at its core, what really did connect the artists, which actually is quite a difficult, nebulous thing to figure out,' says Adam Chodzko.

## WHO ARE THE YBAS?

The vexed issue of what connected the BritArtists has never been resolved for want of a simple answer. While common threads exist in their art, such as black humour, focus on the self or emphasis on death and decay, there was no overriding style. The artists certainly didn't consider themselves as a movement and had no manifesto or shared philosophy; yet they were undeniably a phenomenon. They emerged around the same time, many from the same college, socialized, lived and worked together, and absorbed the same cultural influences.

Inevitably, given their sheer number and the media and curatorial attention they received, it was only a matter of time before they earned a label. The American critic Michael Corris first discussed the 'young British artists' in a 1992 article in *Artforum*, whose glib,

vernacular style rooted the group within the sociopolitical context of British culture and set the tone for much subsequent literature on them.[6] The writer Simon Ford is credited with coining the abbreviation YBA from the title of Saatchi's Young British Artist shows in his 1996 article 'Myth making' in *Art Monthly,* dissecting the mythology that had grown up around the group.[7] Ford rightly pointed out that the emphasis on the anti-authority nature of the group was at odds with the fact the YBAs were funded by state grants and rapidly embraced by the establishment with exhibitions and prizes. However, what is not a myth is that these artists did effect a sea change in British culture and put emerging British artists on the international map.

> [The label YBA] is so <u>threadbare in terms of description</u>....It's like hands up everyone who's got a British passport.
>
> JAKE CHAPMAN

The moniker YBA quickly caught on and became a convenient journalistic tag for the group. 'The first time I heard the term YBA, I thought, "This is a disaster,"' says Carl Freedman. 'People went along with it because it was just naming it. Now it's defining.' Ask any of the group if they view themselves as YBAs or like the label, most will answer in the negative. It 'grates' on Sarah Lucas, although she now finds it comical given their age; Damien Hirst hates it; for Jane and

Angus Fairhust and Angela Bulloch celebrating Mat Collishaw's birthday without him, 1997. Photograph by Sarah Lucas

Louise Wilson, it's 'soundbitey'; Ian Davenport thinks it's 'daft'. 'I don't think anyone particularly likes being labelled, especially labelled to do with where you're from, and your age….But then, in hindsight, I think those were the only things that linked our work, because the work was so disparate,' says Sam Taylor-Wood. 'It's disappointing that it has an age-related and nationalistic element,' Dinos Chapman says. His brother Jake agrees: 'It's so threadbare in terms of description of actually what those people are. It's like hands up everyone who's got a British passport.' On the positive side, Angela Bulloch admits she would rather be included than left out and Gary Hume recognizes that the label afforded the artists greater visibility. All these artists have now forged individual careers, some having shifted direction, which partly accounts for their desire to distance themselves from their immature years. 'But you can't separate them from that,' says David Thorp, former South London Gallery director. 'It's part of their development. And there was a group. And at its core, it was cohesive. And it was a phenomenon, and it had a momentum.'

> And there was a group.
> And at its core, it was cohesive.
> And **it was a phenomenon,**
> and it had a momentum.
>
> DAVID THORP

Throughout history critics have assigned labels to artists' groups, such as the Fauves and Cubists (although those had a common aesthetic), and the artists have often resisted them. But likewise, the sobriquet YBA offered a useful umbrella under which to talk about a group of artists who changed the rules for practising, showing, selling and promoting art in the UK.

Between 'Brilliant!' and 'Sensation' a profusion of shows took place, of which it would be impossible and pointless to detail every one. A few snapshots of artists and events offer a flavour of the time.

After a difficult couple of years experimenting in his Hoxton Square studio, Gary Hume had resurfaced on Jay Jopling's roster, with a solo show at White Cube as well as 'Minky Manky'. His new figurative paintings presented ambiguous narratives, dissolving depth of field with planes of bold colour that verged on abstraction. *Four Feet in the Garden* (1995), for instance, at first glance resembles two misshapen profiles or a Rorschach blot until one's eyes settle onto the four pairs of naked feet pressed sensuously together on the inky ground. Gary has often been quoted as saying, 'With me, surface is all you get', but he clarifies this as 'a shorthand to saying the object

Gary Hume in his studio.
Photograph by Fiona Rae

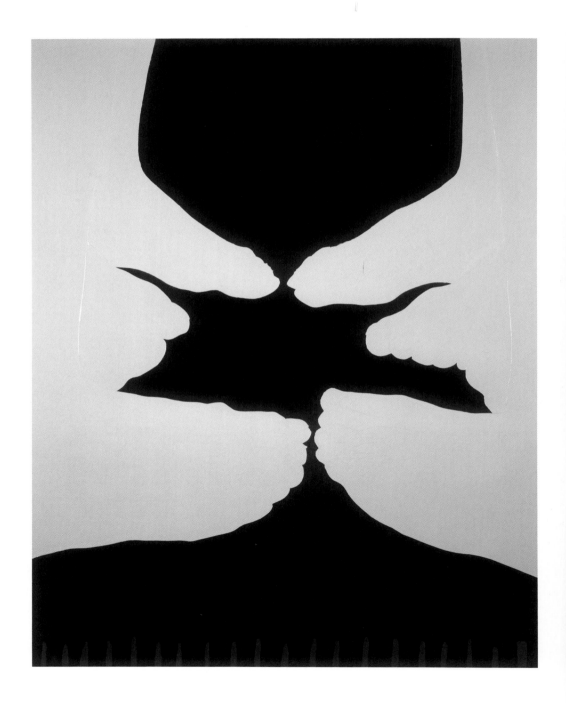

tells the story, not me'. Rather than any linear narrative, 'it's about… taking some time and arriving intact in front of an object and then, by looking at it, you become no longer intact. And in that process of dismembering, you think and feel about things. And when you stop looking at it…you've had an experience.'

Richard Patterson, by then going out with Fiona Rae, had the studio next to Gary's, and was alternately inspired and intimidated by their success. 'I felt like this complete nothing…but it also gave me this energy that I really had to act on…to prove that I could come through,' he says. Around this time Richard, who stopped painting after Goldsmiths, came in from the wilderness with a series of hip, zeitgeisty canvases of life-size toys and 1960s Californian nostalgia. It had been a long, frustrating struggle. Knowing Richard's obsession with motorbikes, Fiona had bought him a cheap plastic toy motocrosser in Day-Glo colours. One day he slathered paint on it to disguise the ugly parts and it metamorphosed into something 'really interesting…like an exotic bird'. He photographed it, scaled it up to a large size, and then painted the photo of his daubed toy, capturing the blurred photographic effects of the surrounding space and light. From the size and context it wasn't clear whether the figure was real or imaginary, human or toy. 'When I try and invent something completely, I feel like I'm not being interesting at all,' says Richard, 'whereas if I'm translating and transforming and transgressing, that's when it becomes more interesting.'

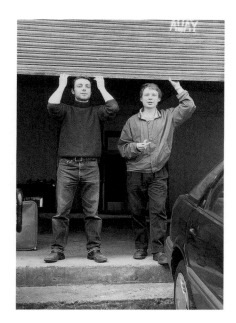

ABOVE: Richard and Simon Patterson at Richard's Hoxton Square studio, 1993. Photograph by Fiona Rae

OPPOSITE: Gary Hume, *Four Feet in the Garden*, 1995. Gloss paint on aluminium panel, 221 × 170.9 cm ( 87 × 67 ⁵⁄₁₆ in.)

Richard played with this juxtaposition between the real world and abstraction in different ways. His *Culture Station no.1, Zipper* (1995), for instance, incorporated a photorealist image of a 1960s magazine advert showing two men and women in swimwear with shiny motorbikes within a Mondrian-esque abstract composition. For a white, heterosexual male painter in the 1990s, the subject was problematic in its objectification of pretty girls and backward-looking nostalgia. At Goldsmiths there was a group of feminists, 'a kind of militia that would come into your studio…and accuse you of painting

ABOVE: Richard Patterson, *Culture Station no.1, Zipper*, 1995. Oil on canvas and acrylic on canvas (seven panels), overall 213.4 × 459.7 cm (84 × 181 in.)

OPPOSITE, ABOVE: Richard Patterson in white leather biker suit, 1996. Photograph by Johnnie Shand Kydd

OPPOSITE, BELOW: Richard Patterson on his bike in front of his painting *MOTOCROSSER II* in his studio, 1995. Photograph by Fiona Rae

in a male-dominating way...you had to be answerable for why you were doing this,' he recalls. Richard wondered, 'Am I allowed to paint a woman at all? Especially a woman in a bikini?' But he went ahead, depicting the group in swimsuits, yet the image is neutralized as just one of seven geometric monochrome panels in a 4.5-metre (15-foot) work. 'Right from the beginning I'd decided it was going to be part of a multi-panelled painting. Its original title was *Green Monochrome*. I saw it as an abstract painting,' explains Richard. Sadie Coles, who

then worked at Anthony d'Offay, saw these paintings and offered Richard a show in 1995 in the gallery's project space coinciding with a Gerhard Richter exhibition in the main gallery. 'That was probably the greatest moment of my life, really, because it was such an amazing affirmation and also a huge relief to finally get to show after all that time,' he says. Suddenly he was the toast of the town with mega-gallerists such as Larry Gagosian calling him up and Saatchi in hot pursuit. In a tongue-in-cheek nod to his new public status as an artist, he bought a motorbike and a bespoke white leather suit with his name emblazoned on it in which he would ride around town looking like the American stuntman Evel Knievel.

Also in 1995, Abigail Lane had an exhibition at the ICA, 'Skin of the Teeth', which extended her interest in the physical traces left by humans. She decorated the period gallery's walls with attractive red patterning, which on closer inspection turned out to be bloody handprints of a murder victim reproduced from forensic photographs of a police investigation. The wallpaper originated from Abigail's musings about the literal ways in which people leave their mark, from the angst-ridden gesturing of an artist like Jackson Pollock to a murder victim's handprints. 'So an artist might thrash his paint onto the canvas..., but then you can also get handprints falling down a wall, which by now are a very considered silkscreen of something that was incredibly emotional at the time.' Complementing the wallpaper, unsettling scratching noises emanated from behind a door and red casts of head and body parts dangled from the ceiling: *American*

ABOVE: Abigail Lane preparing a red ink pad

OPPOSITE: Abigail Lane, *Bloody Wallpaper with Concrete Dog and Ink Pad (red)*, 1995. Ink on lining paper, each roll 56 cm × 10 m (22 in. × 33 ft). Exhibition view of 'Skin of the Teeth', ICA, London, 1995

*Psycho* meets Habitat. Described by one reviewer as a 'maddeningly ironic exhibition', Abigail's show combined humour and disquiet, not least at the apparently blithe use of murder documentation as interior decoration.[8] This tone of wry detachment, equally found in Mat Collishaw's disturbing photographs and Damien Hirst's pickled animals, embodied a 1990s cool that seemed to reflect a cynical age.

A similarly provocative attitude was apparent in Saatchi's Young British Artists IV show that year, including Goldsmiths graduate Marcus Harvey and Gavin Turk. Saatchi exhibited Marcus's 'porn paintings' edged with white to mimic Polaroid snaps from the 'readers' wives' section of porn magazines. These explicit paintings of close-up views of crotches and splayed buttocks, with titles such as *Doggy* and *Golden Showers*, unapologetically embraced the notion of the painter as voyeur and sexual predator, tracing a long line of male artists such as Pierre-Auguste Renoir and Auguste Rodin who felt their creativity was inextricably tied to their virility.[9] Where many male contemporaries steered clear of depicting the female body after feminist protests, Marcus revelled in the taboo, using his fingers to create a colourful impasto surface in an orgiastic celebration of the sensuality of the material and subject matter.

Over this often abstract background of vigorous markings he outlined the forms and defined the genitalia in thin black lines. The paintings played with the tensions between photography and painting, public and private domains, high art and hard-core porn. 'I never tasked myself to become conclusive about those arguments. Just to toss them into a bath of paint with myself, my gloves and have some fun,' Marcus says.

Equally eye-catching were Gavin Turk's works addressing celebrity and the role of the artist. In *Identity Crisis* (1994) he presented an advert for a *Hello* magazine cover adorned with himself and his family 'relaxing at home': the pinnacle of celebrity achievement. His waxwork *Pop* (1993) showed himself dressed as Sid Vicious in the guise of a gun-toting Elvis from an Andy Warhol silkscreen. Gavin's use of these dead pop giants of music and art underscored the

ABOVE: Marcus Harvey. Photograph by Johnnie Shand Kydd

OPPOSITE: Marcus Harvey, *Julie from Hull*, 1994. Oil and acrylic on canvas, 2.43 × 2.43 m (8 × 8 ft)

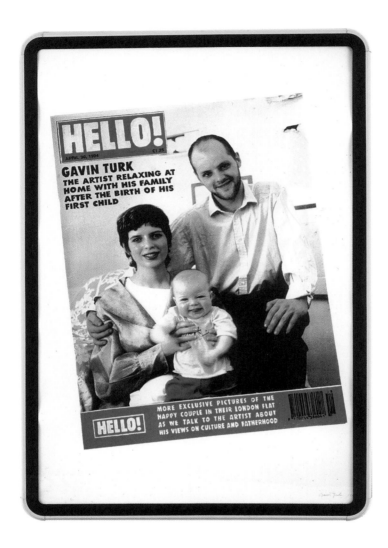

ABOVE: Gavin Turk,
*Identity Crisis*, 1994.
Silkscreen ink on paper
in light box, 172 × 112 cm
(67 ¾ × 44 ⅛ in.)

OPPOSITE: Gavin Turk, *Pop*,
1993. Waxwork in vitrine,
279 × 115 × 115 cm
(109 ⅞ × 45 ¼ × 45 ¼ in.)

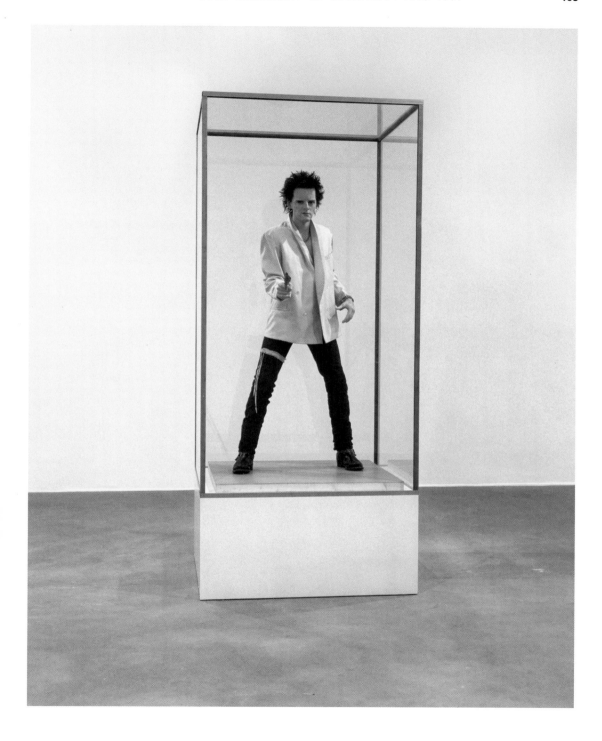

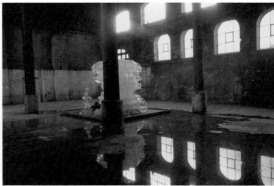

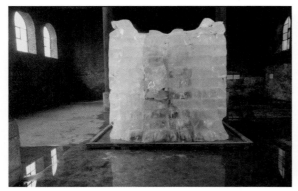

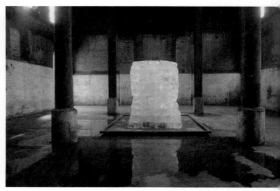

Anya Gallaccio, *Intensities
and Surfaces*, 1996.
Rock salt, 32 tonnes
ice, 300 × 400 × 400 cm
(118 × 157 ½ × 157 ½ in.).
Installation view, Wapping
Pumping Station, London
(Women's Playhouse Trust)

ephemerality of fame and questioned the authenticity of the artist's persona. Snarling Sid's radicalism was reduced to a mere pose, borrowed from another pop icon and commoditized. Since college, Gavin had been preoccupied by the creation of icons and artist brands. 'There's been an element in my work,' says Gavin, 'where I've focused hard on the way that celebrity or fame...can actually...stop people from knowing. It can mask, it can make myths.'

Among other noteworthy events as 1995 ended, Tracey opened her Tracey Emin Museum on Waterloo Road, London, and Damien Hirst won the Turner Prize on his second nomination, beating Mona Hatoum, Callum Innes and Mark Wallinger. Later that night Damien put his £25,000 cheque behind the bar at the Groucho and forgot about it, waking in a panic the next day wondering what had happened to the prize money. It turned out the whole lot had been drunk by him and his friends. For the next two years Damien would disappear into a vortex of drink and drugs with his friend, the actor Keith Allen.[10]

With ox-like constitutions, they pulled through, but others did not. Joshua Compston was found dead in March 1996, at the age of just twenty-five, after inhaling ether. It's unclear whether his death was accidental. Friends say he was depressed by his dire finances and struggle to keep his gallery Factual Nonsense afloat.[11] Gary Hume and Gavin Turk designed a William Morris-inspired coffin and hundreds, including local residents Gilbert & George, thronged to pay their respects. Joshua's coffin was borne through the East End in a spectacle reminiscent of the 1995 funeral of the gangster Ronnie Kray.

The year 1996 would bring upheaval for the gallerist Karsten Schubert. Mat Collishaw, Angus Fairhurst, Gary Hume and Michael Landy had already jumped ship. Anya Gallaccio clung on at the gallery until just after her 1996 exhibition at Wapping Pumping Station, showing a 32-tonne block of ice to wide acclaim. The colossal translucent block, at whose centre gnawed a lump of salt, presented a Minimalist meditation on beauty and transience. 'It was the most ambitious thing I'd ever done in terms of scale and impact, and I felt somehow, naively, that everything was going to change from that point on...that all these different opportunities were going to come flooding in. And they didn't,' says Anya. She felt she represented a 'party trick' for Schubert, whereas his focus was on his top seller (also her friend) Rachel Whiteread, whose international stature had just kept growing

since he took her on in 1989. Schubert admits, 'She arrived and it was like a takeover. And it was very demanding...it became a big one-ring circus.' To Anya it seemed her gallerist was doing nothing to persuade museums to invest in her ephemeral art, despite the precedents offered by the 1960s. 'I felt that I was providing Karsten with a lot of

publicity or a certain type of cultural capital because he appeared to be...showing something that was unsaleable. But I just felt like he wasn't taking me seriously.' Anya made her exit amid acrimony.

Rachel Whiteread would defect to Anthony d'Offay that same year, frustrated at Karsten Schubert's inability to resolve political wrangling over a highly charged Holocaust memorial project in Vienna that she had been awarded in 1995. Her departure marked the final nail in the coffin for Schubert's gallery, which closed in 1997 with debts of £500,000, according to his backer

Richard Salmon.[12] Angus Fairhurst has described the German dealer as 'the wrong man at the right time'.[13] The writer Gordon Burn attributed Schubert's failure to retain his artists in part to his inability to keep up in the partying stakes, unlike Sadie Coles and Jay Jopling: 'he found himself temperamentally unsuited to dealing with the drinking and drugging habits, the mental-as-anything, round-the-clock caning it, no-limits way of living of the brashest and best of the farkin young farkin British farkin artists.'[14] But the real problem was probably Schubert's innate aversion to the vulgar activity of commerce, according to Glenn Brown, who was at the gallery for three years: 'If any collector used to come in that he thought would actually buy something, he'd run away...because it was embarrassing.'

The darker side of drinking was palpable in one newcomer's art. Richard Billingham made his debut in 1994 in a photography exhibition at the Barbican with his unflinching portraits of his alcoholic father Ray, obese tattooed mother Liz and drifter brother Jason going about their lives in a Midlands tower block. In 1996 these were published as a book, *Ray's a Laugh*, which led to a string of exhibitions. The intimate images capture an inebriated Ray falling, slumped by the toilet, eating TV dinner with Liz and fighting with her, with their son Jason making

ABOVE: Richard Billingham. Photograph by Johnnie Shand Kydd

OPPOSITE: Richard Billingham, *Untitled (RAL 28)*, 1994. Colour photograph mounted on aluminium, 105 × 158 cm (41 ⁵⁄₁₆ × 62 ³⁄₁₆ in.). Edition of 5 + 1 AP

ABOVE: Richard Billingham, *Untitled (RAL 25)*, 1994. Colour photograph mounted on aluminium, 80 × 120 cm (31 ½ × 47 ¼ in.). Edition of 5 + 1 AP

OPPOSITE: Richard Billingham, *Untitled (RAL 20)*, 1994. Colour photograph mounted on aluminium, 120 × 80 cm (47 ¼ × 31 ½ in.). Edition of 5 + 1 AP

occasional cameo appearances. 'I think the strength of the work was in its innocence,' Richard says. His is a poignant tale of financial hardship and parental neglect. After losing his job in 1980, his father Ray resigned himself to life on the dole, got swindled out of his home by a local conman and moved the family into a council flat. Aided by a neighbour's toxic homebrew, Ray's drinking spiralled out of control; Jason was taken into foster care and Liz moved out, leaving 18-year-old Richard in charge of his father.

On his art foundation course, Richard began taking snaps of Ray as studies for paintings. 'I thought I'd like to make some paintings about the tragedy of Ray's situation. I realize now I was probably trying to objectify a surreal situation,' he says. Richard used the few objects in Ray's sparse room, such as the electric fire, the mirror, the ashtray, to make little allegories about his condition. The brutal yet tender studies of Ray broadened to include Liz and Jason when they moved back in. 'The composition comes from painting... you can't situate them with other photographs,' says Richard. A tutor at Sunderland University, the only institution to accept Richard after sixteen applications, spotted the vitality of his photos and brought him to the attention of art world contacts in London. The gallerist Anthony Reynolds took him on and Saatchi bought up his work in bulk, enabling him to leave a miserable job stacking shelves at Kwik Save.

Artists at 'Full House' exhibition, Kunstmuseum Wolfsburg, Germany, 1996–1997. L–R: Sam Taylor-Johnson, Abigail Lane, Gillian Wearing, David Falconer, Angela Bulloch, Georgina Starr, Louise Wilson, Sarah Lucas

Richard would take part in two major survey shows at the end of
1996 rounding up the BritArtists: 'Life/Live' in Paris and 'Full House'
in Wolfsburg, Germany.

Also in 1996, Douglas Gordon, Craigie Horsfield, Gary
Hume and Simon Patterson were nominated for the Turner Prize,
a list that drew fire for the absence of women. Simon exhibited sails
bearing names of celebrated authors in recognition that the show
was a race, together with *First Circle* (1996), a gigantic solar-system-
like wall diagram mapping different names for Shangri-La against
a rainbow backdrop, whose title recalls Dante's circles of Hell.
Gary was the favourite in a clear validation of his shift from doors to
figurative paintings, but lost to Douglas. The Scottish artist exhibited
*Confessions of a Justified Sinner* (1995), compiled of looped slow-
motion clips of an early film of Robert Louis Stevenson's *Strange Case
of Dr Jekyll and Mr Hyde*, deconstructing the moment of transformation
from man to monster. The theme of duality underlies Douglas's work,

Simon Patterson, 1996
Turner Prize installation
view (detail). Foreground:
*Untitled (Sails)*, 1996.
Three parts: Dacron, steel,
aluminium and mixed
media, each 550 × 400 ×
200 cm (216 ½ × 157 ½
× 78 ¾ in.). Background:
*First Circle*, 1996. Wall
drawing, 548 × 1,800 cm
(215 ¾ × 708 ⅝ in.)

ABOVE: Douglas Gordon, *Confessions of a Justified Sinner*, 1995. Video installation without sound, dimensions variable. Installation view, Eye Film Institute, Amsterdam, 2012

OPPOSITE: Douglas Gordon, *Between Darkness and Light (After William Blake)*, 1997. Video installation with sound, dimensions variable. Installation view, ACCA, Melbourne, 2014

which often contains a moral dimension as well, informed by his upbringing as a Jehovah's Witness. Douglas and his siblings trawled from door to door, preaching to anyone who would listen. 'They're not happy memories. But it did toughen me up pretty much,' he says. 'When I used to knock on the door and ask, "Do you believe in God, do you read the Bible?" it's basically the same thing I'm doing now.'

Douglas's work asks questions about existence, framed in a dramatic way, the result of a diet of apocalyptic images from religious magazines like *The Watchtower*. That influence is manifest in his work *Between Darkness and Light (After William Blake)* (1997), in which two Hollywood films dealing with the absolutes of good and evil are superimposed: Henry King's *Song of Bernadette* (about St Bernadette's holy visions) and William Friedkin's *The Exorcist* (about a girl possessed). Saintliness is pitted against the devil, yet the overlap highlights more similarities than differences between the protagonists.

Douglas's win marked the first Turner award for video and an important boost for Scottish contemporary art in the face of its rejection at home. 'To get a prize there did mean quite a lot actually. It's not very cool to say that, but it's true. And it made an enormous difference to my career,' says Douglas. The *Daily Telegraph* critic Richard Dorment wrote, 'It is symptomatic of the way British art is changing that Douglas Gordon, the winner, makes dramatic video installations which draw on film, literature and psychology....I don't see how a painter stood a chance.'[15]

Nevertheless, painting appeared in rude health. In 1996 the Museum of Modern Art in Oxford staged the touring exhibition 'About Vision: New British Painting in the 1990s', featuring among others Glenn Brown, Ian Davenport, Peter Doig, Marcus Harvey, Gary Hume, Chris Ofili, Richard Patterson and Fiona Rae. Heading into 1997, Gary and Fiona had a joint show at Saatchi's Boundary Road gallery.

As Karsten Schubert closed, Sadie Coles launched her own gallery in 1997. Her second show was a double bill of Sarah Lucas, at the gallery and off-site. Sarah, who had been avidly pursued by Jay Jopling but wanted a 'less pushy' model of representation, had tried to convince Coles to be her agent exclusively. 'It wasn't a secret that

while I was stuffing them I just stuck them on a chair so I could have a look at them...and just thought, 'Fucking hell, look at that.' **It was one of those eureka moments.**

SARAH LUCAS

I would rather have worked just with her…but then again, that was sort of naive of me,' says Sarah. As Sarah was hanging the off-site show, 'The Law', she fished out a pair of stuffed tights from an aborted effort at making a tortoise and a hare. '…while I was stuffing them I just stuck them on a chair so I could have a look at them and adjust the wire… and just thought, "Fucking hell, look at that,"' she recalls. 'It was one of those eureka moments. I phoned Sadie and said, "You've got to come and see this."' So her trademark 'bunnies' were born, becoming a core motif of her practice and a springboard for other works. For her show at Sadie Coles's gallery, 'Bunny Gets Snookered', Sarah arranged eight bunnies on and around a snooker table in tights the colour of snooker balls. With their splayed stockinged legs and ears with no heads, these louchely sagging forms, clamped to office chairs, are reminiscent of submissive secretaries resigned to being taken

Installation view of
Sarah Lucas, 'Bunny Gets
Snookered', Sadie Coles
HQ, London, 1997

advantage of by leering bosses. The antithesis of Sarah's butch self-portraits, these hyper-feminine, tactile forms, like her other work, touch on gender stereotypes, but Sarah resists specific interpretations of her work. 'People always talk about things the way it's easy to talk about them,' she says. 'It's that other bit that you can't say anything about that is…actually making a real response.'

Issues of gender and 'girl power' were in the air. The female pop band the Spice Girls had burst onto the scene with their infuriatingly catchy debut hit single 'Wannabe'. Rachel Whiteread had been invited to represent Britain at the 1997 Venice Biennale, where Sam Taylor-Wood was awarded a prize for most promising young artist. Britain had regained its confidence: besides music and art, Paris fashion houses were snapping up British designers such as Alexander McQueen and John Galliano, and British chefs like Marco Pierre White were winning accolades for the first time. Newspapers and magazines proclaimed London to be 'the coolest city on the planet';[16] 'Cool Britannia' became a catchphrase for the 1990s renaissance in the way that 'Swinging London' had been in the 1960s. The summer of 1997 saw the momentous victory of New Labour at the polls, ending eighteen years of Tory government and ushering in a brief period of wide-eyed optimism with the young, charismatic Tony Blair as Prime Minister. Basking in the 'Cool Britannia' glow, Blair threw a party at Downing Street to which British designers, novelists, actors and pop stars were invited. Such clear establishment backing would ring the death knell for the 'Cool Britannia' concept. In the late summer, Princess Diana was killed in a car crash in Paris, prompting an unprecedented outpouring of grief by the traditionally reserved nation. This event illustrated a newfound emotional release and the growing impact of celebrity culture in Britain.

### 'SENSATION' BY NAME…

Two weeks after Diana's funeral, the Royal Academy's show, 'Sensation', would thrust BritArt into the public consciousness and mark its transition into the mainstream. The show came about by chance when an Old Masters exhibition fell through and a replacement was needed quickly.[17] Charles Saatchi, a long-time friend of Royal

Academy exhibitions secretary Norman Rosenthal, stepped into the breach. Rosenthal, Saatchi, Michael Craig-Martin and Damien Hirst sat down together and went through Saatchi's inventory to decide on exhibitors. 'A name was released a day. It didn't start off "this is the group",' says Johnnie Shand Kydd, whom Saatchi commissioned to take photos of the participants for the catalogue. 'Why I think it got a little bit woolly at the end of "Sensation" is because I think he [Saatchi] was beginning to put in things he felt he should put in rather than what he wanted to put in.' Early on, Fiona Rae was shown a list of proposed artists and found it lacking in women, a deficiency that was somewhat redressed by the final show, which included eleven women out of a total of forty-four artists. Having never collected their work before, Saatchi at the last minute purchased a costermonger stall by Michael Landy and Gillian Wearing's video *10–16*, which would help to win her the 1997 Turner Prize. He also bought Tracey Emin's tent on the secondary market, since the artist – 'a raving Marxist' when Carl Freedman met her – had long refused to sell anything to the man whose company's adverts helped keep the Tories in power for years.[18]

A riot of wit, irony and provocation, the exhibition gathered together many of the iconic artworks of the decade that were familiar to the art world but not to the wider public. Richard Billingham's *Ray's a Laugh* (1994–1995) photo series and Adam Chodzko's *God Look-Alike Contest* (1992) featured alongside better-known pieces like Marc Quinn's blood head, Damien's shark, pickled animals, and spot and spin paintings, and the Chapmans' mutilated mannequins. Mark Wallinger's racehorse paintings, Rachel Whiteread's cast of a room, *Ghost* (1990), and Sarah Lucas's lewd arrangement of vegetables on a mattress, *Au Naturel* (1994), were also exhibited. Other highlights included Simon Patterson's variation on the tube map, *The Great Bear* (1992), Richard Patterson's painting of a toy minotaur showing the mythic brute as a sympathetic, vulnerable figure, Fiona Rae's fizzing, turbulent black-and-white compositions tussling with discs of colour, and Glenn Brown's versions of Dalí and science fiction illustrations. Photography was also well represented. Besides Richard Billingham's captivating photos, Saatchi displayed a newly commissioned version of Mat Collishaw's *Bullet Hole* and Sam Taylor-Wood's panoramic series, *Five Revolutionary Seconds* (1995–2000), portraying alienated modern lives in opulent interiors. Given the exhibition's title, the unifying

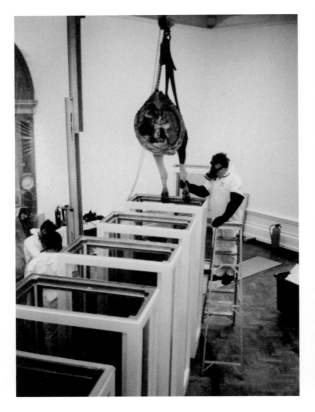

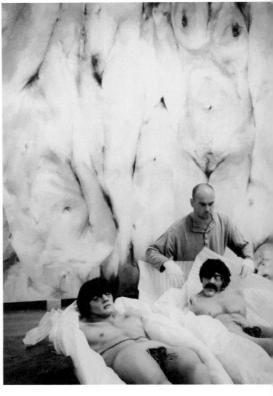

LEFT: Installing Damien Hirst's *Some Comfort Gained from the Acceptance of the Inherent Lies in Everything* (1996) at 'Sensation', Royal Academy, 1997. Photograph by Johnnie Shand Kydd

RIGHT: A man from Momart unpacks Jake and Dinos Chapman's *Great Deeds Against the Dead* (1994) at 'Sensation', 1997. In the background is a painting by Jenny Saville. Photograph by Johnnie Shand Kydd

OPPOSITE, LEFT: Cow's head for Damien Hirst's *A Thousand Years* (1990), awaiting installation at 'Sensation', 1997. Photograph by Johnnie Shand Kydd

OPPOSITE, RIGHT: Installation view with Jake and Dinos Chapman's *Zygotic Acceleration, Biogenetic, De-Sublimated Libidinal Model* (1995) in the foreground, and in the background Damien Hirst's *Beautiful, kiss my fucking ass painting* (1996) and a painting by Martin Maloney, 'Sensation', 1997

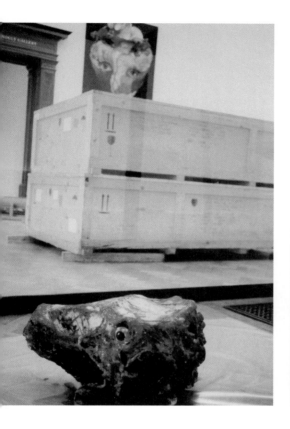

TOP: Sam Taylor-Johnson,
*Five Revolutionary
Seconds VI*, 1996.
C-print, 21 × 200 cm
(8 ¼ × 78 ¾ in.)

ABOVE: Richard Patterson,
*Blue Minotaur*, 1996.
Oil on canvas,
208.3 × 312.4 cm
(82 × 123 in.)

OPPOSITE: Fiona Rae,
*Untitled (Parliament)*,
1996. Oil and acrylic on
canvas, 274.3 × 243.8 cm
(108 × 96 in.)

theme seems to have been an attention-grabbing aesthetic. Certainly that seemed to be a quality Saatchi sought in his collecting, whether it was Jenny Saville's Lucian Freud-style paintings of corpulent women, Gavin Turk's waxwork *Pop* or the diminutive hyper-realistic sculpture *Dead Dad* (1996–1997) by the Australian-born artist Ron Mueck.

If Saatchi dreamt the exhibition would live up to its title, it surely surpassed his hopes. At one point the vice squad was called in but found no reason to press charges for obscenity.[19] However, this paled beside the controversy sparked by one work: Marcus Harvey's portrait of the child killer Myra Hindley, painted on the monumental scale typically reserved for heroic subjects. The portrait was based on the infamous black-and-white police mugshot taken after Hindley's arrest, showing her pouting and defiant, a warped blonde bombshell, the epitome of feminine evil. The image has been reproduced endlessly thanks to a national obsession with Hindley and her boyfriend Ian Brady, dubbed the Moors Murderers, who killed five children in the 1960s and buried them on the moors outside Manchester. The media's mythologizing of Hindley and Marcus's own ambivalence to her image drew him to explore it. 'I was buying into what was being sold really, that this is what a child-killing woman looks like. Or is how society wanted to construct a cold, misfired Marilyn Monroe, Frankenstein creature,' he says. 'And because there was something deeply, animally sexual about her countenance, I found it compelling and troubling.' Blown up on a large scale, the painting stops the viewer in their tracks, forcing them to question their response to the image and ask how much of its power derives from preconceived notions about the subject. Heightening the painting's potency is the fact it was made using thousands of tiny rubber handprints cast from children, producing the effect of ghostly avenging angels clawing at Hindley's face.

I was buying into what was being sold really, that this is what a child-killing woman looks like…. And because there was something deeply, animally sexual about her countenance, I found it compelling and troubling.

MARCUS HARVEY

Even before the show opened, the *Sun* newspaper had blasted it and urged readers to harangue the Royal Academy.[20] The press attacks became more virulent, whipping up public emotions by involving mothers of Moors murder victims such as Winnie Johnson, who begged the Academy to remove the painting. In a heated debate,

Installation view of Marcus Harvey's *Myra* (1995) at 'Sensation', Royal Academy, 1997, with Norman Rosenthal (L) and David Sylvester (R) standing in front of it. Photograph by Johnnie Shand Kydd

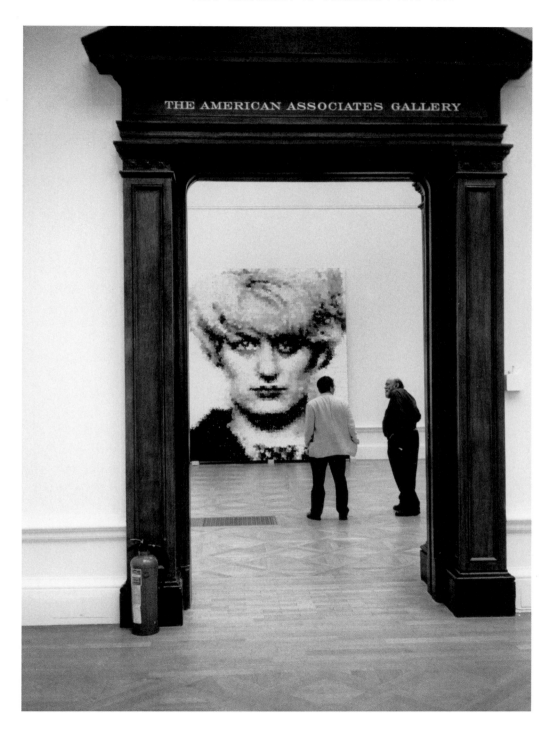

Royal Academy members narrowly voted not to withdraw it.[21] However, such was the passion over the issue that four Academicians resigned. Rocks were hurled, smashing windows of Burlington House, where the Academy is based.[22] When the show opened on 18 September, visitors had to cross a picket line of protesters with megaphones and placards, including Winnie and the pressure group Mothers against Murder and Aggression.[23] On the first day, protesters vandalized the painting twice.[24] The *Mirror*'s front page screamed 'DEFACED BY THE PEOPLE IN THE NAME OF COMMON DECENCY'.[25] According to Marcus, his dealer, Jay Jopling, at one point considered requesting police protection for him after callers to the Academy made death threats.

The painting divided critics too. Marcus was knocked sideways by the affair, torn between sympathy for the victims' families, anger at the media's exploitation of the painting and injured pride over the reaction of the Academicians, with whose traditional values he felt more affinity than his fellow BritArtists. Where some might have thrived on the attention, it dismayed Marcus. 'Shock art, what a disgusting, stupid thing to have to be saddled with, but that's what I am,' he says. Marcus became typecast by that one painting. 'It was so centred on a specific image, I had to row back and re-find my language. I'm still doing it if I'm honest,' he says. However, he remains surprisingly upbeat about 'Sensation' itself: 'I thought it was a ballsy affair. There was something for everyone, and it had thrown off an English, nose-picking, twitching, dowdy, post-war kind of modesty. Snobbery actually.'

Many of the artists in 'Sensation' felt indifferent about the show since they had no influence over it. 'It didn't feel cutting edge,' says Glenn Brown, '...it felt a bit square...to be in the Royal Academy. Because I think a lot of the work that was being made...was meant to be the antithesis of the Royal Academy.' To Sam Taylor-Wood, it seemed like after years of fun the YBA phenomenon 'suddenly started to become dirty'. 'It's that point where you felt like, "I'm being appropriated. I'm being turned into something."' 'Sensation' opened with a buzzing party to which the great and the good of British society were invited. Amid all the razzamatazz and celebration, Gavin Turk turned up as a tramp with newspaper stuffing his holed shoes

> I thought it was **a ballsy affair**. There was something for everyone, and it had thrown off an English, nose-picking, twitching, dowdy, post-war, kind of modesty. Snobbery actually.
>
> **MARCUS HARVEY**

and urine-stained trousers. Gavin, whose studio was on Charing Cross Road, surrounded by homeless people, says his performance-cum-prank was an impromptu social experiment. He was reflecting on 'the symbolism of living on the outside, on the fringe….And I was just quite interested in that as a way of thinking about what is acceptable, what is not acceptable….At what point is someone excluded.' Gavin later turned his tramp character into a waxwork sculpture, *Bum* (1998). The performance expressed Gavin's awkwardness about the congratulatory back-slapping and champagne-sipping of his peers about having made it. 'I didn't really feel like I had made anything, or said anything,' he says. 'Sensation' drew 300,000 visitors, breaking attendance records at the Royal Academy, and demonstrated the British public's newfound appetite for contemporary art.

Following 'Sensation', media interest in the Turner contest was high, especially in light of its all-female line-up. Commentators criticized the selection as a pat response to the all-male shortlist of 1996 and lamented the absence of painters, although all the nominees stood up to scrutiny; the tabloids focused on what the women might wear for the ceremony. Angela Bulloch showed beanbags that made sounds when sat on in a work that appeared interactive but underscored the limitations of participation; continuing her interest in the crossover between art and science, Christine Borland displayed two forlorn leather and plastic dolls titled *Phantom Twins*, replicas of eighteenth-century medical teaching aids that used real fetal skeletons; Cornelia Parker exhibited a hanging sculpture of charred fragments from a Texan church struck by lightning. Gillian Wearing won for her startling video *10–16* (1997), showing adult actors lip-syncing children's anxious musings on life. The use of adults to mask the children's identity emphasized their vulnerability and made for jarring viewing, particularly watching a dwarf actor declare he wants to murder his lesbian mother. Inspired by the 1970s fly-on-the-wall television documentary *Seven Up!*, Gillian says, 'This programme made me realize we carry that child within us through life, and so I wanted to show that in a way that was metaphorical….It is in no way autobiographical but I think we can all relate to those fast-changing years that go from being a child to an adult.' Coming on the heels of Douglas Gordon's win in 1996,

Gavin Turk, *Bum*, 1998.
Waxwork, 167 × 70 × 70 cm
(65 ¾ × 27 ½ × 27 ½ in.)

ABOVE: Installation view of Angela Bulloch's 1997 Turner Prize show 'Superstructure With Satellites'. Mixed-media sculpture with three interactive soundtracks, wall-mounted lamp, disc on floor, bench and various cables, approximately 13 m (43 ft)

RIGHT: Gillian Wearing, *10–16*, 1997. Colour video for projection with sound, 15 minutes

OPPOSITE: Tracey Emin on the night of her drunken performance on a TV panel discussion, 1997. Photograph by Johnnie Shand Kydd

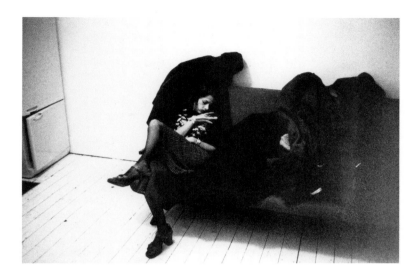

Gillian's victory affirmed the growing acceptance of video as an
art form.

After the prize ceremony, Tracey Emin appeared drunk and
swearing in a televised debate and eventually stormed off, leaving
many with the impression that she was in fact that year's winner.
Tracey had no recollection of the incident later when she joined her
friends. Her then boyfriend Mat Collishaw remembers her bewailing
the fact she had forgotten to appear on the TV show and forfeited her
£500 fee. When Gillian rang the next day to congratulate her on her
hilarious performance, Tracey thought she was pulling her leg until
she saw the newspapers. 'From that I think she became a voice, so
if somebody wanted a comment on Princess Michael of Kent's new
hairstyle, or a new law on immigration, they might call her for some
sort of controversial, wacky opinion,' says Mat.

As 1997 ended Tracey became a household name in Britain,
helping to seal the wild-child reputation of the YBAs. The Royal
Academy, a bastion of tradition, had embraced the upstarts; art had
been knocked off its lofty pedestal and placed within everyone's reach.
'Sensation', a replacement for a cancelled exhibition, had in fact been
a sensation. But while the show celebrated the YBAs' rise, it also
marked the start of the group's gradual dispersal and certainly the
end of its anti-establishment credentials.

Within the art world disaffection with the YBAs was spreading, even as public and media interest grew in the wake of 'Sensation'. Gavin Turk had a major solo exhibition, 'The Stuff Show', at the South London Gallery in 1998 and for the opening covered up all the art with canvas so it couldn't be seen. 'It was quite theatrical but the theatre had already happened....You were part of the theatre,' says Gavin. The reasoning behind the stunt was that no one looks at the art at private views because they are too busy socializing, but coming on the heels of his strange appearance as a tramp at the opening of 'Sensation', it nailed his reputation as a joker. 'What you've got to do as an artist I think is to play with people's preconceptions. And so if you're somehow provoking or trying to tap in and unsettle people's preconceptions, then maybe you become a prankster....I think it's hopefully more profound than that,' he explains. David Thorp, South London Gallery's director at the time, describes the event as 'a once-in-a-lifetime thing, because Gavin was never going to show that work in that way again....So it was a completely unique and special one-night Gavin Turk experience.'

The move annoyed visitors because it seemed yet another easy gimmick from the group, many of whose works thrived on puns, irony and art in-jokes: a classic case of the prevailing Duchampian attitude 'this is art because I say it is' that opponents deemed over-used. Nonetheless, several of the artists came into their own in this period; artists' use of the self as a departure point was also a conspicuous theme. Official recognition continued apace, with BritArtists featuring heavily in the Turner Prize line-ups and Gary Hume representing Britain at the Venice Biennale. But with this group controversy was never far away, whether from the now touring 'Sensation' exhibition or the tell-all antics of one of BritArt's most recognizable figures.

> if you're somehow **provoking** or trying to tap in and unsettle people's preconceptions, then **maybe you become a prankster**....I think it's hopefully more profound than that.
>
> GAVIN TURK

## AUTHENTICITY, SELF AND IDENTITY GAMES

Having publicly named all her lovers and appeared drunk on national television, Tracey Emin would present her own bed, strewn with evidence of debauchery, as art. Artists have of course depicted

themselves in their work over the ages: one thinks of Caravaggio's frequent use of himself as a model in the sixteenth century or the Spanish painter Diego Velázquez in the seventeenth, slipping his own portrait into his renowned court tableau *Las Meninas*. But by the latter half of the twentieth century artists were centring their art on their own bodies and turning themselves into artworks, as with Gilbert & George and Cindy Sherman. Several BritArtists, such as Tracey, Marc Quinn, Georgina Starr and Gavin Turk, continued this exploration, mining the rich vein of the self in very different ways.

Tracey presented her art as inseparable from her life. As part of a solo show at the South London Gallery in 1997, she and her ex-boyfriend, the artist Billy Childish, dissected their relationship in salacious detail before a transfixed audience. Citing the influence of European Expressionist artists, Tracey exploited her intense emotions and intimate experiences as source material for her art. 'Egon Schiele, Kaethe Kollwitz, Edvard Munch, they all used themselves, that's what I liked about their work,' she says. As Schiele did in his day, Tracey thrust the sordid, abject elements of her life into the public consciousness, smashing through the layers of British reserve that disapprove of open airing of dirty laundry. Tracey's scratchy drawings of herself masturbating or having sex, often accompanied by misspelt scrawled phrases voicing longing or hurt, expressed human vulnerability beneath her brazen exterior. In her uplifting video *Why I Never Became a Dancer* (1995), Tracey narrated how she transcended the public humiliation of being branded the town slag on stage by a group of Margate boys. It becomes a metaphor for the triumph of self-belief over the system. 'By refusing to disentangle art and life, by fusing her autobiography with her artistry, Emin creates a world where personal truth-telling moves beyond the me-culture and into collective catharsis,' according to the writer Jeanette Winterson.[1]

Tracey incorporated her diaries, blankets and clothes into her work, making it accessible to ordinary people and showing that art could exist in everyday, personal items. Her vibrant appliquéd blankets

ABOVE: Tracey Emin, *Terrebly Wrong*, 1997. Monoprint on paper, 58.2 × 81.1 cm (22 7/8 × 31 7/8 in.)

OPPOSITE: Tracey Emin, *Pysco Slut*, 1999. Appliquéd blanket, 244 × 193 cm (96 × 76 in.)

evoke the genteel tradition of the needlework sampler and, more recently, the embroidered protest banners used by the suffragettes. These collaged patchworks of memories subvert the notion of sewing as an innocuous domestic pursuit with their emblazoned cacophony of emotions, insults and confessions: 'psycho slut', 'my brain's all split up', 'you cruel heartless bitch', 'I do not expect to be a mother but I do expect to die alone' and so on. Tracey first exhibited *My Bed* in Tokyo in 1998, with two suitcases and a hangman's noose; it was then shown in her first New York solo show, 'Tracey Emin: Every Part of Me's Bleeding', at Lehmann Maupin gallery. Saatchi bought the work for £40,000. *My Bed* may appear self-indulgent, but for Tracey it embodied a moment of despair that she overcame. The German collector Count Christian Duerckheim, who bought it for £2.5 million in 2014, valued its humanity: 'I bought *My Bed* because it is a metaphor for life, where troubles begin and logics die,' he declared.[2] But in 1999, when Tracey's unkempt bed made its appearance at the Tate's Turner Prize show following her nomination, it became the butt of jokes and derision, demonstrating Britain's suspicion at the time of contemporary art and anything that smacked of exhibitionism. Carl Freedman, Tracey's ex-boyfriend, insists that that was never her motivation. 'It's not like she's gone out there creating this persona purposefully. People of their own accord from the very beginning have been attracted to Tracey,' he says. '...Since then, you could make a case for saying she's done a very good job of...making a very successful career out of that, but the origin...was a very genuine interest in making a certain type of art and an unstoppable need to communicate.'

> **the origin**...was a
> very genuine interest
> in making a certain type of art
> and **an unstoppable
> need to communicate**.
>
> CARL FREEDMAN

Gavin Turk, on the other hand, was using himself as a puppet in his work to undermine people's assumptions about identity, authorship and the authority of the artwork. The centrepiece of his 1998 South London Gallery show was *Death of Marat*, a three-dimensional staging of Jacques-Louis David's famed 1793 painting of the same name, with a wax cast of Gavin as the French revolutionary murdered in his bath. 'One of the things about me putting my own self in my work is that...it's actually more to do with it not being someone else,' explains Gavin. 'The idea is that somehow your preconception

Gavin Turk's *Death of Marat*, with Charles Saatchi in the background looking at the works for 'The Stuff Show' at South London Gallery, 1998. Photograph by Johnnie Shand Kydd

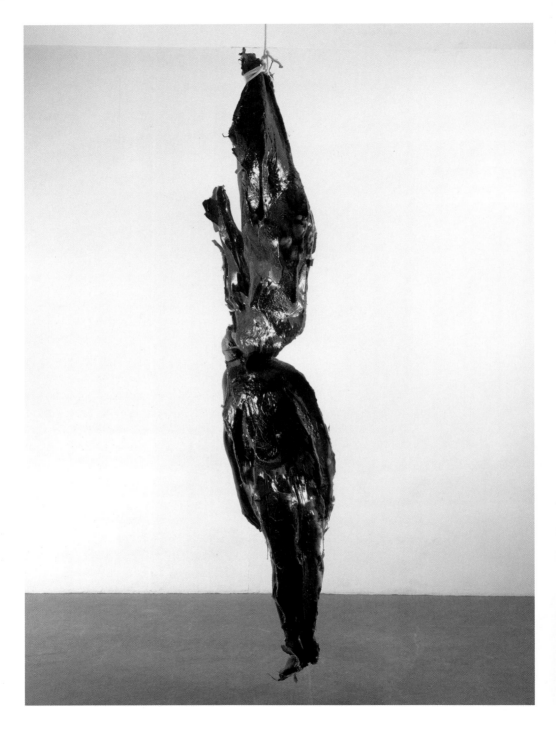

makes you familiar with the work, but then me being in the work makes the work unfamiliar, and makes the work an immediate fake… so that the work…challenges its own authenticity.' The exhibition also included the waxworks of Gavin as a tramp (*Bum*) and as Sid Vicious (*Pop*), a photograph of the artist with camouflage on his face and works bearing his signature across broken egg shells, on polystyrene balls and on a ceramic toilet bowl, in a nod to Duchamp's urinal. Perhaps unsurprisingly, the show prompted accusations of narcissism.[3] In a damning review for the *Guardian*, the critic Adrian Searle wrote, 'This is modern art as a hall of mirrors, offering endless reflections of itself, and stuck with endless replications of its own self-image.'[4] Gavin would later make prints of himself as Joseph Beuys, Elvis, Andy Warhol and Che Guevara. These works examine the relationship between artists' branding and celebrity, and demonstrate how reproducing an image repetitively reduces its potency to cliché.

Rather than the image of the self, Marc Quinn's preoccupation was with the material self and its transience, as seen from his work *Self*, a frozen cast of his head from his own blood. In early 1998, prior to Gavin Turk's exhibition, the South London Gallery hosted a solo show by Marc, peopled by sculptural versions of the artist's body in various media. Among these he presented a life-size ice sculpture titled *Across the Universe* (1998), which evaporated in the course of the exhibition. 'You totally dematerialize the object and in fact the people in the gallery breathed it in. So it's a kind of Eucharistical transformation,' he says. Besides the ice sculpture, casts of the artist's body, or just his head, hung from the ceiling or lay strewn on the floor: in bronze and stainless steel, lead, silver and glass and latex, with anxiety-ridden titles like *No Visible Means of Escape* and *Nervous Breakdown*. Two sculptures suspended from the ceiling resembled flayed bodies, the peeled flesh dangling from them. Marc had given up alcohol around 1994 – 'a choice between life and death really' – and this struggle was mirrored in some of the work. 'When you stop drinking, you definitely feel raw because you've…been seeing the world through this comforting haze. And then suddenly when that goes, it's all a bit sharper and rawer,' he acknowledges. Marc would pursue his enquiry into the self and notions of identity further, creating portraits from DNA samples and scaling up thumbprints and optical irises to make giant abstract paintings.

Marc Quinn, *No Visible Means of Escape IV*, 1996. RTV 75–60 polyurethane rubber and rope, 348 × 80 × 23 cm (137 × 31 ½ × 9 in.)

ABOVE: Georgina Starr, *The Party*, 1995. C-print photographs. 20 panel photo work, each panel 30 × 40 cm (11 13/16 × 15 3/4 in.)

OPPOSITE: Georgina Starr, *The Hungry Brain (Hypnodreamdruff)*, 1996. Video, 15 minutes, dimensions variable

Where Tracey put her real life into her work, Gavin used his identity as a cipher and Marc presented his physical body, Georgina Starr incorporated herself in her art as a character in a performance, blurring fantasy and reality. 'The core of the work is about a fictional world that I exist in at the same time as the real world. And it's the way that these two intermingle that has always been the beginning of the work,' she says. Her animated musical *Tuberama*, presented as a multimedia installation at Birmingham's Ikon Gallery in 1998, revolved around an imaginary adventure triggered by a tube train breakdown, with Georgina as the protagonist. In this innovative drama combining comic strip, kitsch popular culture and an original Rogers and Hammerstein-type soundtrack, the heroine Georgina leads her stranded fellow passengers to a bizarre world, 'Dopplecastle', where they meet bottled personifications of their repressed emotions. The journey thus becomes one of self-knowledge. In her practice, Georgina draws on her childhood memories, cinema history, music and her fertile imagination to construct intricate universes. She assumes multiple identities and performs in much of her work, but her portrayal is never purely autobiographical, even in video works such as *Crying* (1993), showing herself weeping, and *The Party* (1995), in which she plays the roles of both hostess and sole guest at her own house-warming party. So in her multi-video installation *Hypnodreamdruff*,

shown at the Tate in 1996, the action moved through interconnected narratives between a caravan, a young woman's bedroom, a kitchen and a nightclub; dream sequences fused with characters' inner worlds and the actuality. Georgina played the roles of a nightclub chanteuse Elena, as well as Frenchy and friends from the bedroom scene of the movie *Grease*, to portray a girl trying to find her own identity through these stereotypes. In these mesmerizing, familiar yet illusory worlds, multifaceted versions of the artist appear but the 'real' Georgina remains elusive.[5] 'I'm much more interested in the mystery and the magic that happens with fiction, with imagining who you could be, or who you might be, or this other, it's more how a novelist would work. It might be called Georgina, but it's not necessarily me,' she says.

The core of the work is about **a fictional world that I exist in** at the same time as the real world. And it's the way that these two intermingle that has always been the beginning of the work.

GEORGINA STARR

At the other end of the performance spectrum, Damien Hirst was focusing his energies on ventures outside the sphere of art. Together with the actor Keith Allen and Blur guitarist Alex James, he formed a band called 'Fat Les' and released the laddish pop song 'Vindaloo', which became the unofficial British anthem for the 1998 FIFA World Cup. Damien was also part of a consortium behind a restaurant, 'Pharmacy', in Notting Hill, which opened in 1998 and had shelves of medicine in the window and bar stools resembling giant pills. It would be the fashionable place to be seen for a while.

By now Damien was mixing in another league of A-listers. 'He became a door-watcher. People when they get famous, they're always looking for people at the same level of fame,' says his Leeds pal Marcus Harvey, who found Damien now preferred clubs like the Groucho to quiet drinks down the pub. 'It's...an evolutionary thing that happens...and hot on its heels is cocaine.' When Damien saw his old Goldsmiths mates, it was on his terms. 'I think there are some people that you're always at their party. And if you accept that, it's fine. And it was a really fucking great party to be at, but you could feel a little bit lost amongst it,' says Abigail Lane. One time she and her then boyfriend Paul Fryer were asleep in bed and Damien rang up in the middle of the night off his head asking, 'Do you believe in art?' 'I should've just said YES! And put the phone down,' says Abigail, but she engaged in the debate. 'The next thing was he turned up in

our bedroom and was taking coke with Paul.' The three of them went
to Damien's studio to make spin paintings, then headed to Damien's
partner Maia's houseboat, where Abigail crashed out. 'I woke up and
they'd graffitied the whole boat,' she says. 'I don't know if Maia ever
knew because he was sensible enough to ring the decorators first thing
in the morning. He's always pragmatic like that.'

## A COMING OF AGE

Damien's bold confidence was reflected in other artists at the time.
The painter Chris Ofili had an acclaimed show at the Serpentine in
1998 and the same year became the first black artist to win the Turner
Prize (beating Sam Taylor-Wood among the nominees). Chris was
not in 'Freeze' or at Goldsmiths but could be considered a peripheral
member of the BritArt group because of his urban style, use of
unusual media (elephant dung), participation in the big group shows
'Brilliant!' and 'Sensation' and the fact he was collected by Charles
Saatchi. Bursting with energy, Chris's canvases combined elephant
dung balls (on the surface and as a support on the floor), Aboriginal-
style dot patterns, glitter, beads and psychedelic colour. He employed
the sampling of rap music, remixing references to art history, African-
American culture, hip hop, Blaxploitation movies, comics and porn,
while also parodying racial stereotypes: pimps, hookers, gangstas,
drug pushers.

    Jane and Louise Wilson also found their feet in this period,
returning from a German government arts scholarship in Berlin that
marked 'a seismic shift' in their work, according to Jane. '...it became
so apparent you were living somewhere where this history was
embedded in the architecture, it wasn't something that was neutral.'
The direct result of the twins' experience was the film *Stasi City* (1997),
in which the camera prowled around the abandoned headquarters
and prison of the former East German secret police, down echoing,
impersonal corridors and into claustrophobic interrogation rooms,
entered through double sets of padded doors. The film unpicked
the theatricality of the Stasi's interrogation techniques, illustrating
how the building itself was coopted in the practice of control and
intimidation. 'So the doors were sealed with string and wax seals,

OPPOSITE, ABOVE: Jane and Louise Wilson, *Stasi City*, 1997. Video (four-channel video installation, colour, sound), duration 5 minutes, 40 seconds

OPPOSITE, BELOW: Jane and Louise Wilson, *Reconstruction of Double Doors: Hohenschonhausen Prison, Stasi City*, 1997. Mixed media, 293.5 × 232 × 229 cm (115 ½ × 91 ⅜ × 90 ⅛ in.)

ABOVE: Jane and Louise Wilson, *Mirrored Figure, Command Centre, Gamma*, 1999. C-type print mounted on aluminium with diasec, 122 × 122 cm (48 × 48 in.)

but when you actually went into the interview rooms, you realized that the walls were paper-thin,' says Jane. 'So what was this about, this sense of containment and sound proofing? You could actually hear a conversation in the next bloody room if you strained your ear with a glass on the wall.' Jane and Louise showed *Stasi City* projected onto four screens together with an evocative padded door sculpture in a solo show at the Serpentine Gallery in 1999.

Besides *Stasi City*, the Serpentine show included the Wilsons' film *Gamma* (1999) of the infamous former US nuclear base at Greenham Common, site of numerous clashes with police by mainly women anti-nuclear protesters throughout the 1980s. As in *Stasi City*, the artists homed in on telling details such as a piece of graffiti titled 'Dog Fight' depicting a heroic bulldog with a cruise missile chained to its back. 'While it's breaking free from its chains, it also happens to be releasing a cruise missile from its back,' says Jane. 'It did make you realize actually that there was a quite singular hysteria inside the base,' Louise notes. While not overtly didactic, these haunting films shine a light on state repression and challenge the accepted wisdom about unpleasant episodes of history, such as the media's portrayal of the peace protesters as the wrongdoers. Where in their early films such as *Crawl Space* the twins occupied a central role and played up the Gothic elements of the architecture, in these later works the artists figured as shadowy apparitions in the background, making the redolent psychology of the buildings the protagonist.

The Wilsons were now on the roster of the Lisson Gallery – noted for the 1980s Tony Cragg group of abstract British sculptors – along with Christine Borland, Douglas Gordon, Simon Patterson and briefly Mat Collishaw from their own generation. Jay Jopling's White Cube had the bulk of the big names in its stable with the Chapman brothers, Tracey Emin, Marcus Harvey, Damien Hirst, Gary Hume, Marc Quinn and Gavin Turk, while Angus Fairhurst and Sarah Lucas had joined Sadie Coles. Lisson owner Nicholas Logsdail never really embraced the BritArtists. He was 'the great naysayer about the whole thing from the word go, because it wasn't his gig', says Karsten Schubert.

Still, the Lisson played a part in the BritArt story, hosting group shows each summer such as 'Wonderful Life' (1993) and memorable solo exhibitions including Christine Borland's 'L'Homme Double'

Christine Borland,
'L'Homme Double', 1997.
Clay, steel, wood, acrylic,
documents, dimensions
variable

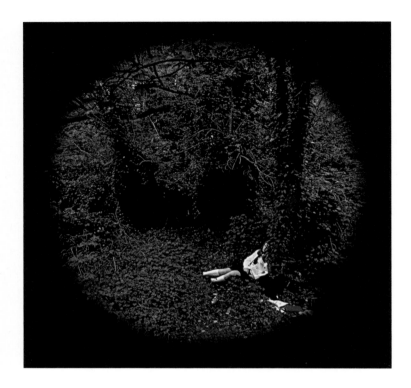

ABOVE: Mat Collishaw, *Awakening of Conscience, Kateline*, 1997. Nova print, wood, glass, 177.1 × 219 × 6 cm (69 ¾ × 86 ¼ × 2 ⅜ in.).

RIGHT: Mat Collishaw, *Snowstorm*, 1994. Video projector and player, glass, wood, dimensions variable

OPPOSITE: Mat Collishaw and Abigail Lane on the beach in Margate, while filming Emin's *Riding for a Fall*, 1998. Photograph by Johnnie Shand Kydd

and Mat Collishaw's 'Duty Free Spirits' (both 1997). For the former, Christine invited six sculptors to create a clay bust of the notorious Nazi doctor Josef Mengele, based on witness descriptions and black-and-white photographs she sent them. 'L'Homme Double' pursued the theme of reconstruction of her 1994 work *From Life*, but whereas that commemorated an anonymous Indian woman in bronze, the subject

here was a man dubbed 'the angel of death', about whom everyone has preconceptions. The finished busts resembled portraits of six different people who clearly did not look evil, triggering questions about how identity and history are constructed. 'I've been very aware of using clay, like in the Mengele work, as it's got a relationship to the monument, but it's very determinedly not a monumental material because...it will break down and eventually...degrade and disintegrate,' Christine explains.

For 'Duty Free Spirits', Mat Collishaw presented his series of photos *Awakening of Conscience* (1997), each depicting a woodland scene in which a schoolgirl lay enveloped in lush undergrowth. The forest clearing evokes a Victorian rural idyll, yet the enchantment is imbued with foreboding, heightened by the photo's circular format, as if seen through a peephole. Looking closer, one notices paraphernalia of substance abuse strewn among the leaves, suggesting that the girls are not slumbering but drugged, perhaps awaiting an assignation. By the mid-1990s, having made seductive works about pornography, bestiality, rape and murder, Mat had tired of gore and horror and found a new off-limit zone in the least likely of places, the Victorian aesthetic. He would take images of fairies and kitsch trinkets of Victoriana and add a dark twist. For instance, he created a set of snow shakers and inserted video projections of homeless people in place of the typically happy scenes – pathos incongruously contained in a saccharine bauble.

Abigail Lane was also taking her art in a new direction, away from criminology towards fantasy. She had moved into a warehouse loft in Shoreditch, which became party central as well as a provisional studio for friends. Here she made her looped video *Figment* (1998),

in which an impish boy/man embodying a figment of the imagination performs a jerky dance under a red spotlight to distorted squeaks and growls mixed with music. 'Hey, do you hear me...? I'm inside you, I'm yours,' the David Lynch-esque figure whispers. *Figment* was frequently paired with her eerie installation *You Know Who You Are*, comprising two smoking men's shoes that suggest a spontaneous combustion or some fiendish magic conjured by the character in *Figment*. She presented these works in a solo show at the Museum of Contemporary Art in Chicago in 1998, alongside her *Still Lives* photographic series (1997–1998) portraying surreal scenes in which wild animals in their habitat are juxtaposed with humans in mundane domestic settings. As in Abigail's earlier work, the uncanny loomed large but the context of forensics had been superseded by theatricality, phantasmagoria and sleight of hand.

Gary Hume's work similarly displayed increased self-assurance. He received a major boost by being invited to represent Britain at the 1999 Venice Biennale, where he showed large glossy mood paintings of flowers and birds and his elegant new *Water Paintings* series of multiple outlines of nude women overlaid against monochrome backgrounds. In the watery setting of Venice, the idealized subjects resembled modern nymphs, seen as a jumble of faces, breasts and limbs beneath the shimmering surface. Damien Hirst had been selected for Venice first but turned it down, thrown off track by his 1997 show at the Bischofsberger Gallery in Zurich that he had felt was a failure.[6] Gary's light-hearted, lyrical works found themselves out of step with the prevailing political mood of the other national pavilions, which showed works alluding to world affairs.[7] Gary's artist friends turned up en masse to support him, and the Britpop band Pulp played

ABOVE: Marcus Taylor, Rachel Whiteread, Fiona Rae and Richard Patterson in Venice to celebrate Gary Hume at the British Pavilion, 1999. Photograph by Fiona Rae

OPPOSITE: Abigail Lane, *You Know Who You Are*, 2000. Colour photographic print, 250 × 135 cm (98 7/16 × 53 1/8 in.)

ABOVE: Gary Hume,
*Water Painting (Lilac)*,
1999. Enamel on
aluminium, 303 × 244 cm
(119 ⁵⁄₁₆ × 96 in.)

OPPOSITE: Mark Wallinger,
*Ecce Homo*, 1999. White
marbleized resin, gold-
plated barbed wire, life
size. Installation view in
Trafalgar Square, London

at a grand palazzo party thrown by Jay Jopling and the British Council to launch the show. 'That was just an utterly joyful experience...it was gorgeous,' he says.

Back home, Mark Wallinger had been commissioned to make a sculpture for the Fourth Plinth of Trafalgar Square and created a statue of Jesus as a vulnerable ordinary man, coinciding with a growing thirst for more reflective, issue-based art. His sculpture *Ecce Homo* (1999) was the first to grace the plinth, empty since 1841, in what has since become a showcase for world-class art. Mark depicted Jesus naked but for a loin cloth and a crown of barbed wire over his shorn, bowed head, hands tied behind his back, at the moment when Pontius Pilate hands him to the rabble. 'It just came to me that if Jesus was nothing else, he was a leader of his people subjugated by another foreign power and put before a lynch mob, so I hoped it was a work about one's responsibility as someone in the square,' he says. Standing at the plinth's edge, the marble resin Jesus appeared dwarfed by the grand scale of the surrounding monuments to imperial military might, vainglorious against his humility. What drove the work was the 'squeamishness' of two successive governments of different stripes who were loath in this multicultural, secular era to make any connection between the forthcoming millennium and the birth of Christ 2,000 years before. 'It was like, "Don't mention Jesus Christ,"' recalls the artist. Horrific images from the Bosnian war – in particular, the 1995 Srebrenica massacre – and the West's reluctance to intervene also preyed on his mind. Mark's reinterpretation of Jesus for a modern audience touched a chord among critics and public alike. Heading into the millennium, it represented a move away from the ironic, spectacular works that had dominated the 1990s.

> It was like, **'Don't mention Jesus Christ'**....People were more preoccupied that all computer systems would shut down or something.
>
> MARK WALLINGER

## GROWING CHORUS OF DISAFFECTION

In 1998 Mark Wallinger wrote an essay, 'Fool Britannia: not new, not clever, not funny', lambasting the YBAs for their apolitical, unoriginal works 'that specialize in stating the bleeding obvious'.[8] 'Art is a

commodity in the marketplace, women have a raw deal, children's sexuality is spooky, we are all going to die, etc. Context is all. What is lamentable on Jerry Springer is presentable in the gallery,' Mark wrote.[9] To his mind the YBAs, in their subservience to powerful institutions, had helped to create a dilettantish environment in which all art was equivalent and meaningful critical engagement was unnecessary.[10] 'Within this fools' paradise, if you look like an artist and live like an artist, then you are indeed an artist.'[11] Then in 1999 the painters Charles Thomson and Billy Childish, Tracey Emin's ex-boyfriend, wrote a twenty-point manifesto for a new artists' group calling themselves the Stuckists, whose aim was to promote figurative painting. The name came from Tracey's pronouncement to Childish, 'Your paintings are stuck, you are stuck! Stuck! Stuck! Stuck!'[12] While some of the manifesto's statements – dislike of the ego-artist cult, for instance – appear reasonable, its insistence that 'Artists who don't paint aren't artists' and anti-conceptual stance give the manifesto a reactionary feel.[13] The group would demonstrate regularly outside the Tate against the Turner Prize, although they were not taken seriously by the art establishment.

A more effective critical group was the artist collective BANK, founded in the early 1990s, whose core members were Simon Bedwell, John Russell and Milly Thompson. Taking its name from a former Barclays branch where its first show was held, BANK positioned itself in opposition to the mainstream art scene. Underlining the art world's subordination to big business and rich collectors, the group appropriated the logos, slogans and jargon of the corporate world, while staging shows with anarchic titles, such as 'COCAINE ORGASM' (1995) and 'FUCK OFF' (1996) in the spaces they ran: BANKSPACE, DOG and Gallerie Poo-Poo.[14] BANK published a satirical magazine with caustic headlines such as 'SIMON PATTERSON – ONE IDEA, EIGHT YEARS' and 'GILLIAN WEARING THIN', and sent back 'corrected' press releases issued by galleries with marks out of ten.[15] A particular bugbear was the trendy art world creed that popular culture was democratic and superior to the elitism of art; hence their exhibition in 1998 'Stop short-changing us. Popular culture is for idiots. We believe in ART'.[16] In 1999 the art historian Julian Stallabrass published *High Art Lite*, his scathing and erudite account of BritArt, which took much the same tack as Mark Wallinger and BANK in his view of the YBAs

THE **BANK** FAX·BAK SERVICE

*Helping You Help Yourselves!*

# THE SHOWROOM

44 Bonner Road London E2 9JS Tel: 0181 983 4115 Fax: 0181 981 4112

**Press Release**

*Nice & neat / distinguished yet casual.*

## Fortuyn/O'Brien

18 November - 20 December
Wednesday - Sunday 13.00 - 18.00

*OBVIOUSLY! She couldn't begin an OLD series of works. Think before you write!*

The work of Fortuyn/O'Brien explores the definitions between public art, architecture and the visual arts. Recently she has begun a new series of works which specifically engage with the geographic location of the site in which the works are shown, achieved by literally mapping the location of the gallery and then showing these images as a time-based work.

*grammatically SUSPECT 'crossover' or something would be correct; 'definitions between' makes no sense. BAD!*

Using the most generic map of London, Fortuyn/O'Brien follows the North, South, East and West co-ordinates on which The Showroom lies, from edge to edge of the cities boundaries. In travelling along each gridded section of the map four black & white Polaroid slides are then taken at each junction, again facing North, South, East and West.

*WRONG! This should be possessive i.e. 'city's' surely? Read more literature.*

*for the rest to make sense this should be 'whilst travelling' or even 'after travelling'! At the moment it's just confusing and nonsensical.*

Once this journey is complete the slides will be shown at The Showroom on Four adjacent projectors. Having specifically travelled to the gallery, viewers are transported on a journey outwards into the surrounds of Greater London, gently revealing the true complexity and reality of urban living which the map can only notate.

*Be careful - remember all the crap you have to talk about the local audience to get all that public funding i.e. people who don't have to 'travel' to the place. It sounds like you're specifically addressing only those who have to travel to get there - which lets face it you probably are.*

*Cop-out word-EMBARRASSING! confusing: sounds like it refers to outside Greater London, when it doesn't?*

*I know the number 4 is extremely important to the work, but capital-ising it is just ridiculous Olde England crap. DON'T DO IT.*

Whilst her works are of international standard and significance, Fortuyn/O'Briens exhibition at The Showroom will constitute her first exhibition in London and the UK.
For further details, images or interviews with the artist, please contact Kirsty Ogg, Gallery Director, on 0181 983 4115.

*before using it Check this sort of pronouncement out - they may just be wishful thinking.*

With thanks to Senior Marsh.

*THIS LOOKS REALLY SHIT - YOU CAN SEE IT'S JUST STUCK ON - BAD FOR A FLUSH REVENUE CLIENT LIKE YOU - Be careful!*

Financially supported by London Arts Board, Exhibition and Events Fund and Mondriaan Foundation. Also supported by Blast Theory.

*Strrange.*

LONDON ARTS BOARD

$$\frac{1}{2}$$
$$\frac{}{10}$$

*Ahhm, very cool.*

THE **BANK** FAX·BAK SERVICE *Helping You Help Yourselves!*

*Not bad on standard Art Bullshit: but it's got to make good English sense. Keep trying*

as trivial, cynical and gratuitously sensational. Stallabrass offered a
pertinent corrective to the prevailing orthodoxy, yet one should be
aware he comes from a Marxist standpoint whereby art should have
a useful social purpose.

Even Charles Saatchi, once the most ardent champion of Young
British Art, was starting to cast around for alternatives. As the YBA
showcase 'Sensation' toured to Berlin in 1998 and then to Brooklyn
in 1999, it seemed the advertising tycoon was already seeking to
found a new artistic movement. At the end of 1998, Saatchi published
a catalogue titled *The New Neurotic Realism* featuring thirty-four
artists whose work he would exhibit in two parts during 1999 at his
Boundary Road gallery. An essay introducing the catalogue proclaims:
'Inevitably, the YBA cult of personality became tired. New artists and
curators began looking elsewhere....Cynicism was finally passé and
the art star a bore.'[17] This overnight rejection of the notion of artist as
celebrity seems a bizarre about-face. Saatchi had lavishly promoted his
YBA shows in the media and insisted, according to the photographer
Johnnie Shand Kydd, on publishing full-page photographs of the
artists in the 'Sensation' catalogue to the 'fury' of his co-curator
Norman Rosenthal, who had wanted the focus to be on the art rather
than personalities. Reviewing part two of 'Neurotic Realism' in *Art
Monthly*, the critic J. J. Charlesworth called the label 'a cynical attempt
to maintain the collection's profile by declaring the exclusive rights
to a movement that doesn't really exist as a specific grouping'.[18]

However, it wasn't time to put the YBAs to bed yet. Public
interest in the group had only just been kindled and 'Sensation' still
had a lot more controversy to run. When it travelled in September 1999
to the Brooklyn Museum of Art in New York, the museum had hyped
up the shock factor in its promotional posters, proclaiming: 'HEALTH
WARNING: The contents of this exhibition may cause shock, vomiting,
confusion, panic, euphoria and anxiety.'[19] The show did indeed
provoke uproar, although not because of any portrait of a child killer
or head of human blood, or even mutilated mannequins. The outrage
this time centred on Chris Ofili's large painting of a black Madonna.
*The Holy Virgin Mary* (1996), propped up on two balls of elephant dung,
depicts the Madonna as an African woman in a robe of traditional
blue, with a bared breast adorned with the same dung. Fluttering
against a radiant golden background appear numerous cherubim,

BANK artist collective,
Faxbak service

which on closer inspection turn out to be genitalia cut-outs from porn magazines. A wall label at the museum quoted Chris explaining some of the influences in the work: 'As an altar boy, I was confused by the idea of a holy Virgin Mary giving birth to a young boy. Now when I go to the National Gallery and see paintings of the Virgin Mary, I see how sexually charged they are. Mine is simply a hip-hop version.'[21]

But it was not the snippets of porn profaning the Virgin that caused offence. Without seeing the actual painting, the Republican New York Mayor Rudolph Giuliani raged against 'a work in which people are throwing elephant dung at a picture of the Virgin Mary' ahead of the show's opening and in this was backed by Catholic and Jewish religious groups.[21] Giuliani suspended the city's annual $7 million grant to the museum and began action to eject it from its premises.[22] The museum sued Giuliani for violating the First Amendment right to freedom of speech and eventually won, forcing him to restore the lost funds. 'For him, it was completely opportunistic...for short-term political gain,' says Norman Rosenthal, referring to the 2000 New York Senate race for which Giuliani hoped to be nominated.[23] In the midst of the furore, several newspapers questioned the ethics of a prestigious public museum promoting Saatchi's art collection in a show – partly funded by the auction house Christie's – that would boost the works' value.[24] When the exhibition opened on 2 October 1999, religious and civil liberties groups protested outside the museum. Catholic groups handed out sick bags.[25] The contentious painting was displayed behind a Plexiglas shield.[26] However, a retired teacher who considered it blasphemous still managed to throw white paint over the work.[27] The National Gallery of Australia cancelled plans to stage 'Sensation' in 2000, following the brouhaha in New York.

In London at the end of 1999, more controversy was brewing in the form of Tracey Emin's Turner Prize installation *My Bed*. Also on the shortlist were Jane and Louise Wilson, fellow Goldsmiths MA graduate Steve McQueen and Steven Pippin, who converted unlikely appliances such as toilets and washing machines into pinhole cameras. Tracey's bed dominated the media coverage, overshadowing strong offerings by the other candidates, but it was McQueen who won the prize for his quietly powerful films. For the exhibition, he presented his black-and-white film *Deadpan* (1997), a restaging of a Buster Keaton stunt in which the artist stands unflinching as repeated shots show a house

façade falling on top of him. The artist is left unscathed thanks to a fortuitously located window, but the effect is unnerving, heightened by the presentation of the film in an enclosed space with the screen stretching from floor to ceiling.

McQueen, who moved to Amsterdam and always distanced himself from the media shebang, became the second consecutive black Turner Prize winner after Chris Ofili in a contemporary British art scene from which many people of ethnic origin felt excluded. Apart from a few artists like British-Asian sculptor Anish Kapoor, Lebanese artist Mona Hatoum, Isaac Julien, Chris Ofili and British-Nigerian artist Yinka Shonibare, representation of ethnicity in mainstream British art was poor, as can be seen from the Turner Prize nominees during the 1990s. Black British artists such as Rasheed Araeen, Sonia Boyce and Hew Locke remained on the sidelines during this period, despite producing challenging work. According to the critic Adrian Searle, who taught at several art schools throughout the 1980s and 1990s, the problem wasn't that black students were rejected, but that they didn't apply. 'It was not a career path that was at all supported by aspirational black parents or Asian parents. It took the example of people like Chris and Steve to be role models to make it possible,' he says. Where in the 1980s the struggle for black artists in Britain had been for visibility and social inclusion, by the 1990s 'blackness' had become hypervisible in US media, music and cinema, with global corporations like Nike and Coca-Cola associating themselves with a particular black identity of youthful success and athletic prowess.[28] However, just as the women artists of their generation felt they did not have to fight the battles of their forbears, artists like Chris, Steve and Yinka resisted being pigeonholed by simplistic readings of diversity. Chris's early work appeared to share the jokey ironic tone of much BritArt, but it would move away from that by the end of the 1990s.

As the decade closed and a new millennium dawned, there was a palpable sense of a corner being turned in British contemporary art; not that BritArt had run its course, but the supposed Britishness at its core felt limiting. More foreign artists were moving to London, attracted by the buzzing environment and growing number of galleries and collectors as Britain's economy strengthened. The art scene was broadening and the YBAs were no longer the dominant force in the field.

By the turn of the millennium, YBA had become a byword for bling and celebrity; artists were making theatrical work, selling for big prices and mixing with stars. Clear divisions had emerged within the art scene, between the decadent excess of the high-profile YBAs and the more conscientious sober work of others in the group and outside it. Exemplifying this contrast are two signature works of the time: the Chapman brothers' massive diorama *Hell* (1999–2000) of tens of thousands of Nazi toy soldiers sodomizing and torturing each other in death camps, and Rachel Whiteread's stark silent monument commemorating Austrian Holocaust victims in Vienna. The latter was unveiled in 2000 after five years of political wrangling during which the project nearly didn't come off. Right from the outset, it had been controversial. Rachel had proposed a concrete, windowless library lined with endless identical out-turned books to represent the slaughtered Jews, the 'People of the Book'. When Rachel's design was selected, someone suggested it evoked a bunker and she 'innocently' dispelled their concerns. 'Of course it was meant to look like a bunker as well as being a library,' she admits. 'I was absolutely aware of what I doing, but if I had said, "Yes, this is what I'm doing because I'm absolutely criticizing you lot," it wouldn't have happened. So I had to be very sneaky about how I approached it.' However, if Rachel felt in control at the start, that soon changed. Politicians tried to move the memorial's location, she got flak from all sides, not least when it was discovered that she wasn't Jewish. 'What we didn't realize was that this thing would become a political football,' says Karsten Schubert. Rachel likens Vienna to a beautiful room seething with maggots under the carpet. 'It was actually a nightmare, every minute of it,' she recalls. When the memorial was finally unveiled, snipers were posted on the rooftops, illustrating the contentiousness of the project. 'I literally fainted. My name wasn't even mentioned at the opening of it. Because it wasn't about me, it was about politics, that's what it became,' says Rachel.

The new millennium saw the landmark opening of Tate Modern and the launch of the Frieze art fair, a two-fold confirmation of London's status as a pre-eminent centre for contemporary art.

Of course it was **meant to look like a bunker** <u>as well as being a library</u>...but if I had said, '**Yes, this is what I'm doing** because I'm absolutely criticizing you lot,' it wouldn't have happened.

RACHEL WHITEREAD

Rachel Whiteread,
*Holocaust Memorial*,
Judenplatz, Vienna,
2000. Concrete,
380 × 700 × 1,000 cm
(150 × 276 × 394 in.)

Since the YBAs' emergence in the late 1980s as a motley assortment of artists organizing warehouse shows, the cultural landscape had changed beyond recognition; the spirit of young British art had been institutionalized by Tate Modern, a literal powerhouse in a gigantic disused industrial space on the south bank of the River Thames. Once-favourable critics were tiring of the group; curator interest was turning instead towards art that was more international and socially conscious. Against the backdrop of the terror attacks on the World Trade Center on 11 September 2001 and the subsequent US-led war on Afghanistan and Iraq, the ironic mirth of the 1990s felt misplaced.

## A FEAST OF SPECTACLE

Tate Modern opened with a fanfare in the summer of 2000. Conjuring a post-industrial secular cathedral with its soaring atrium and colossal dimensions, the museum found an adoring congregation in the British public, who took instant ownership of it. Here, finally, was a worthy rival to Paris's Centre Pompidou or MoMA in New York, validating Britain as a serious player on the international modern art scene. Tate director Nicholas Serota had spearheaded the project, finding the location, convincing the trustees and raising the funds. 'There's no doubt the visionary in all of that is Nick….You don't get people like that very often, who have both the integrity and then the actual political skills to manipulate the situation to create such a thing,' says former Goldsmiths tutor Michael Craig-Martin, who was closely involved in Tate Modern's planning. The £134 million conversion by Swiss architects Herzog & de Meuron had been financed partly from the National Lottery Fund and Art Fund; no money came from direct taxation. Over the years the conservative press had repeatedly denounced Serota for supporting Conceptual art at the expense of traditional media. The *Evening Standard*'s late critic Brian Sewell coined the term 'Serota tendency' for his promotion of such art. While Serota had been strongly involved through the 1990s in the Turner Prize, which profiled so many BritArtists, in fact the Tate had been slow to acquire their work. 'There was an understandable hesitation that we shouldn't be taken in by the hype,' admits Serota. 'I think there was a feeling that we should be

careful about looking as though we were simply validating Charles [Saatchi] in some way.'

Tate Modern is now one of Britain's top tourist draws, attracting five million visitors on average annually.[1] Critics complain that Tate has become an art theme park, its blockbuster shows and Turbine Hall commissions fostering an appreciation of spectacle rather than genuine engagement with art. However, it did meet a public thirst for modern art, awakened by the exhibition 'Sensation', whether as entertainment or as intellectual nourishment. But if there had been any illusions that the Tate's expansion was intended to champion the YBAs who had breathed life into the moribund British scene, Nicholas Serota dispelled these with the 2000 Turner Prize shortlist, which included just one British-born artist. 'The YBAs will be regarded as a phenomenon of the 1990s, not something to continue into the twenty-first century,' Serota declared in a speech that newspapers took to signal the demise of BritArt.[2] He clarifies this in retrospect, 'I think it felt like the moment when treating them as a group was not helpful in understanding what they were doing as individuals.'

As the British cultural horizon was transformed by Tate Modern's arrival, Charles Saatchi strove to recapture his earlier success with a two-part exhibition in 2000 called 'Ant Noises', an anagram of 'Sensation', with many of the same artists. Damien Hirst debuted his towering plastic-looking bronze version of a child's anatomical model called *Hymn* (2000), inspired by Jeff Koons's oversize toys.[3] Saatchi forked out £1 million for it, which Damien felt was an important psychological marker.[4] The publicized price tag certainly didn't harm the value of Saatchi's other holdings by Damien but, to many, the gigantic toy epitomized the vacuity of the adman's creed 'big is best'.

Among the standouts of 'Ant Noises' were Rachel Whiteread's 100 glittering jelly-like resin casts of spaces under chairs and Sarah Lucas's wry plaster sculpture *You Know What* of a woman's lower torso with a fag between her vaginal lips. But the exhibition had a certain sense of déjà vu. Several works had been paraded three years before at 'Sensation' and critics attacked the fare as stale.[5]

You can be as **celebrity-driven** as possible but at a certain point you have to look at the stuff <u>in the cold light of day</u>, **and then it's either a work of art or it isn't,** but that has nothing to do with you being a celebrity or not.

**KARSTEN SCHUBERT**

Many of the artists from 'Ant Noises' featured in the launch show for Jay Jopling's star-studded opening of his second White Cube gallery in the now trendy haunt of Hoxton Square. All the BritArt big hitters took part: the Chapmans, Tracey Emin, Damien Hirst, Gary Hume, Marcus Harvey, Marc Quinn, Sam Taylor-Wood and Gavin Turk. On display were Gavin's hyperreal waxwork of himself as a dead Che Guevara on a mortar slab, a flattened lead body cast of Marc, Marcus's painting of a woman behind a toilet door with knickers around her knees, and a Damien skeleton crucified horizontally across glass panes with ping-pong ball eyes bouncing on air jets. In the Noughties atmosphere of restraint, the persistent promotion of what critics saw as theatrical gimmickry by collector and dealer alike began to grate. 'Jay Jay Jay, Saatchi Damien Tracey. Isn't the constant reiteration of the roll-call unutterably void, without meaning or consequence?' lamented Adrian Searle in the *Guardian*.[6]

That summer of 2000, White Cube artist Sam Taylor-Wood created for the department store Selfridges a 274-metre-long (900-foot) photomural adorned with celebrities, which she described as 'a contemporary version of the Elgin marble frieze from the Parthenon, peopled with modern-day "gods"'.[7] She would make an hour-long video for the National Portrait Gallery in 2004 of the footballer David Beckham asleep, in homage to Andy Warhol's film *Sleep*, inverting the

Sam Taylor-Johnson, still from *David*, 2004. DVD, 1 hour 7 minutes

tradition of erotically charged portraits of women sleeping, painted by men. Celebrity 'was an obsession at the time culturally,' Sam explains. 'And I felt like it was something that had to be reflected in my work…. It was definitely something that I was immersed in.'

White Cube wholeheartedly fanned this connection between art and fame, heavily publicizing its artists and encouraging them to develop a consistent brand. Damien Hirst was mixing with rock stars like The Clash lead singer Joe Strummer; Madonna and Kate Moss were dropping by Tracey Emin's studio.[8] Sam and her husband Jopling became staples of magazine society pages; pop stars like Elton John attended the gallery's openings. As a result, the art was sometimes eclipsed by media hype and the artists' celebrity. 'There was a moment when it looked like if you manipulated that aspect of it hard enough, the rest would take care of itself, and I think that's not true,' says the gallerist Karsten Schubert. 'You can be as celebrity-driven as possible but at a certain point you have to look at the stuff in the cold light of day, and then it's either a work of art or it isn't, but that has nothing to do with you being a celebrity or not.'

Besides Jay Jopling's White Cube in London, Damien Hirst was represented by Larry Gagosian in America, two of the world's most powerful dealers. In 2000 Damien flew a retinue of friends and family over to New York for the opening of his most blingy show to date, 'Theories, Models, Methods, Approaches, Results and Findings', at Gagosian's enormous gallery. Expensively produced fairground-type curiosities abounded. Two large vitrines filled with water contained live tropical fish swimming around gynaecologists' chairs (*Love Lost* and *Lost Love*); a white inflatable ball hovered as if by magic above a bed of gleaming sharp knives (*The History of Pain*); a mirrored cabinet titled *The Void* housed 8,000 colourful pills in rows, pointing up our collusion in the pharmaceutical industry's pretence that its prettily packaged medicines will ward off death. Slick, entertaining and visually arresting, the show exuded an air of carnival excitement, with queues round the block for entry. Damien had also indulged his love of Hammer Horror kitsch with a vitrine lined with bulging black bin bags and the message 'Stop me B4 I kill again' in lipstick. Reviewing the show for the *Financial Times*, Ralph Rugoff posed the question: 'Is Damien Hirst still interested in being taken seriously as an artist, or merely bent on playing the market?'[9] Damien once complained people

only saw dollar signs when they looked at his art but now, rich beyond his dreams, he seemed in danger of allowing money to be his master.[10] He would create an artwork in 2007 that literally embodied cash: his £50 million diamond skull, *For the Love of God*.

As Damien's fame and wealth reached stratospheric levels, his drinking and drugging seemed to be spiralling out of control. The scrapes were accumulating. One time he got sued by an American woman for inserting a chicken bone into his foreskin in a Dublin bar.[11] On another occasion, Norman Rosenthal, the Royal Academy exhibitions secretary and great friend of the group, found Damien lying in the gutter outside the Colony Room Club. 'I thought, "If he lives for another four days, it will be a miracle." He was playing with his life, for sure.' Up a dingy staircase in Dean Street, the cramped green-walled Colony Room in Soho had been Francis Bacon's stomping ground, and many BritArtists whiled away afternoons and evenings chasing the spirit of bohemia there.

'Apocalypse: Beauty and Horror in Contemporary Art' at the Royal Academy in autumn 2000 rounded off a year of loud, attention-grabbing YBA shows. Co-curated by Norman Rosenthal and the artist/gallerist Max Wigram, the exhibition included international artists such as Maurizio Cattelan and Mike Kelley but effectively amounted to a showcase for the installation *Hell* (1999–2000) by Jake and Dinos Chapman. Made up of nine vitrines arranged in swastika formation, *Hell* offered a truly apocalyptic vision of orgiastic brutality. Hordes of Airfix Nazis engaged in mutual mutilation or formed hills and rivers of corpses in the impressive dioramas; aliens and other creatures also cropped up randomly. Many have interpreted *Hell* as a comment on the Holocaust and man's inhumanity to man.[12] But the trickster artists say that the work is about using symbols and stereotypes to make people question their conventional responses to visual language. Jake marvels at viewers' ability to find pathos in their scenes of savagery, 'having real identifications with little plastic soldiers and having real pangs of empathy and compassion for things which don't really deserve that treatment'. Dinos agrees: 'The funniest thing is when people look at those and say

The funniest thing is when people look at those and say it's about the Second World War. They have to ignore the dinosaurs, the mutants, the spacemen, the cavemen, the skeletons, Adam and Eve, Stephen Hawking.

DINOS CHAPMAN

ABOVE: Jake and Dinos
Chapman, *Hell*,
1999–2000. Fibreglass,
plastic and mixed media
in nine vitrines, eight
215 × 128.7 × 249.8 cm
(84 5/8 × 50 5/8 × 98 3/8 in.),
central vitrine 215.4              OPPOSITE: Jake and
× 128 × 128 cm (84 3/4             Dinos Chapman,
× 50 3/8 × 50 3/8 in.)             *Hell* (detail), 1999

it's about the Second World War. They have to ignore the dinosaurs, the mutants, the spacemen, the cavemen, the skeletons, Adam and Eve, Stephen Hawking. The kind of blinkers you have to be able to put on to see that is incredible.'

## ART WITH A CONSCIENCE GAINS FAVOUR

However, within the art world, the taste for extravaganza was declining while art with a social conscience was in the ascendant. Shows such as the Whitechapel Gallery's 'Protest and Survive' and 'Intelligence' at Tate Britain in 2000 countered the recent emphasis on spectacle. Matthew Higgs, who co-curated 'Protest and Survive', declared that

years of British Council-sponsored exhibitions abroad had produced a 'collective weariness with British art that has accelerated its marginalized presence internationally' and made foreign curators suspicious.[13] 'Artists and curators emerging in the wake of the Hirst generation are wary of making shiny, visually striking things to go in galleries. They see themselves as infinitely more serious,' noted Jonathan Jones in the *Guardian*, reviewing 'Protest and Survive'.[14] Liam Gillick, who while at Goldsmiths never identified with the 'sex and death thing' of Damien's circle, was a rare exception from that generation to find favour with his cerebral art. He participated in several institutional shows, including 'Protest and Survive' and 'Intelligence', and earned a Turner Prize nomination in 2002.

Behind 'Intelligence' was the idea that the viewer was an investigator, who activated the art on display and gave it meaning.[15] Liam contributed a bright-coloured suspended ceiling titled *Discussion Platform* to designate a potential area in which visitors could communicate, and a partially panelled barrier, *Applied Distribution Rig*, as somewhere for applied problem-solving and redistribution of ideas.[16] Since his early work exploring the process of newsgathering, Liam's practice had been concerned with engineering social dialogue and interaction through

Liam Gillick in Fiona Rae's flat in the Barbican, London, 1996. Photograph by Fiona Rae

his installations, making him a leading light of the Relational Aesthetic movement. His socially engaged art is intended to be participatory, provocative and subversive, challenging the notion of art being located in one specific object or even discipline, spanning architecture, design and sculpture and often accompanied by text diagrams and literature. Using technological materials of the modern age such as Plexiglas and aluminium, he makes attractive installations with colourful Minimalist ceilings, partitions or benches as social spaces whose actual purpose or function is open to interpretation. His sleek corporate-looking installations with management jargon titles evoke big business and bureaucratic environments, and demonstrate ways in which architecture and language can be used to exert subtle social and economic control over people. 'I think certain things...that I was involved in got mis-characterized as being part of that system rather than conscious and critical of it....I don't think you have to make abject looking things to show that you're being critical,' he says.

Besides Liam Gillick, shows like 'Intelligence' and 'Protest and Survive' brought to wider attention non-Goldsmiths artists such as Martin Creed, Jeremy Deller, Grayson Perry and Wolfgang Tillmans, whose concerns were perceived by curators to be more serious, quieter and less self-indulgent than those of Damien Hirst's group. These four artists would go on to win the Turner Prize in this period, which reflected the changing mood.

Where YBAs had dominated the Turner Prize shortlists through the 1990s, by 2000 the Tate was casting its net wider. That year the German artist Wolfgang Tillmans won the award with his visual bombardment of photographs reflecting contemporary culture. But even so, the media managed to whip up controversies around the nominees. The sole BritArtist Glenn Brown found himself at the centre of a scandal when *The Times* newspaper reported that his painting, *The Loves of Shepherds* (2000), was 'copied' from the cover of a science fiction book without acknowledgment of the original. The wall label acknowledged the original, but the Tate's Turner Prize literature did not. At the Turner Prize ceremony the newspaper arranged for an awkward confrontation between Glenn and the outraged illustrator of the original, Tony Roberts. It led to a costly legal battle that was eventually settled out of court. 'It felt as if every year the journalists were trying to find "What's the freaky bit of publicity we can find in

OPPOSITE: Liam Gillick, *Applied Resignation Platform*, 1999. Plexiglas panels, existing ceiling, dimensions variable. Installation view, Frankfurter Kunstverein, 1999

ABOVE: Liam Gillick, *Big Conference Centre 22nd Floor Wall Design*, 1998. Paint, anodized aluminium, Plexiglas, dimensions variable

this year's Turner prize?" And unfortunately, I was it in my year,' says Glenn. While to the media and public it may have appeared a clear case of plagiarism, to Glenn, who had been immersed at Goldsmiths in Post-structuralist theory about the death of the author and appropriation, the furore seemed absurd. 'It seemed a natural part of the vocabulary of being a contemporary artist to me to appropriate other artists and found images. And to do anything else other than that seemed slightly irrelevant to me as an activity,' he says. 'I always believed my own voice is only made up of the voices of other people.' Glenn's artistic practice relied on unravelling the language of other painters and reinterpreting them for a modern audience.

> It seemed <u>a natural part of the vocabulary</u> of being a contemporary artist to me **to appropriate other artists and found images.**
>
> GLENN BROWN

Since Goldsmiths, Glenn's art had grown in sophistication. His paintings had moved beyond simple appropriation to become elaborate personalized compositions, freed, sometimes beyond recognition, from their original moorings through changes to colour, style or form and the addition of comically discordant titles.

The Turner Prize had come under increasing attack as tired and dominated by Conceptual art, so its award to Slade-trained Martin Creed in 2001 for his installation of an empty room with lights going on and off drew cries of outrage. In 2002, the culture minister Kim Howells ranted, 'If this is the best British artists can produce, then British art is lost. It is cold, mechanical, conceptual bullshit.'[17]

Michael Landy, one of the few YBAs overlooked for the Turner Prize, created an artwork in February 2001 around the destruction of his entire worldly belongings, catching the more sombre mood of the time. He traces the genesis of his spectacularly anti-commercial work *Break Down* to the Tate's purchase of his installation *Scrapheap Services*. 'Suddenly I have a car and suit and my little apartment and I think, "Well how can I fuck this up for myself?"' Staged in a former department store on Oxford Street, London, over two weeks with the help of the non-profit art funding organization Artangel, *Break Down* took more than three years to prepare and, like *Scrapheap Services*, demonstrates the extreme ascetic side of Michael's personality. He explains the work as 'a way to get to understand consumerism which is the number one ideology of our time, to literally take it apart. That's wrapped up with commodity but also oneself

OPPOSITE, ABOVE:
Glenn Brown, *The Loves of Shepherds (after 'Doublestar' by Tony Roberts)*, 2000. Oil on canvas, 219.5 × 336 cm (86 7/16 × 132 3/16 in.)

OPPOSITE, BELOW:
Glenn Brown, *The Tragic Conversion of Salvador Dalí (after John Martin)*, 1998. Oil on canvas, 222 × 323 cm (87 3/8 × 127 3/16 in.)

and about building one's own biography through what one possesses.'
With the help of a team, all his possessions were recorded in a
meticulous inventory, then dismantled and placed in trays on
a conveyor belt headed for landfill; love letters, passport, his record
collection, dad's sheepskin jacket, friends' artworks and his car all
went into the grinder. 'People would literally come in and see the
little things travelling around on the yellow trays and suddenly
they'd make a mental inventory of what they possessed and it's
like a mirror image of their own feelings about possessions,' says
Michael. Religious denominations came to witness the event; sermons
were given about it. Friends tried to persuade Michael to sell some
of the pulped items as a way to make money from the work but he
refused, although he agreed to film the performance. 'I had to destroy
everything, otherwise it would compromise the whole thing,' he says.

In an indictment of the art world, several items were stolen
at the private view. Gary Hume asked to switch a painting he'd
given Michael as a present for another, but then was so moved by
the generosity of Michael's act that he let him destroy the original.

'That's the only time I felt "what am I doing?" It's slightly bizarre to be destroying another artist's work with a blowtorch,' says Michael. Along with Gary's painting, he destroyed works by Tracey Emin, Abigail Lane, Damien Hirst and Simon Patterson. *Break Down* amounted to an excruciating self-portrait; not only was Michael casting off his material goods, he was also effectively baring his soul to complete strangers, taking stock as people do before they die. His mother came and wept. 'It was a mixture of being the happiest two weeks of my life and then witnessing your own death simultaneously...so you go through very paranoid moments as well.' Michael ended up in debt, but felt liberated. It took him over a year to create any work again, but he says the experience 'gave me a way to mine what I was about'. In 2004 he would create a life-size replica of his parents' semi-detached home in Tate Britain's Duveen galleries, articulating for the first time his anguish over his father's industrial accident.

Suddenly I have a car and suit and my little apartment and I think, 'Well how can I fuck this up for myself?'

MICHAEL LANDY

Mark Wallinger had shifted emphasis from horse racing and national identity towards an exploration of the religious framework that defines us, as seen with his Trafalgar Square statue of Jesus. In 1997, Mark created his video work *Angel*, in which he appears as an evangelical emissary called 'Blind Faith' on an escalator in the London underground reciting the opening of St John's gospel phonetically backwards, as if speaking in tongues. 'To learn that is to make pretty clear that language's relationship with the objects of the world is just as fanciful as that scripture has with faith. You can literally learn the bible backwards and never get there in terms of being a believer,' he says. Mark represented Britain at the 2001 Venice Biennale where he exhibited *Ecce Homo* and his video *Threshold to the Kingdom* (2000). A classic example of his love of puns and double entendre, the video shows weary visitors in slow motion entering an airport arrivals section in the United Kingdom to the portentous strains of Gregorio Allegri's 'Miserere Mei', prompting comparison with souls arriving at the gates of Heaven. Mark was struck by the way the state apparatus induced an anxiety in travellers akin to that of the sinner facing religious judgment. 'That movement from no-man's-land through to the official terra firma of the state and "anything to declare?", and that frisson of guilt or even fear that one experiences, was analogous to

Michael Landy, *Break Down*, 2001. Installation view, C&A building, Oxford Street, London. Mixed media, dimensions variable

confession and absolution,' he explains. His preoccupation with the theme of religion appeared highly relevant in the growing climate of religious extremism that would see the 9/11 attacks in 2001.

By 2003 the Turner Prize had effectively become a showdown between the two different art tendencies: the political/serious and spectacular/decadent. Transvestite potter Grayson Perry, whose seductively beautiful pots bore trenchant social commentary, collaged pornographic drawings and expletive-laden graffiti, was pitted against arch provocateurs Jake and Dinos Chapman. While Grayson's pots and the Chapmans' works may have appeared equally sensational to the public, in the art world the former were considered more in line with the trend for serious art. Within the conventional framework of a Grecian urn or Japanese vase, Grayson presented richly textured narratives drawing on his autobiography, popular culture and folk art that were by turns poignant, such as *We've Found the Body of Your Child* (2000) dealing with child abuse, and humorous, like *Saint Claire (37 Wanks Across Northern Spain)* (2003), which references his transvestite persona Claire. Grayson was not considered a frontrunner because of a longstanding snobbery in the art world towards craft. 'Craft was always the...pretentious next door neighbour, and that's where it belonged,' he says. '...the Duchampian leap of intellectual understanding that is the shark and the urinal, that's stock-in-trade for the twentieth-century art world.'

Anya Gallaccio, also nominated that year along with Willie Doherty, considered declining the honour on account of the 'playground bullying type of commentary' in the media coverage of prizes. Yet she sensed a responsibility as a woman artist to be counted, all too aware of the numerous female artists eclipsed in history by their assertive male counterparts and partners. 'I felt that it was important that I had made a considerable body of work and that I didn't want to be invisible,' she says. In the event, the spotlight barely shone her way. The Chapman brothers were the clear favourite to win. 'I think they practically booked the open-topped bus to drive down Shoreditch High Street....They were probably glad they didn't,' says Grayson, the eventual victor.

For their Turner show, the Chapmans presented a bronze sculpture of plastic blow-up dolls in the sixty-nine position and their series *Insult to Injury* (2003) of original etchings of Goya's *Disasters*

OPPOSITE, ABOVE: Mark Wallinger, *Threshold to the Kingdom*, 2000. Installation for video projection, audio, 11 minutes 20 seconds. Video still

OPPOSITE, BELOW: Mark Wallinger, *Angel*, 1997. Installation for video projection, audio 7 minutes 30 seconds. Video still

*of War* that they had 'rectified' by superimposing cartoon heads in the ultimate taboo of defacing another artist's work. The Chapmans had originally hoped to show *Hell*, which had caused such a stir at the Royal Academy's 'Apocalypse' exhibition, but Charles Saatchi refused to loan the work because of a spat with Tate director Nicholas Serota, according to Dinos. 'We only agreed to do the Turner Prize if we could show *Hell* because we thought that's pretty much our Tysonesque knock-out blow,' Jake recalls, '...so that really scuppered it for us.'

Saatchi's refusal to lend *Hell* for the Turner contest came as his influence was waning in the art scene. For years he had bemoaned the Tate's failure to collect and display contemporary art and the fact he had to do its job. However, when Tate Modern arrived he was reportedly unenthusiastic. 'If I had been Charles, I would have welcomed the Tate with open arms,' says Michael Craig-Martin. 'Instead he took the view that the Tate was his enemy...so everything is pitched against the Tate.' Saatchi closed his iconic Boundary Road gallery in March 2003 and relocated to County Hall on the south bank of the Thames near the London Eye, upriver from Tate Modern, fuelling speculation that he regarded the new art colossus as a rival.[18] 'Boundary Road had been so important in refining the way art was presented and contextualized. And then suddenly it seemed like it was just...a tourist attraction,' says the gallerist Sadie Coles. 'There was definitely a shift of seriousness at that point.' Saatchi's new oak-panelled gallery opened with a retrospective of Damien Hirst that was confusingly interspersed with work of other artists in the labyrinthine layout of the Greater London Council former headquarters.[19] Damien was furious about the way his art was displayed. Moreover, Saatchi's show managed to thwart Tate's plans for a survey of Damien's work.[20] In the ensuing row with his former protégé, Saatchi threatened to dump a load of Damien's artworks on the market; White Cube bought back one third of Saatchi's Hirst holdings at considerably more than Saatchi paid for them.[21] Damien was later quoted as saying, 'I'm not Charles Saatchi's barrel-organ monkey. He only recognizes art with his wallet...he believes he can affect art values with buying power.'[22]

Saatchi's vital role in the success of BritArt is beyond question; he was effectively the only collector of the seminal works of the period. His patronage enabled numerous artists to keep going in the impoverished early days, but being collected by Saatchi was a

double-edged sword. While it raised artists' profiles, he invariably demanded massive discounts, at times refused to lend work for prestigious museum shows – as happened to the Chapmans – and he never collected for the duration. Saatchi bought a lot of Sarah Lucas's work and then at a certain point sold most or all of it. It turned out all right for Sarah as Damien bought her work, but others got a knock when their pieces were unceremoniously offloaded at auction by Saatchi, a supposed tastemaker. *Frieze*'s Matthew Slotover recounts a conversation with Saatchi, who asked, '"Why does everyone hate me?" And I said, "Because you sell." And he said, "Well everyone sells. What I love to do is buy stuff, and install it....Surely everyone knows that when they sell to me, there's a chance that I'm going to sell it. Because I keep doing it. This is what I do."' Almost never giving interviews – he declined to contribute to this book – Saatchi cultivated a mystique around himself while his active PR machine kept the tabloids au fait with the outrageous sums he paid for artworks, which in turn augmented the market value of what he collected. Some BritArtists refused on principle to sell to an adman who had helped to keep the Tories in power and whom they regarded as a glorified dealer via auction houses. 'To a certain extent, why he had any clout is because people were all really fascinated by his ruthlessness,' Sarah laughs.

## THE COMEDOWN

As Saatchi was edged to the sidelines by the presence of Tate Modern and a clutch of new collectors, several of the former young turks he had patronized joined the Royal Academy, the famously staid private artists' club founded in 1768 where the Queen is still toasted at dinners. 'It's funny that it went from "Sensation" and shock horror with some RAs resigning in disgust to us actually being there in the meetings, having an influence on the place,' says Fiona Rae, who became a Royal Academician in the early noughties along with Tracey Emin, Gary Hume and Jenny Saville. (Fiona was appointed the first female Professor of Painting at the Royal Academy Schools in 2011.) She was also commissioned to create a 10-metre (33-foot) mural, *Shadowland*, for Tate Modern's restaurant in 2002 and a

ABOVE: Fiona Rae creating
the 10-metre (33-foot)
mural *Shadowland* for Tate
Modern restaurant, 2002.
Oil and acrylic paint
on three canvases, each
143 × 335.3 × 5.2 cm
(57 × 132 × 2 in.).
Photograph by Dan Perfect

OPPOSITE: Fiona Rae's
work *Signal* covers
the façade of BBC
Broadcasting House during
refurbishment, 2003.
Photograph by Dan Perfect

ABOVE: Ian Davenport
working on *Poured
Painting: Magenta,
Orange, Magenta*, 1999.
Photograph by
Sue Arrowsmith

OPPOSITE: Ian Davenport,
*Everything*, 2004. Acrylic
paint on plasterboard,
762 × 1,067 cm
(300 × 420 in.)

giant artwork for the façade of BBC Broadcasting House in 2003 during refurbishment. These dreamy works interweave incongruous computer graphics, symbols and squiggles suspended against a black background, drawing on Pop Art as well as contemporary references such as photographs of space and movie opening titles.[23] 'I did find it exciting to include cultural flotsam and jetsam because it undermines the seriousness of the abstract project, and I think enlivens it,' says Fiona. Such high-profile establishment backing from the Tate and BBC would have seemed utterly impossible to Fiona and the other 'Freeze' participants back in 1988.

People just **see bronze** and they think, 'Oh she's sold out because this is a permanent thing, **it's not going to decay'**….

ANYA GALLACCIO

Since his paint pot experiments at Goldsmiths, fellow painter Ian Davenport had variously played with stripes and arches in his work, absorbing urban influences such as the plastic strip curtain of his local kebab shop and the form of the Rotherhithe tunnel. Always looking for new ways to apply paint without a brush, he came up with ingenious techniques. He had used a watering can to pour paint into shimmering vertical curtains of colour that recall the pumping rhythm of electronic music, as well as the American Colour Field painters.[24] Later inspired by pancake-making, he invented a spindle to flip the canvas round to create perfectly centred circles. Ian returned to stripes, substituting the watering can for a syringe after a disparaging critic wrote that Ian was so 'anal' he would probably start painting with a syringe. 'I thought, actually that's a perfect idea as it's such a perfect tool.' With the syringe he could achieve cascading lines of colour without using masking tape as artists did previously to prevent overruns. These 'colourfall' paintings would become his signature, such as that commissioned by the University of Warwick, which has a shelf at the bottom where the paint puddled, adding chaotic verve to the whole.

Besides Ian and Fiona, other 'Freeze' veterans were also developing their art in new directions. Anya Gallaccio's Turner Prize installation *Because I Could Not Stop* (2002), a bronze sculpture of an apple tree adorned with real apples, had marked a fresh departure in her practice with a move away from purely ephemeral matter into the traditional medium of bronze. Some critics wondered whether the shift to saleable works might compromise Anya's art, but she contends

Anya Gallaccio, *Because
I Could Not Stop*,
2002. Bronze, apples,
dimensions variable

that each bronze she makes is created as a unique object in a hugely labour-intensive and expensive process during which the original gets destroyed. 'People just see bronze and they think, "Oh she's sold out because this is a permanent thing, it's not going to decay"…to me this instability or transience is still intellectually built into the work,' she says. 'It's just not visible.'

Like Anya, Angela Bulloch developed a new strand in her practice with her extraordinary 'pixel box' sculptures using cutting-edge technology. These colour cubes contain red, green and blue fluorescent tubes capable of generating millions of different hues. Displayed as columns or banks of screens, in pulsating colours, these boxes evoked a Minimalist aesthetic. But whereas the Minimalists rejected narrative, these apparently random colour grid patterns bore traces of films and television programmes. For instance, *Z Point* (2001) comprises a wall of boxes showing a looped abstraction of the last eight minutes of Michelangelo Antonioni's 1970 cult classic *Zabriskie Point*, in which a Modernist home explodes repeatedly. The film sequence is re-presented dramatically condensed as a composition of alternating colours whose browns, blues and yellows might evoke the desert, sky and flames of the scene and whose reconstructed soundtrack might spark snippets of recollection, yet the film's narrative cannot be pinned down. 'It's very abstracted to the point where you don't recognize it exactly and yet you can see it,' says Angela. By reducing each image to its smallest component, a single pixel that is enlarged to the size of a monitor, the artist has dissolved the film's visual information into pure abstraction, an almost counterintuitive use of digital technology that generally improves precision. 'It's like a very perverse technical vanguard,' she explains.

As art became more mainstream, a raft of impressive new galleries sprouted around Britain, thanks to National Lottery funding. The Baltic Centre for Contemporary Art in Gateshead was created from a converted flour mill, The Lowry opened in Manchester, the New Art Gallery in Walsall in the Midlands, along with Dundee Contemporary Arts, Edinburgh's Dean Gallery and the Milton Keynes Gallery, all of which would invigorate visual art outside London. These regional galleries offered further testimony of the sea change that Britain's art scene had undergone from the early 1980s, when the limited action was concentrated in London.

Angela Bulloch,
*Z Point*, 2001. 48 plastic dmx modules, dmx controller, soundtrack, sound equipment, 300 × 400 × 50 cm (118 1/8 × 157 1/2 × 19 11/16 in.). Installation view, Modern Art Oxford

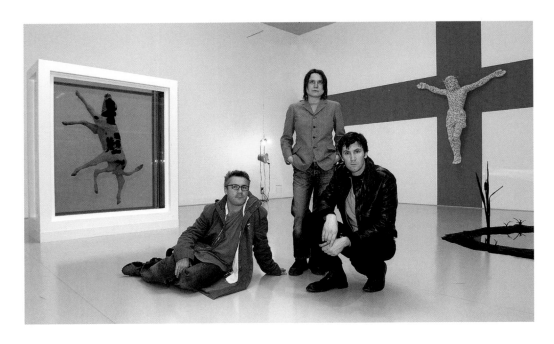

ABOVE: Damien Hirst, Sarah Lucas and Angus Fairhurst at the 'In-A-Gadda-Da-Vida' show at Tate Britain in 2004. In the background L–R: Damien Hirst's *In His Infinite Wisdom*, 2003, and Sarah Lucas's *Christ You Know it Ain't Easy*, 2003

OPPOSITE: Installation view, 'In-A-Gadda-Da-Vida', Tate Britain, London, 2004. In the foreground: Angus Fairhurst's *The Birth of Consistency*, 2004. In the background: Sarah Lucas, *Spam*, 2004; Damien Hirst, *The Pursuit of Oblivion* (detail), 2004; Damien Hirst, *Butterfly Wallpaper*, 2003

*Frieze* magazine's founding editors, Matthew Slotover and Amanda Sharp, launched Frieze art fair in the autumn of 2003, which would prove a game changer for London, helping to catapult it into the art big league commercially. 'Frieze art fair came out of the context of lots of British artists that people internationally wanted to show,' Slotover explains. 'An increasing number of commercial galleries in London...were there partly because of a booming art scene in terms of museums and galleries and artists, but also partly because of the booming international economy in London, and international collectors coming to London,' he adds. Packaged as hip, sexy and cutting edge, the fair was a massive success from the get-go, rapidly becoming an unmissable feature of the art calendar for gallerists.

With so many changes and new players, a sense prevailed by 2004 that as a group the YBAs were past their sell-by date. The reception of Tate Britain's would-be blockbuster show 'In-A-Gadda-Da-Vida', which brought together Goldsmiths mates Angus Fairhurst, Damien Hirst and Sarah Lucas, demonstrated this. The show's title, taken from the lead singer of rock group Iron Butterfly's sloshed attempt to say 'In the Garden of Eden', evoked the breezy

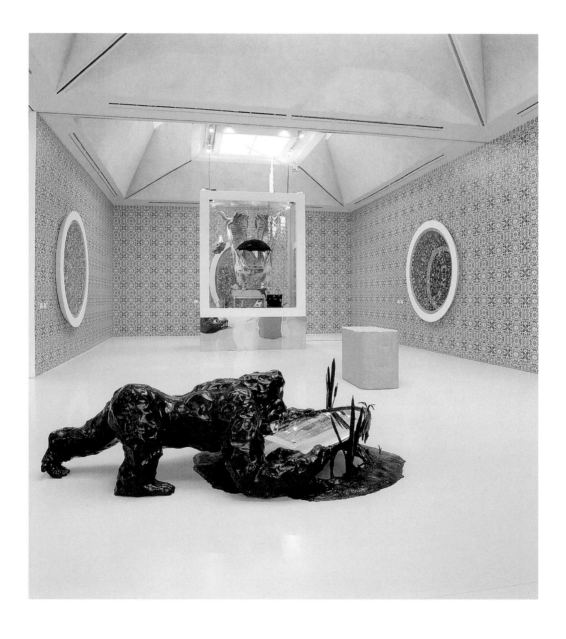

nonchalance of the artists' heyday, but the art world had moved on and the exhibition was panned by critics as both conservative and obvious.[25] Damien's expensive pickled animal vitrines and butterfly paintings vied with Sarah's bawdy sculptures, including a Christ made of cigarettes crucified against the St George's Cross of the English

flag: a long way from the slapdash innocence of their 'Freeze' works. Cigarettes, with their sex and death overtones, were common to both Sarah's and Damien's work. Damien had earlier created paddling-pool-sized ashtrays and cabinets lined with fag ends as a memento mori, while Sarah made an entire exhibition around cigarettes in 2000 called 'The Fag Show' at Sadie Coles, comprising garden gnomes, football-sized breasts and Hoovers all painstakingly covered in cigarettes. 'I started it actually as a kind of weird giving up smoking, just something to do with my hands, a bit like knitting…,' she explains, 'and then I liked this thing of them being like little penises or sperms or tadpole-looking things.' 'In-A-Gadda-Da-Vida' was more about the reunion of friends than unifying themes. 'When Sarah and I were drunk, Angus couldn't get a word in and often went to bed and left us talking…or mostly shouting at each other at the same time, but that was how we communicated,' says Damien. The Tate exhibition seems to mirror this, with Damien's and Sarah's works shouting over Angus's large pensive bronze gorilla sculptures and subtle layered wallpaper.

Gorillas ran through Angus's work as a tragicomic motif: in drawings and looped animations, in a quizzical photographic take on a *pietà* with a naked Angus in the arms of a gorilla, and in his video *A Cheap and Ill-Fitting Gorilla Suit* (1995). In the film he appeared dressed as a gorilla and went through the motions of jumping up and down before stripping off the costume and leaping free, naked and puny. 'Angus's work was very much about the human condition. And the intellect versus the instinctive. There was often a conflict within the work that would reveal or disrupt,' says his dealer Sadie Coles.

Many art world insiders believe the Tate show had a negative impact on Angus, who was less commercially successful than the

ABOVE: Sarah Lucas and Angus Fairhurst in their studio, Clerkenwell, London. *c.* 1994–1995. Photograph by Abigail Lane

OPPOSITE: Angus Fairhurst, *Pietà (first version)*, 1996. Colour photograph, 35 × 50 cm (13 ¾ × 19 ⅝ in.)

other two. 'I think it was a disaster for him. Absolutely,' says Jon Thompson, who rated Angus as one of the most gifted students he taught at Goldsmiths. 'I think there's a profound sense in which he disappointed himself in some way...but I'm only suspecting that. I've no proof of that.' 'I think probably Angus did feel it quite acutely, the terrible feeling he was lagging behind. But also I think he was ambitious...in a way that I would say I'm not,' says his exgirlfriend Sarah Lucas, who has refused Turner Prize nominations on account of her dislike of competition and the media circus. 'I feel in a way me and Damien might have been...opposing forces on Angus about what art should be.' Angus was a central pillar of the Goldsmiths group, viewed as its 'towering intellect' and sounding board. Constantly experimenting with media and styles, to the frustration of collectors, he was always restless, trying to push his practice forward, never satisfied. 'Angus was the most successful of the three of us in the early days, when he was making the tag pieces, but he stopped making them as soon as there was a demand. I never understood that,' says Damien, who in typical generosity to his friends commissioned Angus's first bronze gorilla. Many artists have remarked on a deep loneliness and melancholy that he exuded beneath his gentle and funny exterior. Angus would hang himself

from a tree in Scotland in 2008 on the last day of a solo show at Sadie
Coles's gallery.

In May 2004 a blaze ravaged an east London warehouse used
by the art storage company Momart and destroyed a number of iconic
BritArt works. Tracey Emin's tent, the Chapman brothers' *Hell*, Richard
Patterson's *MOTOCROSSER II* and his three *Culture Station* paintings
were incinerated, as well as over thirty works by Mark Wallinger, others
by Michael Craig-Martin and Damien Hirst, and some fifty irreplaceable
canvases by the late British abstract painter Patrick Heron. The tabloids
and even some broadsheets revelled in the artists' misfortune. 'Can a
fire ever be funny? Only if all the overpriced, over-discussed trash that
we have had rammed down our throats in recent years by these ageing
enfants terribles is consumed by the fire. Then the fire is not merely
funny...it is bloody hilarious,' wrote Tony Parsons in the *Daily Mirror*.[26]
The *Sun* and *Daily Mail* both had the waggish idea to make their
own versions of Tracey's tent and even the *Independent*'s critic Tom
Lubbock suggested Tracey could easily knock up an updated version
with recent conquests.[27] The Chapman brothers in fact did make
a spoof tent, much to Tracey's annoyance. For Richard Patterson, the
loss was devastating as his paintings had each taken months to create
and his style had since changed. The Chapmans, on the other hand,
found *Hell*'s fiery fate highly amusing and took pleasure in laboriously
recreating it as the bigger, even more atrocity-packed *Fucking Hell* (2008).

Damien Hirst's once trendy restaurant Pharmacy had failed,
but on the day the receivers were due to clean out the interior his
canny business manager Frank Dunphy turned up with a van and
bought whatever the artist didn't already own, from the doors and
light fittings to the cutlery and ashtrays.[28] In a risky gambit, Damien
sold the lot through Sotheby's, as well as the art that had graced
the restaurant walls. The sale was marketed as an artwork in itself,
with Damien designing the catalogue and recreating the restaurant's
pharmaceutical look for the pre-sale show.[29] 'I definitely see it as an
element in the composition, I always have,' Damien says of the selling
process. The auction more than tripled forecasts, netting an amazing
£11 million. If the critics were wearying of Damien's output, the public
couldn't get enough of it.

Towards the end of the year, Damien's one-time patron Charles
Saatchi embarked on a massive sell-off of his BritArt collection. He

claimed to have first offered his extensive collection as a gift to the Tate but to have been snubbed.[30] However, the Tate's director Nicholas Serota has a different story. 'In 1998 we approached him for some gifts to open Tate Modern and he declined,' says Serota. 'He subsequently offered us a group of works from his collection, none of which were the iconic works in the collection. We declined that offer. That was it.' Many of the quintessential works of the 1990s went to America. Serota had wanted to buy Rachel Whiteread's cast of a living room, *Ghost*, but Saatchi sold it to the National Gallery in Washington; the American hedge-fund billionaire Steve Cohen bought both Marc Quinn's blood head for $2.8 million and Damien's shark for $12 million, making Saatchi a tidy profit on the £12,000 and £50,000 respectively he paid when Marc and Damien were struggling artists.[31] The sale was widely interpreted as a sign that Saatchi had grown tired of the movement he had championed.[32] In a final break with BritArt, the advertising guru declared that of the late twentieth century, 'every artist other than Jackson Pollock, Andy Warhol, Donald Judd and Damien Hirst will be a footnote'.[33]

As 2004 ended, the YBAs had been ditched by their patron, seminal works had gone up in smoke, Damien had got a lot richer and the group was dispersing. Most of the artists now had galleries (some had country manors), London had a contemporary art fair and the public had a powerful contemporary art museum. But like Tracey's tent, the heady optimism of the egalitarian 1990s would never return. 'There'll never be another tent, that's it,' she says. 'When it burnt, I could've got a million pounds to remake it and I didn't because it can't be remade.'

The history of the Young British Artists began with Damien Hirst as a scruffy young art student organizing a seminal show and ends with him becoming the richest artist in the world,[1] an astonishing feat whatever one thinks, particularly for an English artist, given the country's cultural tradition of reserve and modesty. 'I've always pitched money and art against each other. Because I think that art's more powerful than money,' says Damien. The artist fused the two in 2007 with his diamond and platinum skull *For the Love of God*; made from 8,601 flawless diamonds and priced at £50 million, it is the most expensive artwork ever made. 'It was the perfect thing for him to do, because it was just embracing what his work was all about anyway, that commodification to it,' says the artist Grayson Perry. The skull failed to attract a buyer and was declared to have 'sold' to a consortium consisting of Damien, White Cube and an anonymous group.

> I suppose I started in the beginning saying **I don't care about money**...and then, I think, in the end...even if you don't care about money, you have to somehow respect it in some way.
>
> DAMIEN HIRST

Damien's Midas touch reached its apotheosis in 2008 when he took 223 new works directly from his studio to Sotheby's auction house in a sale that netted £111 million, giving the two-finger salute to his galleries White Cube and Gagosian. The heavily marketed extravaganza entitled 'Beautiful Inside My Head Forever' coincided with the collapse of the investment bank Lehman Brothers, adding a surreal touch to the proceedings, even beyond the formaldehyde bestiary of winged piglets, unicorn and calf with golden hoofs and horns on offer. The event broke countless records and rules, making Damien appear either a far-sighted business genius or reckless daredevil, or both. Amid accusations that Damien's dealers were the main buyers,[2] the sale reportedly made more money in forty-eight hours than all the art by the artists hanging in the National Gallery fetched in their lifetimes.[3] 'I suppose I started in the beginning saying I don't care about money,' acknowledges Damien. 'And then, I think, in the end...even if you don't care about money, you have to somehow respect it in some way.'

The Young British Artists are now on the way to becoming Old-Age Pensioners. They are mid-career, a notoriously tricky hurdle to overcome. Many still show with prestigious museums and galleries, some have dropped away, others died young such as Angus Fairhurst,

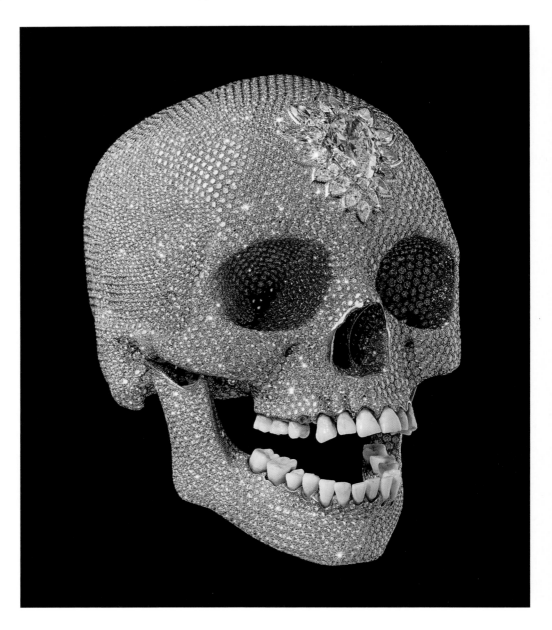

Damien Hirst, *For the Love of God*, 2007. Platinum, diamonds and human teeth, 17.1 × 12.7 × 19 cm (6.7 × 5 × 7.5 in.)

his band member Philippe Bradshaw, who was found tragically washed up in the Seine, Joshua Compston and Lawren Maben. But a surprising number have stayed the course and continue to make their mark individually. Certain friendships remain strong; however, the attraction of opposites that fuelled the dynamic between Sarah Lucas and Tracey Emin during The Shop also pulled them apart, culminating years later in Sarah shoving her workmen's boot in Tracey's head at a party. 'It was a...non-sexual love affair...and it was fraught with complicated tensions,' says Abigail Lane, who is like the glue between the group's factions. 'It's not resolved...perhaps they still don't know where they are with each other.'

> I don't think it's anything to do with whether [Damien's] art is relevant to the contemporary art world anymore. It's become a kind of international asset class.
>
> GRAYSON PERRY

Following the Sotheby's coup, Damien turned his hand to painting, which he has never mastered. With typical bravado, he presented his oil canvases in 2009 at the august Wallace Collection, where they were savaged by critics as derivative and amateur, shrivelled by the grandeur of the masterpieces around. 'There's a difference between early Damien and then Damien becoming a super international big star and repeating his vocabulary. I think there's a really, really, really big difference,' says the German gallerist Esther Schipper. 'I think the first formaldehyde half cow and shark were very important internationally speaking.' 'My feeling is that he very consciously maxed it out to the hilt, and now is dealing with the consequences,' agrees Karsten Schubert. Yet the shows have kept coming. In 2011 Larry Gagosian mounted an exhibition of spot paintings across his eleven galleries worldwide and in 2012 Tate Modern staged a Hirst retrospective (notably excluding his recent paintings) to coincide with the Olympics. Now off the booze and drugs, Damien's energies are diffused across projects ranging from a new museum in south London for his art collection, his retailing and publishing empire Other Criteria and his art. He has found an avid following among billionaire Eastern European oligarchs and Middle Eastern potentates, although his prices slumped when the art market bubble burst shortly after the Sotheby's sale.[4] 'I don't think it's anything to do with whether his art is relevant to the contemporary art world anymore. It's become a kind of international asset class,' says Grayson Perry.

As for the rest of the group, many have become the grandees of British art, an amazing accomplishment considering the bleak prospects they faced setting out from art college in the late 1980s. Several have had impressive retrospectives in British institutions and abroad. Sarah Lucas, now based in Suffolk, represented Britain at the 2015 Venice Biennale with a lusty parade of phallic sculptures and casts of women's bottom halves. In 2013 the Whitechapel Gallery showed her early works and *Nuds*, elegant sausage-like sculptures from stuffed tights or bronze that evolved from the bunnies. Both Whitechapel and Institut Valenciá surveyed Gillian Wearing's career, including *Album* (2003–2006), the unsettling photographic portraits of her family made with silicone masks over her own face, and her 2010 film *Bully*, in which a method-acting class re-enact a bullying incident. Tracey Emin, who has translated her expressionistic nude drawings into embroidery and bronze sculptures, has had survey shows at the Hayward Gallery and the Scottish National Gallery of Modern Art. Paired with Patrick Caulfield in a 2013 show at Tate Britain, Gary Hume presented his alluring paintings with their flat, joyous expanses of colour obliquely suggesting subjects from American cheerleaders to German Chancellor Angela Merkel. Douglas Gordon has had retrospectives at the National Galleries of Scotland and various international museums. He and Philippe Parreno received rave reviews from sports commentators and art critics alike for their 2006 film about French footballer Zinedine Zidane. Jake and Dinos Chapman's retrospective at the Serpentine Gallery in 2013–2014 featured their panoply of nightmarish images interspersed with life-size Ku Klux Klan mannequins who mingled with visitors. Following a residency at the National Gallery, Michael Landy created gigantic kinetic sculptures of saints with their symbols of martyrdom for his 2013 show 'Saints Alive'. 'I do think a lot of those people have carried on really, really interestingly. For a very long time now,' says Karsten Schubert, who now represents a select group of artists, including Bridget Riley, and owns the art publishing imprint Riding House.

In terms of high-profile projects, Rachel Whiteread filled Tate Modern's enormous Turbine Hall with a bewitching landscape of white polyethylene casts of cardboard boxes in 2005 titled *Embankment*, reminiscent of the icy Arctic wastes or a child's paradise of Turkish delight. That same year Marc Quinn created tremendous controversy by

Installation view of Rachel
Whiteread's *Embankment*,
Turbine Hall, Tate Modern,
London, 2005. 14,000
white polyethylene boxes,
12 m (39 ft) at its highest
point

ABOVE: Marc Quinn,
*Alison Lapper (8 months)*,
2005. Marble and plinth,
83.5 × 40.5 × 65 cm
(32 7/8 × 16 × 25 5/8 in.)

OPPOSITE: Mark Wallinger,
*State Britain*, 2007.
Mixed-media installation,
5.7 × 43 × 1.9 m approx.
(19 × 141 × 6 ft). Detail,
installation view at
Tate Britain, 2007

installing a marble statue of the pregnant artist Alison Lapper, who was
born with no arms and shortened legs, on the Fourth Plinth of Trafalgar
Square. Surrounded by the virile male heroes of Britain's military past,
the sculpture presented a fragmented Amazon of the modern age.
A monumental inflatable version became the symbol of the Paralympics
in 2012. Ian Davenport was commissioned in 2006 to create a 48-metre
(157-foot) multicoloured curtain of stripes along Southwark Street near
Tate Modern. Mark Wallinger in 2007 won the Turner Prize (his second
time on the shortlist) for *State Britain*, his recreation of the anti-war
campaigner Brian Haw's protest in Parliament Square. Mark had been
appalled by the feeble public reaction to the Iraq invasion and the
government's restriction of democratic protest; the work gave Brian's
peace camp an urgent reprieve within an apolitical public forum after
it was dismantled by police.

But measures of success vary. Is it earning the respect of one's
peers? A solo show at the Museum of Modern Art in New York, as
Douglas Gordon had in 2006? Winning the Turner Prize? Representing
Britain at the Venice Biennale? A million-dollar auction result? The
BritArtists have achieved success by different measures. Marc Quinn
has gained a strong following among collectors for his diverse works,
from statues of Kate Moss in yogic knots to monumental bronzes and
tapestries of contemporary history. Glenn Brown's distinctive paintings

regularly fetch several million pounds apiece at auction. Sam Taylor-Wood has become a Hollywood film director with her 2015 box-office hit *Fifty Shades of Grey*. She, Tracey Emin and Gillian Wearing have been recognized with Queen's honours. 'I think getting my CBE made a lot of difference to a lot of people because they suddenly had to think, "Oh Christ, she really is part of the establishment,"' says Tracey, who also has 'a property portfolio that stretches on and on', according to her friend, photographer Johnnie Shand Kydd. Jane and Louise Wilson continue to earn critical acclaim for their films and photographs investigating the emotional resonance of architectural spaces, from Second World War bunkers to nuclear test laboratories. But every artist knows that the toast of today may be forgotten tomorrow. Equally, undiscovered artists from the 1990s may be hailed as geniuses in years to come as fashions and sensibilities change.

Since the 1990s, when Charles Saatchi was virtually the sole contemporary art collector in Britain, the global art market – one of the last unregulated arenas of trade – has exploded into a rapacious beast that needs constant feeding. Opulent new buyers from the non-Western world have joined the picture. Middle Eastern nations such as Qatar aspire to build world-class art collections from scratch. Prices keep pushing higher, as seen by the private sale of Paul Gauguin's 1892 oil painting *When Will You Marry? (Nafea faa ipoipo)* in February 2015 for a reported $300 million.[5] Art fairs have proliferated and now dominate the dealer's calendar. Artists in turn come under pressure to churn out baubles for these gigantic supermarkets rather than spend time developing their work. In the rarefied world of art investment, collectors and investors focus on a privileged group of top-selling, mainly male, contemporary artists including Damien Hirst and Jeff Koons.[6] Michael Craig-Martin recounts with dismay how recently a successful art dealer declared that 'except for about a hundred important artists in the world, the rest was just a complete waste of time. And they could just pack up.' But such a view misses the crucial point that the 'star' artists owe their position to the thousands further down the ladder. 'Underneath all that, there's all the other work that always goes on that is often unseen,' says Simon Patterson, who has continued to explore taxonomies since his reworking of London's tube map.

One of the most important achievements of the group was to democratize art by creating work that caught the public imagination.

'An engagement with contemporary art in Britain was its massive legacy,' says Frieze fair co-founder Matthew Slotover. Some critics contend that the British public's interest is superficial, limited to the recognition of a few key names such as Tracey Emin and Damien Hirst, but the huge popularity of the dynamic new regional art venues and Tate Modern suggest otherwise. 'It's...an educated audience, an audience which is enquiring and challenging and questioning and not willing to be fobbed off all the time....And I don't think it existed before,' says the artist Glenn Brown, who has lately switched paint for ink, stripping away colour to focus on line, shading and form in elaborate drawings. Where before contemporary art was considered marginal, now it is part of the mainstream culture along with cinema and music. 'An ambition for art to become more central to people's lives I think was a big change,' says Adam Chodzko, who continues to create intriguing ephemeral communities like his *God Look-Alike Contest.*

BritArt attracted the public because it was sexy, witty and readable, drawing on the language of advertising, television and the media in which the British are proficient. Whether overtly sexual or made of bizarre matter like blood, flies and elephant dung, or breathtakingly intimate, such as Richard Billingham's family photographs, the art often had a gut appeal. (Incidentally, Richard's recent photography has focused on beautifully composed landscapes, zoo animals and his own young family, a world away from the dysfunctional scenes of *Ray's a Laugh.*) The artists 'were taking the world as they found it and commenting on it very directly or using their own lives as the subject for their art, and speaking frequently in a language which was highly accessible,' says Tate director Nicholas Serota, pointing to Sarah Lucas's ribald tabloid images and Damien Hirst's animal works about life and death. 'It's emotional stuff and it immediately provokes a response.' 'It wasn't a dry academic bunch of people,' says Mat Collishaw. '[It was] people who were more motivated by drinking and dancing and talking than by writing manifestos.' After the abstruse Conceptual art of the 1970s, the media jumped on BritArt as something it could finally grasp, that made good copy, although in those days of fledgling art commentary women artists still faced

> **It wasn't a dry academic bunch of people.** [It was] people who were more motivated by drinking and dancing and talking than by writing manifestos.
>
> MAT COLLISHAW

blatant sexism. 'I've got all these reviews where...they...take the mickey out of my accent or talk about my breast size,' says Tracey Emin, noting that her male counterparts escaped this. 'What are they going to do, talk about Anish Kapoor's dick? I don't think so.'

As sweeping as the change was for Britain's art scene and the media, few would argue that the BritArtists radically altered the direction of art. As artists do, they borrowed from the existing repertoire – whether to pay homage, mock or outdo their forbears – and advanced the dialogue in their disciplines in exciting, sometimes spectacular ways. 'Was the change as fundamental as some of the changes wrought by Picasso with Cubism or Duchamp?' asks Nicholas Serota. 'No. But was it a significant step forward? Yes.' 'This is not about a revolution in art....But something does change. A lot of it is not visible. What changes is the terms of engagement,' says Liam Gillick, who has maintained a strong international profile, as seen by his selection to represent Germany at the 2009 Venice Biennale. The YBAs had a sense of their talent and felt entitled to show their work without waiting to be discovered.

The real revolution of this period was in attitude. 'It was all about change. Change of approach. Change of ambition. Change of possibilities. What they did was they showed what could be possible,' says Julia Peyton-Jones, former director of the Serpentine Gallery. 'They provided a really important role, in a way, of destroying the establishment.' Not only did they make art that didn't fit, literally or metaphorically, into most of the existing galleries, but they also circumvented the rigid gallery system. Sadie Coles and Jay Jopling launched galleries in response to the new art that was ambitious in scope and aims. 'The artists did not rely on any of the old boys' networks to get ahead. They made their own history. They made their own platform. And it was bloody impressive,' says Coles.

Moreover, this new egalitarian climate put to bed the perception of the artist as white, male and independently wealthy, as personified by the likes of Anthony Caro or Lucian Freud. 'I think essentially what was great about YBA,' says Jane Wilson, 'was just the sheer demographic of people who were making art....And artists not necessarily from the safe privileged middle classes. There was

> The artists did not rely on any of the old boys' networks to get ahead. **They made their own history.** They made their own platform. <u>**And it was bloody impressive**</u>.
>
> SADIE COLES

a lot of working class.' 'That's what they really proved, that you could come from very modest backgrounds and you could really win the prizes,' agrees Michael Craig-Martin, who has enjoyed a resurgence of popularity with his bright paintings of everyday objects and large outline sculptural versions of these. Women artists also gained visibility and presence. Sarah Lucas, Tracey Emin and Rachel Whiteread are now big names; others such as Christine Borland and Abigail Lane have left the male-dominated gallery system. Christine, a professor at Northumberland University, has extended her artistic investigation of bioethics and medicine. Her latest collaborative project revolves around a sculptural proposal to two organ donors for using their bodies for artistic research. For several years Abigail has curated and participated in the contemporary art exhibition 'SNAP', part of the Aldeburgh Music Festival in Suffolk, bringing in peers such as Glenn Brown, Anya Gallaccio and Sarah Lucas. In the wake of the YBAs, art students in Britain increasingly picked up video cameras and made DIY films, foreshadowing the explosion of video-sharing websites such as Vimeo and YouTube. 'I do think there was a very big impact on how younger artists began to work in the late '90s and also even now,' says Georgina Starr, who has continued to create her lo-fi productions of magical worlds involving performance, song and sculpture. 'The fact that many of us were using our own bodies and voices directly and using performance, video and sound...opened up the possibilities of what art could be.'

In terms of their profile abroad, the BritArtists as a group never carried the same force as in Britain, although individual artists have considerable foreign followings. 'I think that they have had an impact in America and in Continental Europe definitely. They're not just a parochial British phenomenon,' insists Tate's Nicholas Serota. But America and Germany, despite hosting big group shows, were always somewhat lukewarm. 'I always felt that the Americans were actually quite reluctant to give what's due here, which has to do with...a certain chauvinism at work,' says Karsten Schubert. 'I think some of the galleries abroad were a bit turned off by what they saw as brashness,' says one informed art world insider. 'Jay [Jopling's White Cube] is maybe not the most collegiate of galleries....I think Jay was always quite happy to keep all the sales to himself, which hasn't necessarily been great for the artists, or for the city.'

British artists in the 1990s changed the standing of Britain in the art world. 'The history of British art was always referential of something else….And now I think London is really embedded as an art centre, not a satellite,' says Anya Gallaccio, who teaches art in California and has harnessed advanced technology in her ongoing exploration of natural matter such as her 2016 sculpture from a digital scan of a tree for Manchester's Whitworth Gallery. Of course, London's transformation into an art capital is inextricably linked with its rise as a financial hub and strategic gateway for collectors between Europe and Asia. While New York remains the global centre for contemporary art in terms of museums, galleries and the art market, London has usurped the mantle of European art capital from Cologne, as witnessed by the recent flood of American galleries setting up branches in the city.

Not surprisingly, BritArt was a hard act to follow and became a millstone for younger artists. 'It seemed as if the immediate generations that came after that were in danger of being totally squashed by its dominance,' says Sadie Coles. And because by the mid-1990s the BritArtists were splashed all over magazines looking cool and nonchalant, with endless features focusing on their hard partying, it seemed as if success had come effortlessly. 'People now think there's a career that you can have, there's almost the belief there's a methodology to becoming a successful artist, and it just doesn't work,' says Dinos Chapman. Art students became obsessed with getting rich quick, according to several of the group who taught at art schools. 'I'd go into colleges and just get really annoyed with people who just wanted to be famous rather than putting in the slog,' says Rachel Whiteread, who after the public traumas of *House* and the *Holocaust Memorial* has been making 'shy sculptures' for remote places like the Mojave Desert in America. 'They may have pretended otherwise, but a lot of people worked really hard,' insists Glenn Brown. 'Gary's paintings look very easily made. Sarah's work looks like it was thrown together overnight. Tracey Emin's work looks as if… she could hardly be bothered about it. But the opposite was true.'

In parallel to the rise of the YBAs, the celebrity culture took hold in the 1990s, largely due to social changes such as the arrival of the internet, social networking and reality TV. Some of the YBAs reflected the obsession with stardom in their art and became celebrities. While there were plenty of models for artist personalities from Joseph

Beuys to Andy Warhol, the celebrity love-in among certain YBAs and artist branding by White Cube was felt by some to compromise their credibility, and by extension that of the group. Gavin Turk, who has diversified his practice into neon sculptures, left White Cube: 'I probably reacted badly to the star-making system….I just didn't appreciate the competitive nature of it.' Marcus Harvey also departed White Cube and made headlines again with his 2009 sculptural portrait of Margaret Thatcher created largely with dildos. ('I…have a very strong, vivacious, commanding, busty blonde mother. I don't think you need to look further than that really,' he chuckles.) Marcus has launched a painting school and a highbrow magazine, *Turps Banana*.

The history of British art was always referential of something else…. and now I think **London is really embedded as an art centre,** not a satellite.

ANYA GALLACCIO

Traditionalists have always dismissed Conceptual artists as inferior, repeating the familiar refrains 'a child could do that' or 'they can't even draw'. But art is no longer a question of naturalistic representation. 'The challenge for painting in the 1990s in Britain was: can you hold your corner of the stage with all the sharks and God knows what else being wheeled across? But it does have a place. And it's still here,' says Fiona Rae, who has rebooted her practice by abandoning colour for a lush greyscale in painting and charcoal drawings that are delicately poised between abstraction and figuration. Berlin-based Angela Bulloch continues to stretch technological boundaries with ever-more complex pixel box sculptures, optically disorienting columns of geometric figures and drawing machines that involve the viewer. Galvanized by Damien Hirst's gift of a roomful of paint, Mat Collishaw returned to painting after twenty years, with a series of photorealist geometric canvases depicting folded cocaine wraps in a debasement of the Modernist grid and the romantic notion of ennui. 'It was…the idea that the anxiety of the void in the twenty-first century doesn't come through standing on the edge of a cliff, contemplating nature…,' says Mat. 'It was like an empty coke wrap when your drugs have run out at two o'clock in the morning in the Groucho Club toilet.' A contemporary audience may well identify with the concerns of the BritArtists, yet that of course does not detract from the genius of Old Masters such as Leonardo da Vinci or Rembrandt. Gary Hume does in fact call down artists from the celestial canon to help with his paintings. 'The other day I was asking for a

Matisse and Corot....And I do get this sensation that they occupy me for a moment and I'm in quite a joyful conversation with them,' he says.

But there are fair criticisms of the group's art. Some of it was without doubt superficial, sensationalist and over-reliant on irony. The YBAs rejigged the public conception of art so that 'it had to be shocking', says Grayson Perry, who had a solo show at the British Museum in 2011 and has become a household name through his television commentaries. 'And that's put a big onus on artists that they're somehow meant to be shocking.' Moreover, the notion of 'If I say it's art, it's art', much exploited by the group, doesn't mean that it is automatically good art. The flip side of the amazing supportiveness among the group is that some of the critical rigour they learned at college suffered, either out of consideration for each other's feelings or because honest friends were edged out by 'yes' people. Part of the problem for the BritArt generation is that they had to do their developing in the public eye. They didn't have time for reflection and to make mistakes, which form an invaluable part of art-making.

The association with Charles Saatchi and the multi-million dollar advertising industry tainted YBA in the eyes of some who felt art had a duty to retain critical distance from its patrons and the system. Left-wing critics such as Julian Stallabrass, author of *High Art Lite*, opposed BritArt as cynical, blasé and lacking in social conscience. Indeed, most BritArt did not address social issues or have a moral purpose. Matthew Collings takes the view that the YBAs were 'superb shallowists' in an age of shallowness, but that their shocks provoked useful existential questions – almost by mistake – about what we are at a time when we were entering today's society in which nothing has meaning or value: 'They were prophets of a new world but they were prophets who were idiot savants...they were like gifted children making plasticine models of H bombs without knowing the menace of what they were doing.' However, for Collings, a painter himself, the group's refusal to engage with the weight of art history beyond the level of imagery and iconography ultimately makes their work unimportant, although he considers this a wider problem of much contemporary art.

None of these views is wrong or invalid. Art serves a different purpose for each time. BritArt in its glorious diversity offered a portrait of Britain at the end of the twentieth century, a time when reality TV and social media turned inside out notions of public and

private spheres, trade became globalized as the internet narrowed geographical distances and capitalism became the dominant world ideology. Richard Patterson, now based in Dallas and experimenting with freer and more expressive gestural painting and sculpture, calls YBA 'a last hurrah' in art 'before globalization became the new issue, the art world then exploded into the internet auction house fiasco that it is today'. Even if BritArt was largely apolitical, it still served a valuable social purpose in undermining assumptions and forcing people to see the world afresh. 'It's very easy to put things down,' says Norman Rosenthal. 'If you want to say that *The Last Judgment* of Michelangelo is a lot of naked men falling down a wall, you can. You can pull the piss out of about any piece of art that ever was….But art's a wonderful way of celebrating life and the complexities and ambiguities of life. And that's what these kids have done. In their own way.'

To return to Tracey Emin's bed, now installed at the Tate alongside two Francis Bacon paintings – one a reclining nude, the other a frenzied dog, both evoking the terror of loneliness[7] – it has already gained the aura of a classic work, according to Nicholas Serota. 'I think that the Tate exists in part to try and collect, preserve and show those works of art that have had most influence on society or on people's attitudes to art, whether it's *Christ in the House of his Parents* by Millais, which was seen as blasphemous when it was shown at the Royal Academy in 1850, or it's Tracey Emin's bed,' he says. Absolute history, of course, does not exist. There can only be subjective versions and inevitably some people will be excluded. This is one history of BritArt, an attempt to record for posterity a defining and vibrant moment of British art that insisted on Britain's right to a place in the international pantheon. Some of the works will stand the test of time, others will not. In any case, history tends to prune down art movements and groupings to five or six names. What is certain is that this group of artists has exercised a hold over the British public's imagination that perseveres today against the odds. Former Goldsmiths tutor Michael Craig-Martin says he knew art had made the crossover into mainstream culture when a builder on a construction site recognized him from one of the Turner Prize programmes and pronounced his views about the nominees. 'And I thought, "Well that's what we've always been looking for. That's the dream come true. It's happened."'

## NOTES

The following artists were interviewed for this book: Richard Billingham, Christine Borland, Glenn Brown, Angela Bulloch, Jake and Dinos Chapman, Adam Chodzko, Mat Collishaw, Ian Davenport, Tracey Emin, Anya Gallaccio, Liam Gillick, Douglas Gordon, Marcus Harvey, Damien Hirst, Gary Hume, Michael Landy, Abigail Lane, Sarah Lucas, Richard Patterson, Simon Patterson, Marc Quinn, Fiona Rae, Georgina Starr, Sam Taylor-Johnson, Gavin Turk, Mark Wallinger, Gillian Wearing, Rachel Whiteread, Jane and Louise Wilson. Grayson Perry and Johnnie Shand Kydd were interviewed as observers of the scene and Michael Craig-Martin and Jon Thompson as former tutors of the group.

Other people interviewed besides the artists were: Sadie Coles, Matthew Collings, Pauline Daly, Carl Freedman, Barbara Gladstone, Maureen Paley, Julia Peyton-Jones, Norman Rosenthal, Esther Schipper, Karsten Schubert, Adrian Searle, Nicholas Serota, Matthew Slotover and David Thorp.

Unless accompanied by a reference note, all quotes in this book are taken from the author's exclusive interviews with the person cited.

## INTRODUCTION

1   Fiachra Gibbons, 'Satirists jump into Tracey's bed', *Guardian*, 25 October 1999; 'Wales housewife "outraged" by dirty bed exhibit', BBC news, 25 October 1999, http://news.bbc.co.uk/1/hi/wales/485270.stm.
2   Several fascinating accounts of the period have been written by friends of the group (Gregor Muir's *Lucky Kunst*) or detractors (Julian Stallabrass's *High Art Lite*). Matthew Colling's *Blimey!: From Bohemia to Britpop: The London Artworld from Francis Bacon to Damien Hirst* and *Art Crazy Nation* offer a highly entertaining and informative tour of the time recounted with breezy irony. This is the first serious, objective history of this period.
3   This, of course, is not an exhaustive list. Many more artists were making interesting work at this time but it is simply not possible to list them all.
4   The French art historian Nicolas

Bourriaud coined the term 'Relational Aesthetics' in the 1990s for art based on human relations and their social context. This kind of practice will be looked at in more detail in Chapter 3.
5   Simon Ford and Anthony Davies, 'Art capital', *Art Monthly*, February 1998 and Kate Bush, 'Kate Bush on the YBA sensation', *Artforum*, October 2004.
6   Tracey Emin was appointed CBE in the Queen's 2013 New Year Honours and was professor of drawing at the Royal Academy Schools from 2011 to 2013.

## CHAPTER ONE

1   The 'Freeze' participants were: Steven Adamson, Angela Bulloch, Mat Collishaw, Ian Davenport, Angus Fairhurst, Anya Gallaccio, Damien Hirst, Gary Hume, Michael Landy, Abigail Lane, Sarah Lucas, Lala Meredith-Vula, Stephen Park, Richard Patterson, Simon Patterson, Fiona Rae. Dominic Denis is listed in the catalogue but was dropped from the show at the last minute.
2   Until the introduction of student loans in 1990, most UK students were entitled to free tuition, while maintenance grants were means-tested. In 1998, tuition fees were introduced and student grants replaced by repayable loans for all but the poorest students. Source: 'Student Loan Statistics', House of Commons Library briefing paper no. 1079, 5 October 2015.
3   Julian Stallabrass, *High Art Lite: The Rise and Fall of Young British Art*, London, 2006 edition, first published 1999, pp. 141–56. Stallabrass says Mat has a reputation as 'the nastiest of the "Young British Artists"' for his presentation of disturbing material without taking a stance (pp. 150–52).
4   Most Goldsmiths graduates were somewhat versed in the Post-structuralist philosophy of Roland Barthes, Jean Baudrillard and Jacques Lacan, feminist theorists such as Hélène Cixous and Julia Kristeva and Marxist philosopher Louis Althusser, according to several of the artists, although the artist and television presenter Matthew Collings, who did the Goldsmiths MA, says any suggestion that such theory underpins the BritArtists' work is 'laughable'. 'I think it's very healthy to notice that they're not theorists, they're

not intellectual, they're barely articulate... but to notice at the same time that they are seriously efficient and good artists,' he says.
5   Hirst and Burn, 2001, p. 44.
6   Some discrepancy exists over the exact dates of 'Freeze', including the third part. The original press release gives these dates: Part I Aug 6–22, Part II Aug 27–Sept 12, Part III Sept 14–29. However, according to the work schedule Damien sent the artists, and another document he sent notifying everyone of an extension, the dates were as follows: Part I Aug 6–21, Part II Aug 27–Sept 12 (extended to Oct 9), Part III Oct 14–Nov 14.
7   Maev Kennedy, 'David Hockney and Damien Hirst go head to head with solo London shows', *Guardian*, 3 January 2012; 'Eleven for eleven: Damien Hirst's controversial worldwide exhibition', *Huffington Post*, 13 January 2012, citing art world information platform *Artlog*, http://www.huffingtonpost.com/artlog/damien-hirst_b_1200047.html. Damien is quoted as saying: 'The best spot painting you can have by me is one painted by Rachel.'
8   Scott Reyburn, 'Hirst will stop making spin, butterfly paintings, drug cabinets', *Bloomberg*, 14 August 2008.
9   Sacha Craddock, 'The fast Dockland track to simplicity', *Guardian*, 13 September 1988.
10   *Ibid.*

## CHAPTER TWO

1   The influential curatorial training programme at the École du Magasin in Grenoble had opened in 1987, spawning a host of intellectual young thinkers such as German gallerist Esther Schipper, and Florence Bonnefous and Edouard Merino, who founded Air de Paris gallery, located first in Nice then Paris.
2   The exhibiting artists in 'Modern Medicine' were: Mat Collishaw, Grainne Cullen, Dominic Denis, Angus Fairhurst, Damien Hirst, Abigail Lane, Miriam Lloyd and Craig Wood. Cullen and Lloyd were the only non-Goldsmiths participants.
3   Slotover founded *frieze* with co-editor Amanda Sharp and the artist Tom Gidley in 1991.
4   The four non-Goldsmiths artists in 'Gambler' were: Steve di Benedetto, Dan

Bonsall, Tim Head and Michael Scott.
5　Damien Hirst and Gordon Burn,
*On the Way to Work*, 1st edition, London,
5 November 2001, p. 177.
6　*Ibid.*, pp. 180–81. Damien is quoted
in his book saying 'I'm not into stinking
everyone out of the gallery. I'm into
drawing them into the gallery...So long as
they *think* it's real. As long as you don't
know, I don't fucking care. It only fails
when I get a cow's head made that looks
shite. And I fooled Bacon.' (p. 181). On
p. 116 he explains this: 'I'm totally not into
"truth to materials". As long as you can
convince people...I'm into entertainment
and theatre....You know, you've got a
cow's head that looks convincing from a
few feet, it's got flies all over it, it doesn't
matter whether it's real or not.'
7　Andrew Graham-Dixon, 'The Midas
touch?: graduates of Goldsmiths' School
of Art dominate the current British art
scene', *Independent*, 31 July 1990.
8　*Ibid.*
9　http://www.tate.org.uk/art/artworks/
patterson-the-great-bear-p77880 quoting
Greenberg, 1994, p. 47.
10　Hirst and Burn, 2001, p. 29.
11　Alison Sarah Jacques, 'Body of
evidence', *Art + Text*, no. 54, 1996, offers
an interesting discussion of Abigail's work.
12　Jackie Wullschlager, 'Lunch with the
FT: Jay Jopling', *Financial Times*, 2 March
2012.
13　*Ibid.*
14　*Ibid.*
15　Diana told Martin Bashir in an
interview on *Panorama*, broadcast in
November 1995, that there were three
people in her marriage, referring to her
husband's longstanding affair with Camilla
Parker-Bowles.
16　Muir also refers to these shifting
relationships within the group in *Lucky
Kunst*, p. 84.
17　Hirst interviewed by Kirsty Young on
*Desert Island Discs*, BBC Radio 4, 17 May
2013.
18　Alastair Sooke, 'Damien Hirst: we're
here for a good time, not a long time',
*Daily Telegraph*, 8 January 2011.
19　Hirst and Burn, 2001, pp. 45–47.
20　*Ibid.*
21　*Ibid.*
22　Interviewed in Tate art and life
video on the occasion of Damien's 2012
retrospective at Tate Modern: http://www.

tate.org.uk/context-comment/video/
damien-hirst-art-and-life.
23　Jackie Wullschlager, 'Lunch with the
FT: Jay Jopling', *Financial Times*, 2 March
2012.
24　John McJannet, 'Daily Star takes the
chips to the world's most expensive fish',
*Daily Star*, 27 August 1991.
25　Stuart Morgan, 'The art world's Grand
National', *frieze*, issue 1, September–
October 1991.
26　*Ibid.*
27　Peter Schjeldahl, 'Twelve British
artists', *frieze*, issue 7, November–
December 1992.
28　The other exhibitors were Lea
Andrews, Keith Coventry, Steven Pippin
and Marcus Taylor.
29　'Lucky Kunst' featured Don Brown,
Gary Hume, Sam Taylor-Wood, James
White, and Jane and Louise Wilson on the
British side, and on the American Rita
Ackermann, Mariko Mori, Sarah Morris and
Ricardo de Oliveira. For more information
about the show see Gregor Muir, *Lucky
Kunst: The Rise & Fall of Young British Art*,
London, 2009, pp. 79–86.
30　'WM Karaoke Football' took place
first in the Portikus Museum in Frankfurt
in 1994 and then at the South London
Gallery in 1995 for the return 'match'.
The artists who took part were: Monika
Baer, Clio Barnard, Achim Beitz, Wolfgang
Bethke, Angela Bulloch, Adam Chodzko,
Keith Coventry, Tracey Emin, Angus
Fairhurst, Mark Formanek, Liam Gillick,
Martin Gostner, Georg Herold, Georgie
Hopton, Gary Hume, Sean Kimber, Daniel
Kohl, Michael Landy, Abigail Lane, Marko
Lehanka, Sarah Lucas, Hans-Jörg Mayer,
Max Mohr, Simon Periton, Steven Pippin,
Brendan Quick, Tobias Rehberger, Andreas
Rohrbach, Andreas Slominski, Georgina
Starr and Gavin Turk.
31　Edward Verity, 'Celebrities flock to
gaze at a cow's head and a dead shark',
*Daily Mail*, 6 March 1992.
32　Simon Ford makes this point in his
insightful article 'Myth making', *Art
Monthly*, no. 194, March 1996.

**CHAPTER THREE**

1　Gillian Wearing began the
MA at Goldsmiths but left halfway
through.

2　Vanessa Engle, 2002 BBC2
documentary *The History of BritArt*.
3　Darren Coffield, *Factual Nonsense –
The Art and Death of Joshua Compston*,
London, 2013, gives a full account of
Joshua's colourful life.
4　*Ibid.*, pp. 78–84.
5　*Ibid.*, p. 86.
6　*Ibid.*, p. 61 and elsewhere; many
individuals make this point throughout
the book.
7　*Ibid.*, pp. 17–18.
8　*Ibid.*, pp. 49, 55, 127–52.
9　*Ibid.*, pp. 18, 48, Compston's influences
ranged from the Futurists to 1920s
cartoons and the British Communist
Party's pamphlets. He produced
manifestos at a time when they were
deeply unfashionable.
10　*Ibid.*, pp. 181, 189, 194–95.
11　*Ibid.*, foreword p. xii.
12　*Ibid.*, Chapters 10 and 12 on
Compston's dark side, love of danger and
possible mental illness.
13　David Barrett, unpublished interview
excerpt for Royal Jelly Factory, http://www.
royaljellyfactory.com/newartupclose/
chapman-iv.htm.
14　Jackie Wullschlager, 'Lunch with the
FT: Jay Jopling', *Financial Times*, 2 March
2012.
15　Bourriaud in 1996 curated a seminal
exhibition 'Traffic' at the CAPC Museum
of Contemporary Art in Bordeaux around
this type of art, featuring among others
Henry Bond, Angela Bulloch, Liam Gillick,
Douglas Gordon and Gillian Wearing, as
well as European artists Pierre Huyghe and
Philippe Parreno, Mexico's Gabriel Orozco
and America-based Rirkrit Tiravanija.
Bourriaud's 1998 book, *Esthetiques
Relationelles*, expounded his ideas on the
subject.
16　Angus interviewed in 1994, BBC
Omnibus documentary *Freeze, 'But is it
Art'?*
17　Thomas Lawson, 'Hello, it's me',
*frieze*, issue 9, March–April 1993.
18　In Hirst and Burn, 2001, p. 180,
Damian confirms Burn's suggestion
that he is 'systematically going through
Bacon's images and obsessions and giving
them a concrete existence'.
19　James Lingwood on *House*, Artangel
website, http://www.artangel.org.uk//
projects/1993/house/an_idea_without_a_
name/james_lingwood_the_story.

20  Letter by Flounders to the *Independent*, 5 November 1993.
21  Carl Freedman, 'Took the money and ran', *frieze*, issue 14, January–February 1994.
22  Waldemar Januszczak, 'Maybe it's because she's a Londoner', *Sunday Times*, 25 May 1997.
23  Heidi Reitmaier, 'What are you looking at? Moi?', in Duncan McCorquodale, Naomi Siderfin and Julian Stallabrass, eds, *Occupational Hazard: Critical Writing on Recent British Art*, London, 1998, pp. 112–39.

CHAPTER FOUR

1  'General Release' at the 1995 Venice Biennale marked another important BritArt showcase and is well documented in Gregor Muir's, *Lucky Kunst: The Rise & Fall of Young British Art*, London, 2009.
2  Steven Pippin and Critical Décor (comprising Toby Morgan and David Pugh) also took part.
3  Adrian Searle, 'Life, the universe and everything', *Independent*, 18 April 1995.
4  Patricia Bickers, *The Brit Pack: Contemporary British Art, the View from Abroad*, London, 1995, p. 14.
5  *Ibid.*, p. 20.
6  Michael Corris, 'British? Young? Invisible? w/ Attitude?', *Artforum*, May 1992; Bickers makes this point eloquently in 'The Brit Pack'.
7  Ford, 'Myth making'.
8  Richard Cork, *Breaking Down Barriers*, New Haven, 2003, pp. 95–96.
9  Sarah Kent, *Shark Infested Waters*, London, 1994, pp. 32–35. See also Rosemary Betterton, *An Intimate Distance: Women Artists and the Body*, London, 1996, pp. 79–105.
10  Hirst and Burn, 2001, p. 103.
11  Coffield, 2013, Chapters 10 and 12.
12  Salmon interviewed in Vanessa Engle's 2002 BBC2 documentary *The History of BritArt*.
13  Gordon Burn, 'Party or die', *Guardian*, 12 April 2000.
14  *Ibid.*
15  Richard Dorment, *Daily Telegraph*, November 1996, cited on Tate website: http://www.tate.org.uk/whats-on/tate-britain/exhibition/turner-prize-1996.

16  'London reigns', *Newsweek*, 3 November 1996; *Vanity Fair*'s March 1997 cover had Patsy Kensit and Liam Gallagher in bed under the banner 'London Swings Again!'.
17  Norman Rosenthal, 'What makes Charles Saatchi Tick', *The Times*, 23 June 2011.
18  Saatchi's advertising agency Saatchi & Saatchi produced the 1979 Conservative election campaign poster 'Labour Isn't Working', showing a long dole queue.
19  Tamsin Blanchard, 'Sensation as ink and egg are thrown at Hindley portrait', *Independent*, 19 September 1997.
20  John Kay, 'It's an artrage!', *Sun*, 26 July 1997.
21  Dalya Alberge, 'RAs vote for Hindley picture', *The Times*, 12 September 1997.
22  Tamsin Blanchard, 'Sensation as ink and egg are thrown at Hindley portrait', *Independent*, 19 September 1997.
23  *Ibid.*
24  *Ibid.*
25  The full headline was 'Exhibited by the Royal Academy in the So-called Name of Art, Defaced by the People in the Name of Common Decency', Mirror, 19 September 1997.

CHAPTER FIVE

1  Foreword in Tracey Emin and Carl Freedman, *Tracey Emin Works 1963–2006*, New York, 2006, p. 6.
2  Anita Singh, 'Tracey Emin's bed to be displayed at Tate', *Daily Telegraph*, 29 July 2014.
3  Judith Palmer, 'I am art, therefore I am', *Independent*, 17 September 1998.
4  Adrian Searle, 'Here's looking at me', *Guardian*, 22 September 1998.
5  David Frankel, 'Now you see it, now you don't', *Artforum*, November 1996.
6  Hirst and Burn, 2001, p. 168.
7  Waldemar Januszczak, 'The shape of things to come?', *Sunday Times*, 20 June 1999.
8  Wallinger in David Burrows, ed., *Who's Afraid of Red, White and Blue?: Attitudes to Popular and Mass Culture, Celebrity, Alternative and Critical Practice and Identity Politics in Recent British Art*, Birmingham, 1998, pp. 78–82.
9  *Ibid.*

10  *Ibid.*
11  *Ibid.*
12  http://www.stuckism.com/stuckistmanifesto.html.
13  *Ibid.*
14  www.john-russell.org/; Stallabrass, 2006, p. 70.
15  Matthew Collings, *Art Crazy Nation*, London, 2001, p. 36.
16  Stallabrass, 2006, pp. 72–73.
17  Dick Price, 'Don't stop 'til you get enough', in *The New Neurotic Realism*, London, 1998, n.p.
18  J.J. Charlesworth, 'Neurotic Realism: Part Two', *Art Monthly*, no. 230, October 1999.
19  Alicia Ritson, 'Between Heaven and Hell: the Holy Virgin Mary at the Brooklyn Museum', New Museum and Skira Rizzoli, in *Chris Ofili: Night and Day*, exh. cat., New Museum, New York, 2014, p. 163.
20  Alan G. Artner, 'Don't believe the hype: "Sensation" fails to live up to its name', *Chicago Tribune*, 11 October 1999, http://articles.chicagotribune.com/1999-10-11/features/9910110134_1_advertising-mogul-charles-saatchi-giuliani-brooklyn-museum.
21  *Chris Ofili: Night and Day*, exh. cat., New Museum, New York, 2014, pp. 163–81.
22  *Ibid.*
23  *Ibid.*
24  *Ibid.*
25  *Ibid.*
26  *Ibid.*
27  *Ibid.*
28  Kobena Mercer, in Ziauddin Sardar, Rasheed Araeen and Sean Cubitt, eds, *The Third Text Reader on Art, Culture and Theory*, London, 2002, pp. 116–23.

CHAPTER SIX

1  In 2014 Tate Modern had 5.8 million visitors compared with 4.9 million in 2013, according to the Association of Leading Visitor Attractions www.alva.org.uk.
2  Fiachra Gibbons, 'BritArt is out of the picture', *Guardian*, 15 June 2000; Anon., 'BritArt is banished', *Daily Telegraph*, 16 June 2000.
3  Hirst and Burn, 2001, p. 147.
4  *Ibid.*, p. 153.
5  Laura Cumming, 'What the Sensationalists did next', *Observer*, 23 April 2000.

6   Adrian Searle, 'A relentless litany of self-abuse', *Guardian*, 18 April 2000.

7   'Sir Elton gets the big picture', *BBC News*, http://news.bbc.co.uk/1/hi/entertainment/740751.stm.

8   Muir, 2009, p. 217.

9   Ralph Rugoff, 'Empty window dressing: is Damien Hirst still interested in being taken seriously as an artist, or merely bent on playing the market?' *Financial Times*, 28 October 2000.

10   Hirst and Burn, 2001, p. 83.

11   Simon Hattenstone, 'Damien Hirst: "Anyone Can be Rembrandt"', *The Guardian*, 14 November 2009.

12   Brian Sewell surprisingly declared: 'Hell is first great work of the 21st century', *Evening Standard*, 6 June 2008.

13   Matthew Higgs, 'Ars brevis, vita longa/ Success can be overcome', in Judith Bumpus, Matthew Higgs and Tony Godfrey, Hayward Gallery, *British Art Show 5*, exh. cat., London, 2000, pp. 13–18, p. 15.

14   Jonathan Jones, 'Squeaks of protest', *The Guardian*, 19 September 2000.

15   Tate Gallery, *Intelligence: New British Art 2000*, exh. cat., London: Tate Publishing, 2000, pp. 55–57.

16   *Ibid.*, p. 57.

17   Nicholas Watt, 'Bottom marks for Turner prize as culture minister vents his spleen', *Guardian*, 31 October 2002.

18   Tim Adams, 'Saatchi's open house', *Observer*, 23 March 2003.

19   Alex Farquharson, *frieze*, issue 76, June–August 2003.

20   Fiachra Gibbons, 'Hirst buys his art back from Saatchi', *Guardian*, 27 November 2003.

21   Ben Lewis, 'Charles Saatchi: the man who reinvented art', *Observer*, 10 July 2011; Anon., 'Hands up for Hirst: how the bad boy of Brit-Art grew rich at the expense of his investors', *The Economist*, 9 September 2010.

22   Fiachra Gibbons, 'Hirst buys his art back from Saatchi', *Guardian*, 27 November 2003.

23   Fiona Rae interviewed by Simon Wallis, in Carre d'Art – Musée d'art contemporain de Nîmes, *Fiona Rae*, exh. cat., Nîmes, France, 2002, pp. 66–74.

24   Ian Davenport interviewed by Michael Bracewell, in Martin Filler and Michael Bracewell, *Ian Davenport*, London, 2014, pp. 265–72, p. 271.

25   Adrian Searle, 'Trouble in paradise', *Guardian*, 2 March 2004; Mark Beasley, 'In-a-Gadda-da-Vida', *frieze*, issue 84, June–August 2004.

26   Tony Parsons, 'Bonfire of the vanities', *Daily Mirror*, 31 May 2004.

27   Toulouse Le Plot, 'I replaced burned masterpieces for £39.99', *Sun*, 27 May 2004; Paul Harris, 'But all is not lost… How the Mail recreated Tracey's tent (saving Mr Saatchi £39,932)', *Daily Mail*, 27 May 2004; Tom Lubbock, 'Lost art isn't irreplaceable; but it probably won't be replaced', *Independent*, 27 May 2004.

28   Sean O'Hagan, 'Interview: The man who sold us Damien', *Observer*, 1 July 2007.

29   Will Bennett, 'Hirst's clearance sale: Pharmacy auction', *Daily Telegraph*, 18 October 2004.

30   Martin Bailey and Christina Ruiz, 'Did Tate miss its chance to get the Saatchi Collection?', *The Art Newspaper*, no. 153, December 2004.

31   Carol Vogel, 'Another round for Saatchi vs. Tate', *New York Times*, 27 November 2004; Colin Gleadell, 'Saatchi sells another key work in his Collection', *ARTnews*, May 2005.

32   Peter Aspden, 'Saatchi sale seen as ending of love affair with Brit art', *Financial Times*, 21 April 2005; Sophie Kirkham, 'Has Saatchi, patron of sharks and unmade beds, gone off Brit Art?' *The Times*, 4 July 2005.

33   Q&A with Charles Saatchi, *The Art Newspaper*, no. 153, December 2004.

POSTSCRIPT

1   According to data published in October 2013 by WealthX (www.wealthx.com), an intelligence provider on 'ultra high net worth' individuals, Damien Hirst was the world's richest artist with a net worth of $350 million, far above Jasper Johns and Andrew Vicari, who ranked joint second with a net worth of $210 million each, and Jeff Koons fourth with $100 million. The Sunday Times Rich List of 2015 calculated Hirst's wealth at £215 million (around $335 million).

2   Ben Lewis's 2009 documentary *The Great Contemporary Art Bubble*, and the *Financial Times* video: 'Damien Hirst at Tate Modern', FT Arts, 10 April 2012

3   Kirsty Young in discussion with Damien Hirst on *Desert Island Discs*, BBC Radio 4, 17 May 2013.

4   Anon., 'Hands up for Hirst', *The Economist*, 9 September 2010. Qatar in 2013 hosted Hirst's biggest retrospective ever, including a reported £20 million commission of embryo sculptures, according to Natalie Paris, 'Damien Hirst exhibition opens in Doha', *Daily Telegraph*, 10 October 2013.

5   Scott Reyburn and Doreen Carvajal, 'Gauguin's painting is said to fetch $300 million', *New York Times*, 5 February 2015.

6   Don Thompson, *The $12 Million Stuffed Shark*, London, 2008, pp. 53–60. The group varies but usually includes Koons, Hirst and Japanese pop artist Takashi Murakami.

7   Tracey Emin explains her choice of Bacon works on Tate website http://www.tate.org.uk/context-comment/articles/perfect-bedfellows.

## SELECT BIBLIOGRAPHY

The primary sources for this book are my exclusive interviews with some 50 artists, gallerists, museum directors and critics.
  The secondary sources listed below comprise a portion of the material consulted in researching this book.

### BOOKS, MONOGRAPHS AND EXHIBITION CATALOGUES

*Anya Gallaccio*, texts by Jan van Adrichem, Norman Bryson, Briony Fer and Lucía Sanromán, and a conversation between the artist and Clarrie Wallis, London: Ridinghouse, 2013

Betterton, Rosemary, *An Intimate Distance: Women Artists and the Body*, London: Routledge, 1996

Bickers, Patricia, *The Brit Pack: Contemporary British Art, the View from Abroad*, Manchester: Cornerhouse, 1995

British Council, *General Release: Young British Artists at Scuola di San Pasquale*, Venice, 1995

Burn, Gordon, *Sex & Violence, Death & Silence: Encounters with Recent Art*, London: Faber and Faber, 2009

Burrows, David, ed., *Who's Afraid of Red, White and Blue?: Attitudes to Popular and Mass Culture, Celebrity, Alternative and Critical Practice and Identity Politics in Recent British Art*, Birmingham: ARTicle Press, 1998; text and images first presented at a day-long conference on 28 March 1998

Carre d'Art – Musée d'art contemporain de Nîmes, *Fiona Rae*, exh. cat., Nîmes, 2002

*Chris Ofili*, texts by David Adjaye and Thelma Golden, New York: Rizzoli, 2009

Coffield, Darren, *Factual Nonsense: The Art and Death of Joshua Compston*, London: Darren Coffield, 2013

Collings, Matthew, *Art Crazy Nation: the Post-Blimey Art World*, London: 21 Publishing, 2001

Collings, Matthew, *Blimey!: From Bohemia to Britpop: the London Artworld from Francis Bacon to Damien Hirst*, London: 21 Publishing, 1997

Cooper, Jeremy, *Growing Up: The Young British Artists at 50*, Munich and London: Prestel, 2012

Cork, Richard, *Breaking Down the Barriers: Art in the 1990s*, New Haven, CT and

London: Yale University Press, 2003

Emin, Tracey, *Strangeland: Tracey Emin*, London: Sceptre, 2005

*Freeze*, exh. cat., London, 1988

*Gambler*, exh. cat., London, 1990

*Gillian Wearing*, texts by Daniel F. Herrmann, Doris Krystof, Bernhart Schwenk and David Deamer, exh. cat., London: Ridinghouse, 2012

Harris, Jonathan, ed., *Art, Money, Parties: New Institutions in the Political Economy of Contemporary Art*, Liverpool: Liverpool University Press, 2004

Hayward Gallery, *The British Art Show 5*, exh. cat., London, 2000

Herbert, Martin, *Mark Wallinger*, London: Thames & Hudson, 2011

Hirst, Damien and Gordon Burn, *On the Way to Work*, London: Faber and Faber, 2001

*Ian Davenport*, text by Martin Filler and Michael Bracewell, London: Thames & Hudson, 2014

Institute of Contemporary Arts, *Abigail Lane: Skin of the Teeth*, exh. cat., London, 1995

Kent, Sarah, *Shark Infested Waters: the Saatchi Collection of British Art in the 90s*, London: Zwemmer, 1994

Klein, Jacky, *Grayson Perry*, London: Thames & Hudson, 2009

McCorquodale, Duncan, Naomi Siderfin and Julian Stallabrass, eds, *Occupational Hazard, Critical Writing On Recent British Art*, London: Black Dog, 1998

*Marc Quinn: Memory Box*, Germano Celant, ed., exh. cat., Milan: Skira Editore, 2013

*Mat Collishaw*, Jessica Watts and Eloise Maxwell, eds; essay by Sue Hubbard and interview by Rachel Campbell-Johnston, exh. cat., London: Blain/Southern, 2012

*Michael Landy, Everything Must Go!*, texts by Richard Flood, Richard Shone and Rochelle Steiner, and an interview with the artist by James Lingwood, London: Ridinghouse, 2008

*Modern Medicine*, exh. cat., London, 1990

Muir, Gregor, *Lucky Kunst: The Rise & Fall of Young British Art*, London: Aurum, 2009, 2012

Museum of Contemporary Art, Chicago: *Abigail Lane: Whether the Roast Burns, the Train Leaves or the Heavens Fall*, exh. cat., Chicago, 1998

National Galleries of Scotland; Glasgow Life, *Generation: 25 years of Contemporary Art in Scotland*, exh.cat.,

Edinburgh and Glasgow, 2014

New Museum and Skira Rizzoli, *Chris Ofili: Night and Day*, exh. cat., New York, 2014

Renton, Andrew and Liam Gillick, eds, *Technique Anglaise: Current Trends in British Art*, London: Thames & Hudson, 1991

*Richard Patterson*, texts by Toby Kamps and Jeremy Strick, and an interview with the artist by Martin Herbert, London: Ridinghouse, 2013

Rogers, Richard and Marc Quinn, *Fourth Plinth*, Germany: SteidlMACK, 2006

Royal Academy of Arts, *Apocalypse: Beauty and Horror in Contemporary Art*, exh. cat., London, 2000

Royal Academy of Arts, *Sensation: Young British Artists from the Saatchi Collection*, exh. cat., London: Royal Academy of Arts/Thames & Hudson, 1997

Saatchi, Charles, *My Name is Charles Saatchi and I am an Artoholic*, London: Booth-Clibborn Editions, 2012; first published by Phaidon, 2009

Saatchi Gallery, *Ant Noises at the Saatchi Gallery*, exh. cat., London, 2000

Saatchi Gallery, *The New Neurotic Realism*, exh. cat., London, 1998

Saatchi Gallery, *Young British Artists IV*, exh. cat., London, 1995

Saatchi Gallery, *Young British Artists V*, exh. cat., London, 1995

Self, Will and Marc Quinn, *Selfs*, text by Will Self, and an interview with the artist by Tim Marlow, exh. cat., Basel: Fondation Beyeler, 2009

Serpentine Gallery, *Broken English*, exh. cat., London, 1991

Serpentine Gallery, *Some Went Mad, Some Ran Away*, exh. cat., London, 1994

*Simon Patterson*, essays by Bernhard Fibicher and Iwona Blazwick, London: Locus+, 2002

Stallabrass, Julian, *High Art Lite: The Rise and Fall of Young British Art*, London and New York: Verso, 2006, 1999

Sydney Museum of Contemporary Art, *Pictura Britannica: Art from Britain*, exh. cat., Sydney, 1997

Tate Gallery, *Intelligence: New British Art 2000*, London: Tate Publishing, 2000

Thompson, Don, *The $12 Million Stuffed Shark: The Curious Economics of Contemporary Art and Auction Houses*, London: Aurum, 2012

Thompson, Jon, *The Collected Writings of Jon Thompson*, Jeremy Akerman and

Eileen Daly, eds, London: Ridinghouse, 2011

Timms, Robert, Alexandra Bradley and Vicky Hayward, eds, *Young British Art: The Saatchi Decade*, London: Booth-Clibborn Editions, 1999

*Tracey Emin: Works, 1963–2006*, text by Carl Freedman, Rudi Fuchs and Jeanette Winterson; Honey Luard and Peter Miles, eds, New York, NY: Rizzoli, 2006

Walker Art Center, *Brilliant!: New Art from London*, exh. cat., Minneapolis, MN, 1995

Whitechapel Art Gallery, *Protest & Survive*, exh. cat., London, 2000

TELEVISION AND AUDIO

1992–2004, Tate Audio arts – relevant volumes in which BritArtists are interviewed; also Tate video interviews, 'Tate Art Talks' and Tate shots with many of the artists

1994, *Omnibus: Freeze, 'But is it Art'?* BBC documentary, directed by Mark James

1996, *Two Melons and a Stinking Fish*, documentary for BBC TV/Arts Council, produced and directed by Vanessa Engle

1999, *This Is Modern Art*, six-part television series for Channel 4, presented by Matthew Collings

2002, *The History of BritArt,* documentary for BBC2, produced and directed by Vanessa Engle

2008, Hirshhorn museum video interview with Douglas Gordon

2009, *The Great Contemporary Art Bubble,* produced and directed by Ben Lewis

2009, *The Reunion, Brit Art*, a Whistledown production for BBC Radio 4

2012, *Damien Hirst: Art and Life*, produced by Tate to accompany Damien's exhibition; Ann Gallagher, curator of the Tate Modern exhibition, tours the show with Damien Hirst, produced by Tate and Science Ltd

2012, *Damien Hirst: Thoughts, Work, Life*, directed by Chris King for Drop Out Pictures/Damien Hirst and Science Ltd

2012, *Financial Times* video: 'Damien Hirst at Tate Modern', FT Arts

2013, *Desert Island Discs*, Damien Hirst interviewed by Kirsty Young, BBC Radio 4, 17 May

2014, *Documentary: 'Relics' exhibition*, produced by Oxford Film and Television

for Damien Hirst and Science Ltd/Qatar Museums Authority

2014, *Perspectives – Kick Out the Jams*, presented by Gary Kemp for ITV

ESSAYS, PRESS ARTICLES AND REVIEWS

Anon., 'BritArt is banished', *Daily Telegraph*, 16 June 2000

Anon., 'Eleven for eleven: Damien Hirst's controversial worldwide exhibition', *Huffington Post*, 13 January 2012, citing art world information platform *Artlog*, http://www.huffingtonpost.com/artlog/damien-hirst_b_1200047.html.

Anon., 'Hands up for Hirst: how the bad boy of Brit-Art grew rich at the expense of his investors', *The Economist,* 9 September 2010

Anon., Q&A with Charles Saatchi, *The Art Newspaper*, no. 153, December 2004

Anon., 'Sir Elton gets the big picture', *BBC News*, 8 May 2000 http://news.bbc.co.uk/1/hi/entertainment/740751.stm

Anon., 'Wales housewife "outraged" by dirty bed exhibit', *BBC News*, 25 October 1999, http://news.bbc.co.uk/1/hi/wales/485270.stm

Adams, Tim, 'Saatchi's open house', *Observer*, 23 March 2003

Adams, Tim, 'I've always been a bit of a listener' [Gillian Wearing], *Observer*, 4 March 2012

Aidin, Rose, 'The future's bright' [Fiona Rae], *The Times*, 1 March 2003

Akbar, Arifa, 'No more shock tactics' [Marcus Harvey], *Independent*, 15 September 2011

Alberge, Dalya, 'RAs vote for Hindley picture', *The Times*, 12 September 1997

Archer, Michael, 'Jesus Christ in goal', *frieze*, issue 8, January–February 1993

Artner, Alan G., 'Don't believe the hype: "Sensation" fails to live up to its name', *Chicago Tribune*, 11 October 1999

Bailey, Martin and Christina Ruiz, 'Did Tate miss its chance to get the Saatchi Collection?', *The Art Newspaper*, no. 153, December 2004

Barber, Lynn, 'Drag queen' [Sarah Lucas], *Observer Magazine*, 30 January 2000

Barber, Lynn, 'Candid camera' [Richard Billingham], *Observer Magazine*, 28 May 2000

Barber, Lynn, 'Well-hung, drawn and

sculpted' [Marc Quinn], *Sunday Times*, 15 August 2000

Barber, Lynn, 'Show and tell' [Tracey Emin], *Observer*, 22 April 2001

Barclay Morgan, Anne, 'Memorial for anonymous: an interview with Christine Borland', *Sculpture Magazine*, vol. 18, no. 8, October 1999

Barrett, David, 'Gary Hume interview', Royal Jelly Factory, 2004, http://www.royaljellyfactory.com/newartupclose/hume-iv.htm

Barrett, David, 'Jake & Dinos Chapman interview', *Royal Jelly Factory*, 2007, http://www.royaljellyfactory.com/newartupclose/chapman-iv.htm

Batchelor, David, Kate Bush, Jutta Koether, Sotiris Kyriacou and Adrian Searle, 'It's a maggot farm: the B-boys and fly girls of British art', *Artscribe*, no. 84, November–December 1990

Beasley, Mark, 'In-a-Gadda-da-Vida', *frieze*, issue 84, June–August 2004

Bennett, Will, 'Hirst's clearance sale: Pharmacy auction', *Daily Telegraph*, 18 October 2004

Bevan, Roger, 'What is – or was – the Goldsmiths phenomenon?', *The Art Newspaper*, no. 48, May 1995

Bickers, Patricia, 'Meltdown' [interview with Anya Gallaccio], *Art Monthly*, no. 195, April 1996

Blanchard, Tamsin, 'Sensation as ink and egg are thrown at Hindley portrait', *Independent*, 19 September 1997

Bowditch, Gillian, 'Handy with the camera', *Sunday Times*, 27 May 2001

Bracewell, Michael, 'The all-singing, all-crying self-portrait' [Georgina Starr], *Independent*, 27 February 1996

Bulloch, Angela, 'Freeze', *Art & Design*, vol. 5, no. 3/4, 1989

Burn, Gordon, 'The knives are out' [Damien Hirst], *Guardian*, 10 April 2000

Burn, Gordon, 'Party or die', *Guardian*, 12 April 2000

Bush, Kate, 'Kate Bush on the YBA sensation', *Artforum*, October 2004

Bussel, David, 'Lowest expectations' [Angus Fairhurst], *frieze*, issue 34, May 1997

Bussel, David, 'Who controls what? Interview with Angela Bulloch', in *Art from the UK*, Munich: Sammlung Goetz, 1997

Campbell-Johnston, Rachel, 'A shock-jock's deliverance,' *The Times*, 2 April 2008

Charlesworth, J.J., 'Neurotic Realism: Part Two, The Saatchi Gallery', *Art Monthly*, no. 230, October 1999

Cohen, David, 'A new generation driven beyond abstraction', *The Times*, 2 November 1991

Collings, Matthew, 'Transformer man' [Gavin Turk], *Guardian*, 18 October 1995

Cork, Richard, 'Meltdown at the cube station' [Anya Gallaccio], *The Times*, 20 February 1996

Cork, Richard, 'Playing to the gallery' [Douglas Gordon], *The Times*, 19 October 1996

Cork, Richard, 'The Establishment clubbed', *The Times*, 16 September 1997

Cork, Richard, 'Young, gifted and rising too fast?', *The Times*, 8 November 1991

Cork, Richard, 'At home with Ray and Liz' [Richard Billingham], *The Times*, 9 June 2000

Corris, Michael, 'British? Young? Invisible? w/Attitude?' *Artforum*, May 1992

Cottingham, Laura, 'Wonderful life', *frieze*, issue 12, September–October 1993

Craddock, Sacha, 'The fast Dockland track to simplicity', *Guardian*, 13 September 1988

Craddock, Sacha, 'Great British hopes', *The Times*, 19 November 1994

Cumming, Laura, 'What the Sensationalists did next', *Observer*, 23 April 2000

Dannatt, Adrian, 'Meanwhile in Minneapolis', *Independent*, 14 November 1995

Darwent, Charles, 'Who do they think they are?' [Adam Chodzko], *Independent on Sunday*, 4 July 1999

De Lisle, Rosanna and Annabel Auerbach, 'Arts: the new establishment', *Independent*, 31 August 1997

Eyre, Hermione, 'Mat Collishaw is art's Mr Nasty', *Evening Standard*, 25 September 2009

Farquharson, Alex, *frieze*, issue 76, June–August 2003

Flood, Richard, 'Smashing!', *frieze*, issue 25, November–December 1995

Ford, Simon, 'Myth making', *Art Monthly*, no. 194, March 1996

Ford, Simon and Anthony Davies, 'Art capital', *Art Monthly*, no. 213, February 1998

Frankel, David, 'Now you see it, now you don't' [Georgina Starr], *Artforum*, November 1996

Freedman, Carl, 'Took the money and ran', *frieze*, issue 14, January–February 1994

Garfield, Simon, 'I like it, I'll take the lot' [Charles Saatchi], *Independent*, 20 March 1993

Gayford, Martin, 'Ice man with a hot future' [Marc Quinn], *Daily Telegraph*, 14 February 1998

Gibbons, Fiachra, 'Satirists jump into Tracey's bed', *Guardian*, 25 October 1999

Gibbons, Fiachra, 'BritArt is out of the picture', *Guardian*, 15 June 2000

Gibbons, Fiachra, 'Hirst buys his art back from Saatchi', *Guardian*, 27 November 2003

Glancey, Jonathan, 'Charles Saatchi buys artworks like Imelda Marcos bought shoes', *Independent*, 17 February 1996

Glass, Nicholas, 'You start to think you're Midas' [Damien Hirst], *Financial Times*, 7 December 2010

Gleadell, Colin, 'Saatchi sells another key work in his Collection', *ARTnews*, May 2005

Gooding, Mel, 'The art of noise', *Independent*, 24 May 1997

Graham-Dixon, Andrew, 'The Midas touch?: graduates of Goldsmiths' School of Art dominate the current British art scene', *Independent*, 31 July 1990

Graham-Dixon, Andrew, 'Thrown on the Scrapheap' [Michael Landy], *Independent*, 9 July 1996

Greenberg, Sarah, 'The word according to Simon Patterson', *Tate: The Art Magazine*, issue 4, Winter 1994

Harris, Mark, 'Putting on the style', *Art Monthly*, no. 193, February 1996, pp. 3–6, p. 5

Harris, Paul, 'But all is not lost...How the Mail recreated Tracey's tent (saving Mr Saatchi £39,932)', *Daily Mail*, 27 May 2004

Hattenstone, Simon, 'Damien Hirst: "Anyone can be Rembrandt"', *Guardian*, 14 November 2009

Higgs, Matthew, 'Ars brevis, vita longa/ Success can be overcome', in *British Art Show 5*, exh. cat., London: Hayward Gallery, 2000; exhibition curated by Pippa Coles, Matthew Higgs and Jacqui Poncelet

Hilton, Tim, 'The critics: was this what the Academy wanted?', *Independent on Sunday*, 21 September 1997

Hunt, Ian, 'Guilt by association', *frieze*, issue 7, November–December 1992

Hunt, Ian, 'Serious play' [Christine Borland], *frieze*, issue 26, January–February 1996

Jacques, Alison Sarah, 'Body of evidence', *Art + Text*, no. 54, 1996

Januszczak, Waldemar, 'Just scratching the surface' [Abigail Lane], *Sunday Times*, 12 March 1995

Januszczak, Waldemar, 'Maybe it's because she's a Londoner', *Sunday Times*, 25 May 1997

Januszczak, Waldemar, 'Facing the scary art of our time', *Sunday Times*, 21 September 1997

Januszczak, Waldemar, 'The shape of things to come?', *Sunday Times*, 20 June 1999

Johnson, Ken, 'Art begetting art, and social commentary too' [Liam Gillick], *New York Times*, 5 July 2012

Jones, Jonathan, 'Squeaks of protest', *Guardian*, 19 September 2000

Joseph, Branden W., 'Ambivalent objects' [Angela Bulloch], in *Theanyspacewhatever*, exh. cat., New York: Guggenheim Museum, 2008

Kastner, Jeffrey, 'British art today: a new powerhouse', *ARTnews*, no. 7, vol. 93, September 1994

Kastner, Jeffrey, 'Brilliant?', *Art Monthly*, no. 192, 1995–96

Kay, John, 'It's an artrage!', *Sun*, 26 July 1997

Kennaway, Guy, 'Living with Jay Jopling', *The London Magazine*, 29 September 2011

Kennedy, Maev, 'David Hockney and Damien Hirst go head to head with solo London shows', *Guardian*, 3 January 2012

Kunzru, Hari, 'Damien Hirst and the great art market heist', *Guardian*, 17 March 2012

Thomas Lawson, 'Hello, it's me' [Douglas Gordon], *frieze*, issue 9, March–April 1993

Legge, Rob, 'The broader picture: the faces of God' [Adam Chodzko], *Independent on Sunday*, 19 September 1993

Leith, William, 'Interview: Jane and Louise Wilson – we are a camera', *Independent*, 29 August 1999

Leris, Sophie, 'YB Abigail', *Evening Standard*, 2 December 2005

Lewis, Ben, 'Charles Saatchi: the man who reinvented art', *Observer*, 10 July 2011

Lingwood, James, on *House*, Artangel

website, 1995, http://www.artangel. org.uk//projects/1993/house/an_idea_ without_a_name/james_lingwood_the_ story

Longrigg, Clare, 'Sixty seconds, noise: by art's bad girl' [Tracey Emin], *Guardian*, 4 December 1997

Lubbock, Tom, 'Stupid like a conceptualist', *Independent*, 10 August 1993

Lubbock, Tom, 'Painting themselves into a corner' [Fiona Rae], *Independent*, 4 January 1994

Lubbock, Tom, 'Nothing special' [Sam Taylor-Wood], *Independent*, 7 May 2002

Lubbock, Tom, 'Lost art isn't irreplaceable, but it probably won't be replaced', *Independent*, 27 May 2004

Luyckx, Filip, 'Tuberama, A Musical on the Northern Line', Sint-Lukasgalerji, 1998

McGuire, Stryker, 'London reigns', *Newsweek*, 3 November 1996

McJannet, John, 'Daily Star takes the chips to the world's most expensive fish', *Daily Star*, 27 August 1991

Macritchie, Lynn, 'Where you can't believe your eyes' [Douglas Gordon], *Financial Times*, 25 July 2000

Macritchie, Lynn, 'Interview: Glenn Brown', *Art in America*, April 2009

Malinsky, Brandon, 'Victims' mums get Hindley art invite', *Sun*, 17 September 1997

Mercer, Kobena, 'Ethnicity and internationality: new British art and diaspora-based blackness', in Ziauddin Sardar, Rasheed Araeen and Sean Cubitt, eds, *The Third Text Reader on Art, Culture and Theory*, London: Continuum, 2002

Millard, Rosie, 'The art gang: the movers and shakers behind Britain's artistic renaissance', *Independent*, 30 August 1997

Millard, Rosie, 'The tastemakers', *Independent*, 20 October 2001

Moore, Suzanne, 'Meat and two veg' [Sarah Lucas], *Independent*, 22 March 1997

Morgan, Stuart, 'The art world's Grand National', *frieze*, issue 1, September–October 1991

Morgan, Stuart, 'Confessions of a body snatcher' [Glenn Brown], *frieze*, issue 12, September–October 1993

Morgan, Stuart, 'Rude awakening' [Jake and Dinos Chapman], *frieze*, issue 19, November–December 1994

Morgan, Stuart, 'The story of I' [Tracey Emin], *frieze*, issue 34, May 1997

Moyes, Jojo, 'Son's stark portrait of a family at war' [Richard Billingham], *Independent*, 25 August 1997

Muir, Gregor, 'Yesterday' [Georgina Starr], *frieze*, issue 13, November–December 1993

Mullins, Charlotte, 'The Young British Artists have gone out of fashion', *Independent*, 15 June 2000

Murphy, Dominic, 'Little promises' [Gary Hume], *Guardian*, 7 September 2002

Norman, Geraldine, 'Art market: the contemporary capital', *Independent on Sunday*, 6 March 1994

Norman, Geraldine, 'Selling like pickled cows', *Independent on Sunday*, 6 October 1996

O'Hagan, Sean, 'Interview: the man who sold us Damien', *Observer*, 1 July 2007

O'Hagan, Sean, 'Damien Hirst: 'I still believe art is more powerful than money', *Guardian*, 11 March 2012

O'Hagan, Sean, 'Gary Hume: I couldn't hold down a job. That's why I became an artist', *Observer*, 18 May 2013

Packer, William, 'The diminishing value of novelty', *Financial Times*, 6 August 1991

Packer, William, 'The awful reduced to the banal', *Financial Times*, 8 April 1995

Palmer, Judith, 'I am art, therefore I am', *Independent*, 17 September 1998

Paris, Natalie, 'Damien Hirst exhibition opens in Doha', *Daily Telegraph*, 10 October 2013

Parsons, Tony, 'Bonfire of the vanities, *Daily Mirror*, 31 May 2004

Pitman, Joanna, 'Art breaker', *The Times*, 13 September 1997

Pitman, Joanna, 'One-man show', *The Times*, 15 April 2000

Popham, Peter, 'Jake and Dinos and all their little friends', *Independent*, 12 May 1996

Price, Dick, 'Don't stop 'til you get enough', in *The New Neurotic Realism*, London: Saatchi Gallery, 1998

Rebentisch, Julianne, 'Angela Bulloch's digital reduction', *Parkett*, no. 66, 2002, pp. 27–32

Reitmaier, Heidi, 'What are you looking at? Moi?', in Duncan McCorquodale, Naomi Siderfin and Julian Stallabrass, eds,

*Occupational Hazard: Critical Writing on Recent British Art*, London: Black Dog, 1998, pp. 112–39

Reyburn, Scott, 'Hirst will stop making spin, butterfly paintings, drug cabinets', *Bloomberg*, 14 August 2008

Reyburn, Scott and Doreen Carvajal, 'Gauguin's painting is said to fetch $300 million', *New York Times*, 5 February 2015

Richards, Jane, 'I should be working at Kwik Save' [Richard Billingham], *Guardian*, 26 November 1998

Ritson, Alicia, 'Between Heaven and Hell: the Holy Virgin Mary at the Brooklyn Museum', *Chris Ofili: Night and Day*, exh. cat., Massimiliano Gioni, Gary Carrion-Murayari and Margot Norton, eds, New York: New Museum and Skira Rizzoli, 2014

Rittenbach, Kari, 'Good sport: Liam Gillick takes on the German pavilion', *Art in America*, 5 June 2009

Roberts, James, 'Making a drama out of a crisis' [Sam Taylor-Wood], *frieze*, issue 44, 1999

Roberts, John, 'Notes on 90s art', *Art Monthly*, no. 200, October 1996

Rosenthal, Norman, 'What makes Charles Saatchi tick', *The Times*, 23 June 2011

Rugoff, Ralph, 'Empty window dressing' [Damien Hirst], *Financial Times*, 28 October 2000

Sales, Nancy Jo, 'Bad boy back in the Big Apple' [Damien Hirst], *Vanity Fair*, 6 November 2000

Sawyer, Miranda, 'Arty spice' [Tracey Emin], *Observer Life Magazine*, 20 July 1997

Sawyer, Miranda, 'Happy return' [Sam Taylor-Wood], *Observer*, 11 November 2001

Schjeldahl, Peter, 'Twelve British artists', *frieze*, issue 7, November–December 1992

Searle, Adrian, 'Shut that door' [Gary Hume], *frieze*, issue 11, June–August 1993

Searle, Adrian, 'Rachel doesn't live here anymore', *frieze*, issue 14, January–February 1994 Searle, Adrian, 'Life, the universe and everything', *Independent*, 18 April 1995

Searle, Adrian, 'Faces to watch in the art world 8: Gillian Wearing', *Independent*, 26 September 1995

Searle, Adrian, 'Would you want to live next door to these two sisters?' [Jane

and Louise Wilson], *Independent*, 10 October 1995

Searle, Adrian, 'Here's looking at me', *Guardian*, 22 September 1998

Searle, Adrian, 'A relentless litany of self-abuse', *Guardian*, 18 April 2000

Searle, Adrian, 'Cooked twice and still flavourless', *Guardian*, 12 September 2000

Searle, Adrian, 'Road to nowhere' [Liam Gillick], *Guardian*, 14 May 2002

Searle, Adrian, 'Trouble in paradise', *Guardian*, 2 March 2004

Searle, Adrian, 'Same again Saatchi', *Guardian*, 23 March 2004

Self, Will, 'The Will Self interview: Tracey Emin, a slave to truth', *Independent*, 21 February 1999

Sewell, Brian, 'Hell is first great work of the 21st century', *Evening Standard*, 6 June 2008

Sharp, Rob, 'Jay Jopling: big space, big art, big ego', *Independent*, 12 October 2011

Singh, Anita, 'Tracey Emin's bed to be displayed at Tate', *Daily Telegraph*, 29 July 2014

Sooke, Alastair, 'We're here for a good time, not a long time', [Damien Hirst], *Daily Telegraph*, 8 January 2011

Sooke, Alastair, 'Gillian Wearing: everyone's got a secret', *Daily Telegraph*, 28 March 2012

Tomkins, Calvin, 'The modern man: how the Tate Gallery's Nicholas Serota is reinventing the museum', *The New Yorker*, 2 July 2012

Toulouse Le Plot, 'I replaced burned masterpieces for £39.99', *Sun*, 27 May 2004

Turner, Grady T., 'Gillian Wearing', *Bomb*, issue 63, Spring 1998

Verity, Edward, 'Celebrities flock to gaze at a cow's head and a dead shark', *Daily Mail*, 6 March 1992

Carol Vogel, 'Another round for Saatchi vs. Tate, *New York Times*, 27 November 2004

Wullschlager, Jackie, 'Lunch with the FT: Jay Jopling', *Financial Times*, 2 March 2012

Younge, Gary, 'A bright new wave' [Chris Ofili], *Guardian*, 16 January 2010

## ACKNOWLEDGMENTS

My thanks go firstly to all the artists for their enormous generosity in sparing their time and sharing their memories. Many were initially skeptical about participating in another discussion of the YBAs but came on board in the interest of documenting this important period in British art. Almost all of the interviews were face to face, or via Skype for those based in America, and lasted between one hour and eight hours. In many cases these were followed up with further interviews and emails to clarify outstanding questions and the artists were kind enough to indulge me. Every interview offered fascinating insights into the practice of each artist and left me with a deep respect for their endeavours. In alphabetical order the artists are: Richard Billingham, Christine Borland, Glenn Brown, Angela Bulloch, Jake and Dinos Chapman, Adam Chodzko, Mat Collishaw, Ian Davenport, Tracey Emin, Anya Gallaccio, Liam Gillick, Douglas Gordon, Marcus Harvey, Damien Hirst, Gary Hume, Michael Landy, Abigail Lane, Sarah Lucas, Richard Patterson, Simon Patterson, Marc Quinn, Fiona Rae, Georgina Starr, Sam Taylor-Johnson, Gavin Turk, Mark Wallinger, Gillian Wearing, Rachel Whiteread, Jane and Louise Wilson.

I am also extremely grateful to the museum directors, gallerists, artist commentators, critics and others who gave up their time to be interviewed and provided astute observations about the events and artworks. They are: Sadie Coles, Matthew Collings, Michael Craig-Martin, Pauline Daly, Carl Freedman, Barbara Gladstone, Maureen Paley, Grayson Perry, Julia Peyton-Jones, Norman Rosenthal, Johnnie Shand Kydd, Esther Schipper, Karsten Schubert, Adrian Searle, Nicholas Serota, Matthew Slotover, Jon Thompson and David Thorp.

A special thank you to Abigail Lane for her kind hospitality and helpful advice, for the long stints she spent going through her photos of the time with me, sharing stories and contacts. I am also hugely obliged to Angela Bulloch, who generously dug up and allowed us to use unseen photos and documents from the period.

Similarly, Fiona Rae showed great trust and kindness in letting me explore her personal photos and make my selection. The photographers Johnnie Shand Kydd and Ed Woodman deserve an additional mention for so patiently trawling through their archives with me. A particular thank you to Vanessa Fristedt for her fantastic street map that brings to life so colourfully the '90s scene in London and for the many extra hours she tirelessly put into its creation.

Still in the art world, I owe thanks to the following for helping to arrange interviews, providing archive images, answering factual queries and much more: Martina Aschbacher at Douglas Gordon's studio, Meri Atkins at Gavin Turk's studio, Rosa Maria Bacile at Sadie Coles, Madeleine Bertorelli at Karsten Schubert, Patricia Bickers, Kate Blake, Kyle Bloxham Mundy at Timothy Taylor, Kathryn Braganza at Carl Freedman, Anna Campeau at Science, Toby Clarke at Vigo, Amie Corrie at Science, Alan Cristea, Daniel Davis at Anthony Reynolds, Katie Doubleday at Marc Quinn's studio, Grazyna Dobrzanska-Redrup at Mark Wallinger's studio, Doro Globus at Karsten Schubert, Cate Halpin, Amy Houmoller at Frieze, Mark Inglefield, Anika Jamieson-Cook at the Chapmans' studio, Edgar Laguinia, Eleanor Macnair, Roisin Mcqueirns at Simon Lee, Lala Meredith-Vula, Eimear O'Raw at Tracey Emin's studio, Pilar Ordovas, Ben Reed at R3 Photography Ltd, Elli Resvanis, the Saatchi Gallery, Kat Sapera at Timothy Taylor, Jude Tyrell at Science, Hazel Willis at Rachel Whiteread's studio, Jonathan Watts, and Rosie at Sam Taylor-Johnson's studio.

I have been so lucky to have wonderfully supportive friends and would like to single out Juliette Jowit and Sophie Brickell for consistently and uncomplainingly giving sound advice. In addition, Jennifer Sprackling's help with endless hours of top notch transcription was an immeasurable boon and Johanna Dresdner kindly shared her memories of Goldsmiths in the late '80s and lent me her MA dissertation on Media and the YBAs.

This book would never have come about without Jacky Klein, who commissioned it, and the dedicated team at Thames & Hudson, especially Roger Thorp and Sarah Hull, the picture researcher Annalaura Palma, the designer Lisa Ifsits and my editor Linda Schofield. I am deeply thankful to them.

I owe a massive thank you to my parents for their constant support and encouragement, and in particular, my mother, an art historian and former curator at the Brooklyn Museum, for her perceptive insights and unstinting devotion of her time and energy to this project.

Lastly, I want to thank my amazing children, Oliver and Theo, and my husband Matthew for their forbearance, understanding and support during this project. I am indebted to Matthew for his incisive editing input in this book, giving up many hours to go through each draft chapter in addition to his day job; he is without doubt one of the most talented editors I know. This book is dedicated to them.

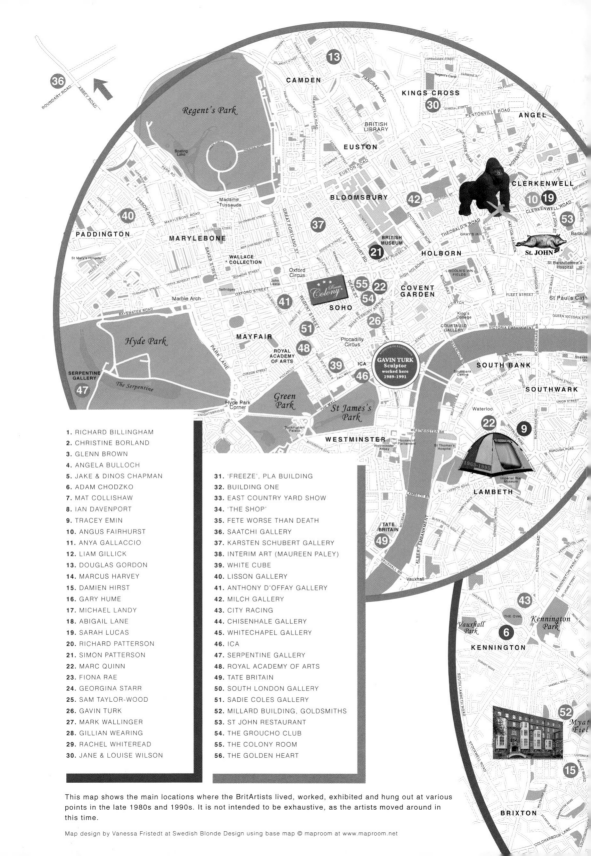

1. RICHARD BILLINGHAM
2. CHRISTINE BORLAND
3. GLENN BROWN
4. ANGELA BULLOCH
5. JAKE & DINOS CHAPMAN
6. ADAM CHODZKO
7. MAT COLLISHAW
8. IAN DAVENPORT
9. TRACEY EMIN
10. ANGUS FAIRHURST
11. ANYA GALLACCIO
12. LIAM GILLICK
13. DOUGLAS GORDON
14. MARCUS HARVEY
15. DAMIEN HIRST
16. GARY HUME
17. MICHAEL LANDY
18. ABIGAIL LANE
19. SARAH LUCAS
20. RICHARD PATTERSON
21. SIMON PATTERSON
22. MARC QUINN
23. FIONA RAE
24. GEORGINA STARR
25. SAM TAYLOR-WOOD
26. GAVIN TURK
27. MARK WALLINGER
28. GILLIAN WEARING
29. RACHEL WHITEREAD
30. JANE & LOUISE WILSON

31. 'FREEZE', PLA BUILDING
32. BUILDING ONE
33. EAST COUNTRY YARD SHOW
34. 'THE SHOP'
35. FETE WORSE THAN DEATH
36. SAATCHI GALLERY
37. KARSTEN SCHUBERT GALLERY
38. INTERIM ART (MAUREEN PALEY)
39. WHITE CUBE
40. LISSON GALLERY
41. ANTHONY D'OFFAY GALLERY
42. MILCH GALLERY
43. CITY RACING
44. CHISENHALE GALLERY
45. WHITECHAPEL GALLERY
46. ICA
47. SERPENTINE GALLERY
48. ROYAL ACADEMY OF ARTS
49. TATE BRITAIN
50. SOUTH LONDON GALLERY
51. SADIE COLES GALLERY
52. MILLARD BUILDING, GOLDSMITHS
53. ST JOHN RESTAURANT
54. THE GROUCHO CLUB
55. THE COLONY ROOM
56. THE GOLDEN HEART

This map shows the main locations where the BritArtists lived, worked, exhibited and hung out at various points in the late 1980s and 1990s. It is not intended to be exhaustive, as the artists moved around in this time.

Map design by Vanessa Fristedt at Swedish Blonde Design using base map © maproom at www.maproom.net

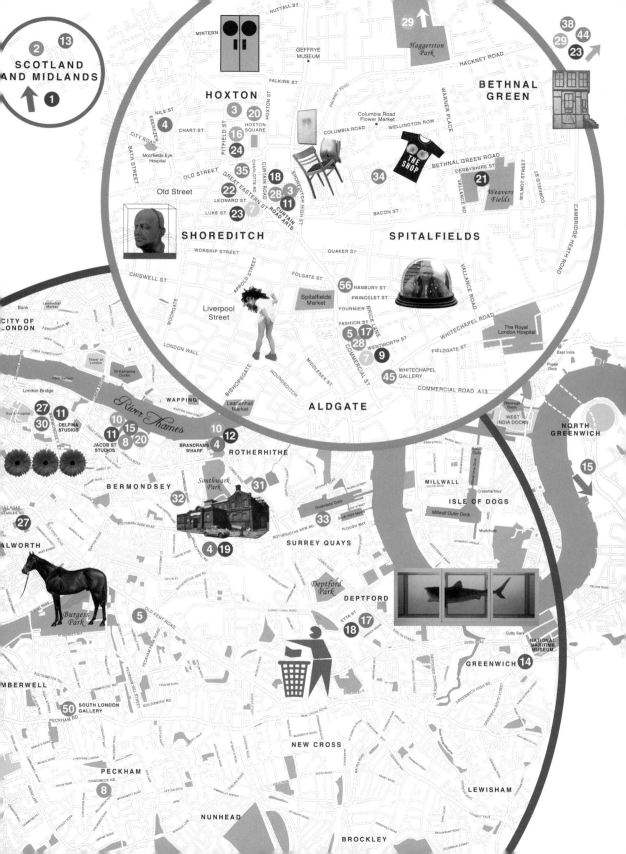